Pelican Books

Style and Civilization | Edited by John Fleming and Hugh Honour

Neo-classicism by Hugh Honour

Hugh Honour was born in 1927 and was educated at the King's School, Canterbury, and St Catharine's College, Cambridge. After working in the British Museum he became assistant director of the Leeds City Art Gallery. His first book, *Chinoiserie: The Vision of Cathay,* appeared in 1961, and *The Companion Guide to Venice* was published in 1965. He also collaborated with Nikolaus Pevsner and John Fleming in *The Penguin Dictionary of Architecture* (1966), and with John Fleming on *The Penguin Dictionary of Decorative Arts* (1977). His book on the European vision of America, *New Golden Land,* was published in 1976.

D0062582

Hugh Honour

Neo-classicism

With 109 illustrations

Penguin Books

Penguin Books Ltd, Harmondsworth, Middlesex, England
Penguin Books, 625 Madison Avenue, New York, New York 10022, U.S.A.
Penguin Books Australia Ltd, Ringwood, Victoria, Australia
Penguin Books Canada Limited, 2801 John Street, Markham, Ontario, Canada L3R 1B4
Penguin Books (N.Z.) Ltd, 182–190 Wairau Road, Auckland 10, New Zealand

First published 1968
Reprinted 1973, 1975
Reprinted with revisions 1977
Reprinted 1979, 1981, 1983

Printed in Great Britain by
Fletcher & Son Ltd, Norwich
Set in Monotype Garamond

Designed by Gerald Cinamon

Contents

Editorial Foreword 7

Acknowledgements 9

Introduction 13

1 *Classicism and Neo-classicism* 17

2 *The Vision of Antiquity* 43

3 *Art and Revolution* 69

4 *The Ideal* 101

5 *Sensibility and the Sublime* 141

6 *Epilogue* 171

Catalogue of Illustrations 193

Books for Further Reading 209

Index 213

Editorial Foreword

The series to which this book belongs is devoted to both the history and the problems of style in European art. It is expository rather than critical. The aim is to discuss each important style in relation to contemporary shifts in emphasis and direction both in the other, non-visual arts and in thought and civilization as a whole. By examining artistic styles in this wider context it is hoped that closer definitions and a deeper understanding of their fundamental character and motivation will be reached.

The series is intended for the general reader but it is written at a level which should interest the specialist as well. Beyond this there has been no attempt at uniformity. Each author has had complete liberty in his mode of treatment and has been free to be as selective as he wished – for selection and compression are inevitable in a series such as this, whose scope extends beyond the history of art. Not all great artists or great works of art can be mentioned, far less discussed. Nor, more specifically, is it intended to provide anything in the nature of an historical survey, period by period, but rather a discussion of the artistic concepts dominant in each successive period. And, for this purpose, the detailed analysis of a few carefully chosen issues is more revealing than the bird's-eye view.

Acknowledgements

First of all I should like to thank the Ingram–Merrill Foundation for a generous grant without which I should not have been able to study – or even see – a great many buildings and works of art. Many friends have helped to guide my footsteps and drawn my attention to works I should otherwise have overlooked. I should particularly like to thank Mr Anthony M. Clark for ideas and information generously imparted over many years. And I must also thank Miss Jennifer Montagu for speedy help with a last-minute problem. I am deeply indebted to Professor Robert Rosenblum for providing me with a proof copy of *Transformations in Late Eighteenth Century Art* while my work was in its final stage and for commenting most helpfully on my typescript. My thanks are due also to Professor Leopold Ettlinger, Professor Francis Haskell and Mr Michael Levey for reading my typescript and enabling me to improve it in many places. But my greatest debt of gratitude is to Mr John Fleming who has helped me at every stage and whose name should really be placed with mine on the title page.

For permission to reproduce photographs I am indebted to Her Majesty the Queen, Major Crompton-Inglefield, Mr Brinsley Ford, the Viscountess Galway, Herr Georg Schäfer, the Hon. Andrew Vanneck and the trustees of the several public collections named in the catalogue of plates. For help in obtaining photographs I should like to thank especially Miss N. Cossareva, Mr John Harris, Mrs Francis Haskell, Professor W. S. Heckscher, Mr Bevis Hillier, Mr Terence Hodgkinson, M. Daniel Meyer, Dr Oscar Reutersvard, M. Pierre Rosenberg and Mr Robert Rowe.

H.H.

Tofori, September 1967

Neo-classicism

Introduction

Neo-classicism is the style of the late eighteenth century, of the culminating, revolutionary phase in that great outburst of human inquiry known as the Enlightenment. The moral earnestness, the urgent seriousness, the high-minded, sometimes starry-eyed, idealism of the free-thinkers, *philosophes* and *Aufklärer* were all reflected in it. For Neo-classicism, in its most vital expressions, fully shared their spirit of reform which sought to bring about – whether by patient scientific advance or by a purgative return *à la* Rousseau to primitive simplicity and purity – a new and better world governed by the immutable laws of reason and equity, a world in which *l'infâme* would be for ever *écrasé*.

Yet the art of a period which witnessed political and social revolutions greater than any since the fall of the Roman Empire, which overturned long-established institutions and out of which modern Europe and America were to emerge, such an art could not have been 'classical' in any *simpliste* sense of the term. It was deeply marked by underlying and suppressed contradictions: and its increasingly uncompromising stance derived from the pressure of these inner tensions. But important though these subversive undercurrents were – especially for what was to follow – it is the more positive, conscious aspects of this complex style with which I shall be mainly concerned in this book. For it is in them that its true nature can most easily be seen and its links with the general aspirations of the period most clearly observed. The French Revolution was dedicated, in the words of Sir Isaiah Berlin, 'to the creation or restoration of a static and harmonious society, founded on unaltering principles, a dream of classic perfection, or at least the closest approximation to it feasible on earth. It preached a peaceful universalism and a rational humanitarianism.' If the word 'art' were substituted for 'society' these sentences might well be adopted to characterize the essence of the Neo-classical revolution.

It is difficult for us now to see Neo-classicism as a youthful, fiery, rebellious movement. The name itself is a stumbling block. It was invented in the mid nineteenth century as a pejorative term for what was then thought to be a lifeless, chilly and impersonal 'antique revival' style expressed in still-born imitations of Graeco-Roman sculpture: and these negative connotations still cling to it. (One still reads today of Canova's smooth and icy marbles, of the 'erotic frigidaire'.) Furthermore, the term Neo-classicism invites us to conceive the style as having been opposed to Romanticism – a conception quite foreign to the eighteenth century and very misleading if it tempts us to read back into it that *querelle* between Classics and Romantics which was an exclusively nineteenth-century phenomenon.

Neither the term 'Neo-classicism' nor even 'Classicism' was used in the late eighteenth century to describe the style which is the subject of this book. Critics, theorists and the artists themselves called it simply the 'true style' and referred to it as a 'revival of the arts' or a *risorgimento* of the arts, conceiving it as a new Renaissance, a reassertion of timeless truths and in no sense a mere mode or fashion. The fashion-conscious mania for novelty was among those aspects of the Rococo which were most abhorred by protagonists of the 'true style'.

But it is not only the name which hinders an understanding of Neo-classicism. By a curious reversal of values, the essential has become confused with the incidental, the main plant with its sports and suckers. Neo-classicism has come to mean a decorative style: interiors by Robert Adam and James Wyatt, furniture by Riesener and Weisweiler, silver by Auguste and Paul Storr, late Sèvres porcelain and early Wedgwood pottery. Flaxman is now known for his elegant pottery designs while his austerely primitive line engravings, which once fired the artistic youth of Europe, are neglected. And the great master-pieces of Neo-classicism – the paintings of David, the sculpture of Canova, the architecture of Ledoux, Soane and Latrobe – fit still less easily than Flaxman into this decorative strait-jacket. So they have tended to be absorbed into Romanticism or proto-Romanticism or into a hybrid Romantic–Classical style excogitated by art historians solely in order to cope with them.

Neo-classicism matured very rapidly, its moment of flowering was brief and followed by a period of no less rapid deterioration and devaluation during the Empire – often (and

how ironically) regarded as its climax. Of course, many elements survived into the Empire and became transmuted into Romantic art; others provided convenient motives and formulae for the academies and art schools – so rational a style had always been eminently teachable – and finally became the stock in trade of *l'art officiel* and *l'art pompier* of the mid nineteenth century. But worse was to follow. Fascists and Nazis propagated a so-called Neo-classical architecture, thus bringing the style's history full circle and making it the embodiment of the most reactionary of political programmes. This long line of bastard progeny looms large in the perspective of history, overshadowing the movement itself and its true aspirations. But like other styles which have begotten similar offspring, Neo-classicism should be seen for what it was rather than for what it became. We do not allow the Pall Mall clubs to colour our attitude to Renaissance architecture, or 'dainty rogues in porcelain' to trouble our enjoyment of Rococo sculpture.

In groping my way through the semantic jungle which threatens to smother Neo-classicism – through the variety of terms and myriad shades of interpretation, not to mention the bewildering variety of visual expressions associated with them – I have done my best to listen only to what the writers and artists themselves have to tell us. When we try to understand the art of the late eighteenth century it does not matter very much which aspects seem most appealing now or which seem true or false by present-day standards. What matters is whether our conception of the whole, and hence the definition of our term, corresponds to what the artists thought and believed themselves. It seems to me therefore that the most valid and useful definition of Neo-classicism will be that which comes closest to what these men understood by the 'true style' and the new Renaissance of the arts.

To go back to original sources in the period itself and start again from scratch is a process which the Neo-classical artists would thoroughly have approved; and fortunately there is no shortage of first-hand evidence. The period which saw the first appearance of the art critic (as opposed to art theorist) and invented the term 'aesthetics' is nothing if not articulate. And on one point – the outright rejection of the Baroque and Rococo – *avant garde* artists and writers were all very early united. In their attacks on these styles we find the first clear indications of the new artistic principles they sought to establish.

I

Classicism and Neo-classicism

'A most remarkable change in our ideas is taking place,' wrote d'Alembert in 1759, 'one of such rapidity that it seems to promise a greater change still to come. It will be for the future to decide the aim, the nature and the limits of this revolution, the drawbacks and disadvantages of which posterity will be able to judge better than we can.' He was, of course, writing of philosophy but his words could be as easily applied to the arts. For it was at this moment that a wind of change began to sweep through the Parisian *salons*, freshening up their close and perfumed atmospheres, smoothing out Rococo curves and curlicues, blowing away the delicately fragile ornaments – rosebuds and shells and powdered cupids with their behinds as delicately rouged as their cheeks, all the posturing *Commedia dell' Arte* figures and other exquisite frivolities and perversities which had delighted a fastidious, over-sophisticated society.

The change to which d'Alembert referred was the triumph of the *philosophes* whose rigorously rational views on everything from astronomy to zoology are enshrined in the great *Encyclopédie* of which he and Diderot were co-editors. But this moment also marked a shift in the direction of the Enlightenment itself. It had now begun to take on a more earnest, moralizing tone and to concentrate less on attacking superstition and dogma than on building a new world. Voltaire, the witty, mocking, elegantly shocking author of *La Pucelle* was beginning to develop into the outraged and passionately committed champion of the French Protestant, Jean Calas, whose persecutors he attacked with savage indignation. Rousseau also had appeared on the scene, questioning the accepted values of civilized society, suggesting that the arts and sciences had corrupted mankind and declaring the right of liberty for all men. The notion that infidelity, like hair powder, was a privilege of the aristocracy was giving way to a more general demand for tolerance. In this new world there were to be no

double values, no compromise with truth – if truth could be established.

The intellectual reaction against flippancy, cynicism and all the iniquities summed up by *l'infâme* was paralleled in the arts by a rejection of the Rococo. This was no modish change from one fashion to another, from the *genre pittoresque* to the *goût grec*. It was as radical a rejection as that of the philosophers and differs from most previous stylistic changes in the history of art by its self-awareness. Nor was it confined to artistic and intellectual circles in Paris: a similar revulsion occurred contemporaneously throughout Europe, though in modified and usually less positive forms outside France. In Germany, paradoxically, it allied itself with anti-Gallican sentiment since the Rococo had been so closely associated with French taste. But it had become so general by the 1770s that artists, architects and theorists in France, Italy, Germany and England were congratulating themselves in almost identical terms on its success. The Rococo had not, of course, been crushed as thoroughly as they would have us believe: it persisted in certain quarters until almost the end of the century – but it lingered on merely as a survival of *ancien régime* taste and attitudes.

This revulsion against the Rococo and all the values it was felt to express, or at any rate to imply and condone, amounted in certain cases to an instinctive nausea; but in general the new moralizing fervour which began to penetrate the arts around the mid century was rational and stoic in tone and can be paralleled in contemporary literature, in the novels of Richardson, for example, and the plays of Diderot. To relate this movement to the growth of bourgeois patronage – identifying the Rococo with aristocratic taste and Neo-classicism with that of the rising middle-classes – is very tempting. But, as we shall see later, this would be a gross over-simplification of a very complex situation. For although anti-Rococo criticism was frequently directed against the rich, and the corrupting or trivializing influence of their taste for luxury, it is by no means clear to what extent such polemics reflect the writers' actual first-hand knowledge and experience of contemporary patronage. It is certain that Neo-classical artists found as much if not more support and encouragement among the aristocrats and wealthy as they did among the bourgeois. (Indeed, a case – though not a very plausible one – could even be made out for the interpretation of Neo-classicism as an aristocratic and Rococo as a bourgeois style.)

At all events the missionary zeal of the critics was now focused not only against Rococo subject matter with its hedonistic and licentious overtones, its *fêtes galantes* and scenes of casual dalliance suggestive of the boudoir and feminine voluptuousness, but also against all those sensuous qualities on which Rococo art was based – *esprit*, *charme*, grace and the free play of the artist's fancy – which appeal not to the mind but to the grosser sense perceptions and are by definition amoral. A high-minded puritan contempt for the mundane and elegant, a distrust of virtuosity, of being taken in by mere dexterity and deftness of touch, was probably at the bottom of this. Deep suspicion of all those painterly, illusionistic devices employed by Baroque and Rococo artists for their atmospheric and textural effects, was combined with a distaste for 'fine quality', the sheer beauty of *facture* and all the other exquisite surface effects which seemed to typify an art in the service of private and self-indulgent luxury. It was the attitude of mind which made Flaxman dismiss the highly accomplished sculptors Rysbrack and Scheemakers as 'mere workmen' and Winckelmann advise painters to 'dip their brush in intellect'. And it implied a new and more elevated estimate of the artist and his role in society. He should raise himself above the status of the complaisant craftsman, patiently answering the whims of his patron, titillating his jaded appetite, perpetually seeking to delight him with novelties. He should take on the mantle of the high priest of eternal truths, the public educator. And it was to the public at large, not to the private patron, that he should address his message. As the German aesthetician Sulzer remarked in 1771, the use of the arts 'for display and luxury' reveals a failure to understand 'their divine power . . . and their high value'. For, if art follows the 'dictates of fashion, or a patron's whims', wrote Fuseli, 'then its dissolution is at hand'.

In place of the Rococo Olympus of amorous gods and goddesses and that perennial *fête champêtre* in which the *jeunesse dorée* philandered through an eternal, languorous afternoon, we now find themes and subjects of a very different kind: sobering lessons in the more homely virtues, stoic exemplars of unspoilt and uncorrupted simplicity, of abstinence and continence, of noble self-sacrifice and heroic patriotism. The stark death-bed and the virtuous widow replace the *chaise longue* and the pampered *cocotte* (just as in literature Cowper's *Task* takes the place of Crébillon's *Sopha*). And an

equally severe and chastened style was required for the expression of these noble and edifying themes: an honest, straightforward anti-illusionistic style capable of blunt uncompromising statements – of sober clarity and archaic purity.

And so the flickering highlights and impulsive, nervous modelling which give so much Rococo painting its subtlety and sparkle – that delicate surface sheen akin to shot silk – was sacrificed in favour of firm and unequivocal contours and bold flat areas of paint. In composition, the diagonal gave way to the rigorously frontal view, the sinuous, oblique complexities of Rococo space to the elementary clarity of a simple perspective box. Powdery pastel hues were replaced by clear though often sombre colours which tended towards the primary and eventually, in the interests of truth and honesty, to the elimination of colour altogether in favour of the most rudimentary linear techniques. There could be no visual deception with pure unshaded outline.

In architecture a similarly ruthless process of purification and simplification can be observed, leading eventually to even more extreme and abstract results, in this case to a symbolic architecture of pure geometry and Platonic essences. Rejecting the Rococo conception of architecture as a matter primarily of intimate, informal environments on the small and unpretentious scale demanded by good breeding and polite manners – *boudoirs* and *Spiegelzimmer* in which space is enclosed and defined, or rather left deliberately undefined, by a shimmering net of intricate and highly coloured, gauzy decorations which lead the eye a restless dance over a rippling surface of perpetually merging and interweaving asymmetries – the Neoclassical architect sought effects of solidity and permanence, of solemnity and rigidity, of a stillness and silence evocative of that archaic world of timeless truths from which his architectural principles were drawn. In place of a composite art – for it was in the Rococo style that the intricate fusion of painting, sculpture and architecture reached its apogee – he sought an architecture of primitive purity, stripped of all colouring, mouldings and sculptured ornaments so that it might be reduced to its primal and strictly autonomous state. Such radical ideals were not likely to be shared by many private patrons, but this did not unduly disturb the Neoclassical architect whose ambitions were increasingly directed towards public commissions and, failing them, posterity, which might better understand the exalted nature of his

Utopian conceptions and have adequate means to execute works on the vast and frequently megalomaniac scale he demanded.

Significantly enough it was in music – the most abstract of arts – that these artistic ideals found one of their more explicit expressions. In the dedicatory epistle to his opera *Alceste* (1769), Gluck pleaded for a 'noble simplicity', condemned 'superfluous ornament' and stated that he had avoided 'parading difficulties at the expense of clearness'. 'When I undertook to write the music for *Alceste*,' he tells us, 'I resolved to divest it entirely of all those abuses, introduced either by the mistaken vanity of singers or by the too great complaisance of composers, which have so long disfigured Italian opera and made the most splendid and most beautiful of spectacles the most ridiculous and wearisome.' His designs, he went on, 'were wonderfully furthered by the libretto' in which Calzabigi had expressed 'strong passions' in 'heartfelt language' and had eliminated altogether the 'florid descriptions, unnatural paragons and sententious, cold morality' of Rococo libretti.

In the vast and seemingly interminable literature of anti-Rococo abuse, it is to classical antiquity that writers regularly appeal to establish the principles of the 'true style'. The only way to become great, wrote Winckelmann, 'is to imitate antiquity'. By imitation he did not, of course, mean copying. Imitation implied a rigorous process of extraction and distillation. It was 'to attain the real simplicity of Nature' that Reynolds recommended the study of antiquity – and both Diderot and Winckelmann said the same in almost identical terms. This is of fundamental importance for an understanding of the Neo-classical attitude to the antique.

Of course, not all artists and theorists regarded antiquity in this way, as a regenerative and virile source of new artistic truths and ideals. Indeed, classical precedents were very often quoted in the most perfunctory manner, very much as poets would rephrase a tag from Juvenal to castigate the society of Régence Paris or early Georgian London. Nor do classicistic condemnations of lavish complexity and irrationality in the arts (or even the frivolous tastes of opulent patrons) necessarily imply a desire for classical standards: many are no more than *topoi* – rhetorical clichés or commonplaces. In an attack on contemporary Parisian architecture published in 1738, for example, A.-F. Frézier just lifted bodily, in his own translation,

a passage from Vitruvius denouncing certain architects of the age of Augustus. And even more extreme instances of the unmeaningful use of classical authority can be found – sometimes passing beyond mere lip-service into the realms of the higher double-talk. Pöppelmann, most wilful and fancy-free of Rococo architects, went to the length of publishing a pamphlet about his fantastically frothy masterpiece, the Zwinger in Dresden, from which an innocent reader might well imagine that he had faithfully obeyed the tenets of Vitruvius.

In most cases, however, antiquity was neither deliberately abused nor freshly studied. For it had long since become part of the furniture of the educated mind. In France its authority was established early in the seventeenth century by Poussin and had subsequently been entrenched in the official programme of the Académie Royale (the enormous production and wide circulation of reproductive engravings after Poussin testifying to his continuing authority throughout the eighteenth century). While in Italy a classicizing tradition had persisted with fluctuating vitality ever since the Renaissance. This classical 'survival' raises awkward problems in the early eighteenth century and later, when the first stirrings of the Neo-classical movement become visible. But such accomplished and delicately classicizing painters as Houasse in Paris or Benefial and Trevisani in Rome, are better understood as last-ditch survivors of the seventeenth-century classical tradition than as Neo-classical artists *avant la lettre*. The position of some other comparable though slightly later figures is more difficult to define, but I think they are best seen in the context of that Louis XIV revival which dominated the official artistic scene in France around the mid century. Similarly in England, the early eighteenth-century Neo-Palladian architects were inspired by or formed part of an Inigo Jones revival rather than a precociously Neo-classical movement.

For some thirty years after the death of Louis XIV the arts in France had been used by the Crown almost exclusively for the decoration of exquisite, intimate interiors. But in 1745 Mme de Pompadour's uncle, Lenormant de Tournehem was appointed *Directeur Générale des Bâtiments du Roi* and promptly began to sweep a new broom through the dusty offices of official patronage. He conceived his first duty to be that of reinstating the classical, academic hierarchy of subjects which the Rococo, with its looser scale of values, had disrupted by unduly elevating the portrait and landscape, genre scenes and

still-life. History painting was to resume its primacy and the official scale of fees was accordingly readjusted so that artists would receive substantially more for history pieces than for portraits. With the same end in view he established in 1748 a new École Royale to give young art students a wider general education with emphasis on history: Livy, Tacitus, Rollin's *Histoire ancienne* and Bossuet's *Histoire universelle* were their chief textbooks. Thus they received instruction not merely in art but also imbibed the moral cult of the ancients, which was the backbone of all eighteenth-century education in France, and throughout Europe for that matter.

But de Tournehem was no more than the precursor of his nephew, the Marquis de Vandières (later and better known as Marigny) who was carefully trained to succeed him. In 1749 the young marquis was sent off to inspect the ancient and modern wonders of Italy accompanied by the architect Souf-flot and the engraver C.-N. Cochin the younger who was later to write one of the wittiest and most influential attacks on the Rococo (he later became secretary of the Academy and Marigny's main adviser on artistic matters). Marigny returned home in 1751 to take up the appointment he was to hold until 1773. Almost immediately he began to commission paintings, sculpture and several notable buildings in Paris, including the École Militaire, the Place Louis XV (now the Place de la Concorde) and the church of Sainte Geneviève (later called the Panthéon).

This programme of patronage was inspired by a conscious desire to recapture the glories of the *grand siècle*. Within a few years of the death of Louis XIV his reign had been added to the canonical series of great historical periods – the reigns of Alexander, Julius Caesar, Augustus, Pope Julius II and Pope Leo X. But the corollary to such an age of splendour was one of decadence: as d'Alembert remarked in 1751, 'the century of Demetrius Phalerus succeeded that of Demosthenes, the century of Lucan and Seneca that of Cicero and Virgil, and our own century that of Louis XIV'. And Voltaire in his *Siècle de Louis XIV*, also of 1751, echoed the same views in the nostalgia with which he looked back to the literary glories of the preceding period. Similarly, it was to the Grande Galerie at Versailles 'where the immortal Le Brun displayed the extent of his genius' that the first French art critic, La Font de Saint-Yenne, had directed the attention of artists in 1747. In a pamphlet significantly entitled *L'ombre du grand Colbert* he

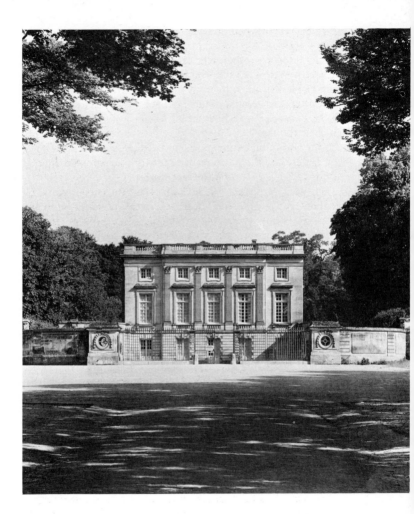

1. The Petit Trianon, Versailles, 1761–8. J.-A. Gabriel

eulogized Perrault's east façade of the Louvre and pleaded for the restoration and completion of the building. At the same time the influential teacher of architecture, J.-F. Blondel, was preaching a return to the grandeur and elegance of the *grand siècle*. There was even a revival of interest in the music of this period – the 'elegant simplicity' of the songs of Lully being contrasted with the puerile sallies, the confusion and affectation of his successors.

This nostalgic hankering after the *gloire* of Louis XIV is most apparent in architecture – in the spectacular monumentality of Gabriel's École Militaire (begun in 1751), in his two buildings in the Place de la Concorde, which are heavily indebted to the Louvre façade, and to some extent also in the monumental scale and noble simplicity of Soufflot's Sainte Geneviève. Gabriel's masterpiece, the Petit Trianon was perhaps rather less dependent on this revivalism [1]. As careful to avoid the pomposity of Versailles as the wilful preciosity of the *petits appartements*, he took from the one a classical regard for decorum and simplicity, from the others a feeling for elegance and poise, to create what is not only the perfect expression of the nascent Louis XVI style but one of the most beautiful buildings in the world. Here we find a volumetric clarity and stress on the cubic mass of a building which clearly looks forward to Neo-classical architecture. Perfect balance and uniformity is maintained without any loss of vivacity, by the most subtle variations in decorative detail and the most delicate adjustments of proportion between one façade and another.

A similar combination of unpedantic correctness and unfrivolous elegance marks the sculpture of Edmé Bouchardon. The statue he modelled to stand in the middle of Gabriel's Place de la Concorde [2] is inspired by both Girardon's statue of Louis XIV and the most famous equestrian statue of antiquity – the Marcus Aurelius in Rome. But Bouchardon's horse is more naturalistic than the antique and less animated and high spirited than Girardon's. The rider is dressed wholly *à l'antique* and seated in a position at once restful and commanding – unlike Louis XIV who sports a billowing peruke over his Roman armour and turns his head in one direction while pointing in the other, as if communicating with some aide or general. It is easy to see why Diderot should have thought Bouchardon's works were infused with the spirit of 'nature and antiquity, that is to say simplicity, strength, grace and truth'.

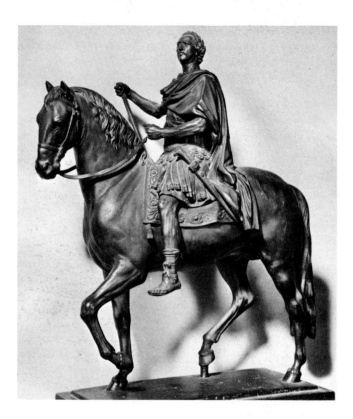

Not only in court and official circles was the rejection of the Rococo associated with a return to Louis XIV classicism. In Parisian interior decoration a style thought to be *à la grecque* began to emerge in the 1750s. But it was Greek in name only. No attempt was made to copy the form and structure of Greek or even Roman chairs and other pieces of antique furniture already familiar from ancient paintings and sculpture. Rectilinear forms were, however, substituted for Rococo curves, whimsical ornaments were swept away and replaced by such architectural embellishments as the Vitruvian scroll and heavy swags – similar to those used on the east façade of the Louvre which Gabriel had imitated in the Place de la Concorde and Petit Trianon. Significantly enough, the most notable of these

2. *Louis XV* after Edmé Bouchardon, *c.* 1762–70

3. Writing-table, *c.* 1756. L.-J. Le Lorraine

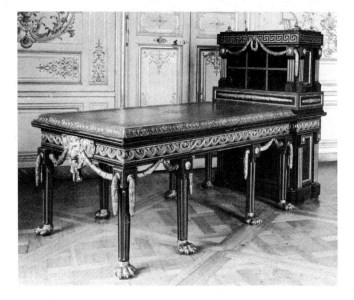

pieces of furniture [3] was until recently thought to date from
the Louis XIV period. It is, in fact, a perfect example of the
Louis XIV revival.

Within a few years the 'Grecian taste' became a mania:
everything in Paris was *à la grecque* wrote Grimm in 1763 –
exteriors and interiors of buildings, furniture, fabrics, jewel-
lery. 'Our ladies have their hair done *à la grecque*, our *petits
maîtres* would be ashamed to carry a snuff-box that was not
à la grecque.' And though he scoffed at the absurdity of the
fashion, he admitted that it was preferable to the Rococo.
'*Si l'abus ne peut s'éviter, il vaut mieux qu'on abuse d'une bonne
chose que d'une mauvaise.*' This remark should put us on our
guard against attributing any very great importance to the

4. Masquerade costume design, 1771. E.-A. Petitot

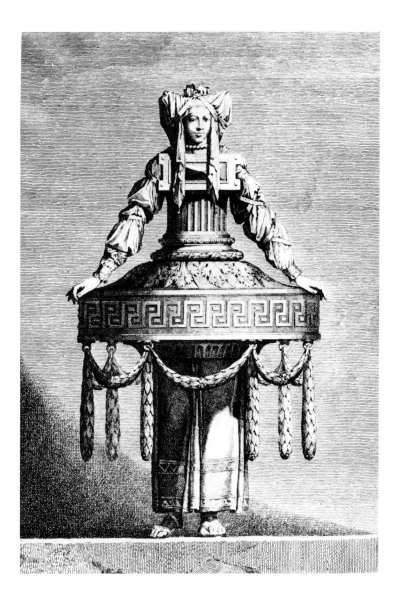

so-called Grecian style in the development of Neo-classicism. It found its best expression perhaps in masquerade costumes [4] which are as superficially related to their classical source as are chinoiserie *brûle-parfums* to the arts of the Sung dynasty. The *goût grec*, like the *style étrusque* which succeeded it, is but an offshoot, a branch of prettily variegated leaves, stemming from the main trunk of the Neo-classical movement.

The Louis XIV revival was, of course, peculiar to France. In Germany and Switzerland and to some extent in England and Italy as well, the revulsion from the Rococo was partly a reaction against French taste. (Both Winckelmann and Lessing nursed an almost pathological hatred of the French.) But other motives played a part. One of the most vociferous Italian sponsors of the attack on the Baroque (the Rococo hardly mattered outside Venice and Piedmont) was Mgr Bottari, a prominent Jansenist who associated the style with the Jesuits. In England, on the other hand, the Neo-classical style was linked with a patriotic desire to aggrandize the arts and create a national school on a par with those of Italy and France. It was an expression of the mood in which Robert Adam dedicated his *Ruins of Spalatro* (1764) to George III:

At this happy Period, when Great Britain enjoys in Peace the Reputation and Power she has acquired by Arms, Your Majesty's singular attention to the Arts of Elegance, promises an Age of Perfection that will complete the Glories of your Reign, and fix an Aera no less remarkable than that of Pericles, Augustus or the Medicis.

But though the circumstances of the rejection of the Rococo differed widely from country to country, the new style rapidly acquired an extraordinarily homogeneous international character. Universality was, of course, one of its prime aims. The Neo-classical artist sought to appeal not to the individual of his own time but to all men in all times. As Reynolds wrote: 'That wit is false, which can subsist only in one language; and that picture which pleases only one age or nation, owes its reception to some local or accidental association of ideas.' But the speed with which stylistic unity was attained is none the less remarkable.

A voracious appetite for works of artistic theory secured their quick diffusion throughout Europe. Laugier's *Essai sur l'Architecture* published in France in 1753 was available in English in 1755. Winckelmann's *Gedanken über die Nachahmung der griechischen Werke* of 1755 was translated into English (by

Fuseli) in 1765, and his greater *Geschichte der Kunst des Altertums* of 1764 was available in French by 1766. Daniel Webb's *Inquiry into the Beauties of Painting* which plagiarized some ideas he had picked up in conversation with Mengs, appeared in England in 1760 and was quickly translated into French (1765), German (1766) and Italian (1791). Mengs's own *Gedanken über die Schönheit* first published in 1762 later came out in Italian and Spanish in 1780, in French in 1781 and English in 1792.

Another factor which assisted the rapid development of the new style was the emergence of Rome as a kind of free port for the exchange of artistic ideas. Nearly every artist of any importance spent a few years there studying antiquities and High Renaissance paintings. Rome was also the Mecca for the dilettanti of all nations. The education of an English gentleman or German princeling was not complete until he had visited the Eternal City under the guidance of a bear leader

5. *Lord Dundas*, 1764. Pompeo Batoni

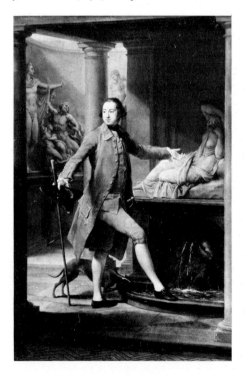

or *cicerone* who instilled in him a taste for the most famous buildings, statues and paintings. Many of these grand tourists commissioned commemorative portraits of themselves from Pompeo Batoni who developed a knack for rendering their nonchalant airs, their pink faces and languid bodies in close proximity to some of the objects they were being taught to admire [5].

Works of art executed in Rome were displayed before an international audience. Hence the importance of, for example, Gavin Hamilton's vast, solemn, static pictures of Homeric subjects, painted in Rome in the 1760s. A preference for serious themes and an almost contemptuous disregard for subtleties of handling and colour mark these large-scale anti-Rococo manifestoes. Of greater contemporary renown was the more ably painted *Parnassus* which Anton Raphael Mengs executed in 1761 for the main room of the villa where Cardinal Albani

6. *Parnassus*, 1760–61. A. R. Mengs

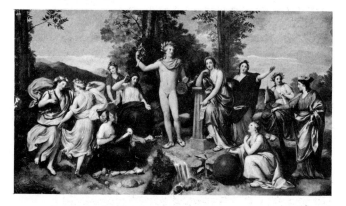

displayed his collection of antique sculpture. There can be little doubt that Winckelmann, the Cardinal's librarian and a friend of Mengs – whom he considered 'the greatest artist of his own, and perhaps of later times' – had a hand in the conception of this work which reflects so many of the ideas of early Neo-classical theorists and artists [6]. Striving for the 'noble simplicity and calm grandeur' extolled by Winckelmann, Mengs eschewed colouristic effects, the closely integrated compositions, deep recessions and illusionistic devices of Baroque ceiling painters – and to make this abundantly clear he flanked

31

the *Parnassus* with two roundels painted in hotter colours, bolder chiaroscuro and *trompe l'œil* perspective. And in innumerable details he paraded his considerable erudition. If, by taking thought, it were possible to produce a masterpiece, this would be one. It is easy to see why it appealed to those who admired the Graeco-Roman marbles displayed beneath it, but rather difficult to admire it nowadays. Belonging to the early, negative anti-Rococo phase of Neo-classicism, it seeks to do no more than recreate a dream of classical perfection by a synthesis of antique sculpture and Raphael's paintings. For the constructive and forward-looking aspects of the style we must turn to later works, also executed in Rome, by David and Canova.

2. THE RISORGIMENTO OF THE ARTS

The various and sometimes complex tendencies which had begun to emerge around the middle of the century – tendencies towards high-minded and instructive themes of an austere and stoic morality, secular in tone even when ostensibly Christian in subject, and corresponding tendencies in style towards an equally radical purification and Spartan simplicity – all coalesced in the 1780s to produce a sudden crop of masterpieces: David's *Oath of the Horatii* [8], Canova's monument to Clement XIV [10] and Ledoux's Parisian *barrières* [13]. All these powerful and revolutionary works were created simultaneously between 1783 and 1789. The fact that they were the distillation and culmination of three individual processes of artistic development, and in fact produced quite independently of each other, only serves to make their stylistic affinities still more striking.

The sudden, explosive nature of this artistic phenomenon was fully recognized at the time – it was called a *risorgimento* of the arts – and was patently inspired by a new, almost militant fervour and purposefulness. Yet despite the fact that these works were produced on the eve of the French Revolution they had as little specifically political implication as the word *risorgimento* itself at this date – indeed, some of the most revolutionary in an artistic sense, were, as we shall see, created by and for political reactionaries. The immediate public acclaim which greeted David's *Oath of the Horatii* both in Rome and Paris, no less than the similarities between the plaudits which were bestowed on it and on Canova's Papal monument, should

be enough to put us on our guard against reading any explicit political meaning into it.

David began in the Rococo shadow of his distant relation, Boucher, who recommended him to join the studio of Vien, a sophisticated purveyor of fashionable erotica who had remained fully Rococo in feeling while paying lip-service to the new classicizing trends of taste [15]. Under his guidance David won a place among the *élèves protegés* of the Academy school – where his education, classical as well as artistic, was continued – and in 1775 at the French Academy in Rome. He went to Italy convinced that he had little to learn from the antique. But a meeting in Naples with the theorist Quatremère de Quincy, who considered himself a disciple of Winckelmann, had the effect, as he later remarked, of a cataract operation which enabled him to see and understand antiquity for the first time.

The result was his *Belisarius Receiving Alms* [7]. A soldier who had served under Belisarius recognizes his former general,

7. *Belisarius Receiving Alms*, 1780–81. J.-L. David

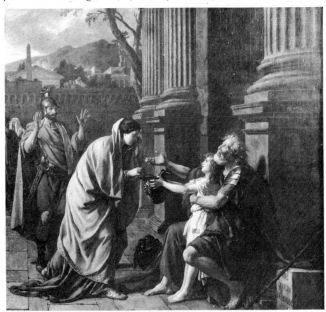

now old, blind and forsaken, with a child who holds out his helmet to take a coin from a passer-by. The subject had been represented before, but never with such an austere concentration on essentials. David elevated an historical anecdote into a theme of universal significance, a poignant lament for the transience of human glory, the helplessness of age, combined with a meditation on moral heroism in adversity. The dignity of the message is reflected in the sobriety of the handling; gestures are restrained, colours subdued. Its truth is emphasized by the accuracy with which historical details are rendered. It reminds one of Diderot's advice to *'peindre comme on parlait à Sparte'*. Indeed, it was exactly the type of picture, heroic in subject and grand in manner, which Diderot had been demanding since the 1750s, and he saluted the young David with the heartfelt words: *'il a de l'âme'*. Yet this work still harks back to the Louis XIV revival in its amplitude and *mesure*: it belongs to Neo-Poussinism rather than Neo-classicism.

With the *Oath of the Horatii* [8] David suddenly reached full maturity. Completely emancipated and completely in command of a new and rigorously purified style, he now achieved a perfect fusion of form and content in an image of extra-

8. *Oath of the Horatii*, 1784–5. J.-L. David

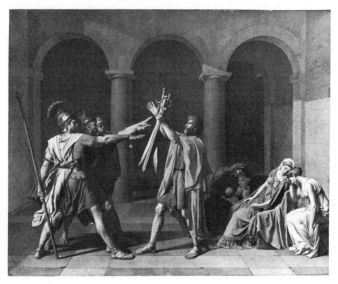

ordinary lucidity and visual punch. This is no consoling lament, like the *Belisarius*, with warm and reassuringly Poussinesque overtones, but a clarion call to civic virtue and patriotism.

The choice of subject is extremely revealing of David's aims and intentions. Perhaps stirred by a performance of Corneille's *Horace*, he seems to have turned to Livy for a 'true' account, both historically and morally, of how the three Horatii brothers agreed to settle a war between Rome and Alba by personal combat with the three Curiatii brothers and how the only survivor, returning to Rome in triumph, found his sister mourning one of the Curiatii to whom she was betrothed. The survivor thereupon killed his sister, was condemned to death and only reprieved after his father pleaded publicly for clemency. Yet even this version of the story – though an improvement on Corneille's which implied the supremacy of patriotism over all other moral imperatives – did not illustrate Roman virtue in a sufficiently pure and exemplary form for David. As Livy himself admitted, Horatius was acquitted more in admiration for his valour than for the justice of his cause. He had displayed an admirable patriotism but a deplorable lack of the main stoic virtue, self-control. David therefore abandoned Livy's version of the story, after basing a preliminary sketch on it, and selected for his subject a moment not mentioned by any historian (though suggested by Dionysius of Halicarnassus whom there is no reason to suppose David had read) – the one moment in which the highest Roman virtues were crystallized in their finest and purest form. This was the moment of the oath when the three youths selflessly resolved to sacrifice their lives for their country.

By selecting this scene David was able to extract and isolate the essence of the story and reveal its inner meaning, the nobility of Roman stoicism, with a correspondingly stoic directness and economy of visual means. Moreover, the solemnity of the oath-taking heightened the effect by adding an extra dimension to the moral, universalizing it and generalizing its human relevance. Thus, while the message is conveyed in personal terms which were immediately understood by David's contemporaries, it was clearly intended as a lesson applicable to all men and for all time.

David extols an heroic world of simple, uncomplicated passions and blunt, uncompromising truths. Masculine courage and resolve is contrasted with feminine tenderness and

acquiescence: the taut muscles of the brothers, vibrant with an almost electric energy, are balanced, across the noble, aspiring stance of the father, by the softly pliant draperies and meltingly compassionate gestures of the women – to point up the pathos he added to the sisters the figures of a widow and two children, though they are not mentioned in any of the sources. This tonic compositional lucidity is reinforced by the limpid early-morning clarity of lighting and pristine purity of colour, as well as the rudimentary simplicity of the setting with its primitive Doric columns and semicircular arches. Significantly enough, a critic remarked in 1785 that 'the simplicity and energy of the Order is worthy of the simple and heroic times of which we are here given a true portrayal'.

Though archaeological accuracy was considered a *sine qua non* for any 'true' depiction of such high Roman themes, David probably owed less to antique art than might at first seem likely. The sculptural grouping of the figures and their rigid rectilinear alignment across the elementary box space, exactly parallel with the picture plane, inevitably suggests a direct borrowing from Roman low reliefs. And indeed this had already become a critical cliché in the 1780s. But it was one which met with a good deal of ridicule from David's friends. Certainly the creative process is seldom if ever as simple a matter as this.

Some indication of the multiple sources out of which David distilled his masterpiece may be gleaned from the origins of the compositional principle of dissociation or isolation of parts from which so much of the picture's power derives. This was the one element in the painting to be adversely criticized when it was first exhibited in 1785 – for it was thought, not without reason, to be the cause of all its most novel and disconcerting features: its hard-edge clarity, its abrupt transitions, its large sonorous areas of empty canvas. Yet the origin of this Davidian 'brutalism' lay in accepted academic theory taught at the École for twenty years and stressed by David's teacher Dandré Bardon in his *Traité de peinture* (1765) which stated that groups of figures should be formally contrasted with each other, and the contrasts reinforced by the expressions. But no one before David had pushed this academic doctrine to its logical extreme. In the process he called in the aid of antique sculpture, descriptions of paintings by Polygnotus and the 'single plane' compositions of Perugino and 'certain of his predecessors', which, according

to his pupil Delécluze, he was later extolling. He may even have looked at Giotto whose monumental groupings, clarity of composition and calm serenity of tone reflects a similar depth and strength of conviction. For it was at this moment in the 1780s that Giotto and earlier Italian painters were arousing the interest not only of historian-collectors like Seroux d'Agincourt (the 'Winckelmann des peintres Barbares'), whom David knew in Rome, but also of such artists as Canova and Flaxman.

Canova's early development took a course similar to that of David who was nine years his senior. Trained in Rococo Venice, he soon achieved a degree of technical virtuosity, naturalistic elegance and sophistication which delighted his compatriots on the lagoon. But he displayed no rebellious tendencies until after 1780 when he went to Rome, fell in with an international set of artists and theorists (notably Gavin Hamilton), renounced the laurels he had already won and applied himself to the creation of a new style, revolutionary in its severity and uncompromising in its idealistic purity. His *Theseus and the Dead Minotaur* was the result [9]. At first he

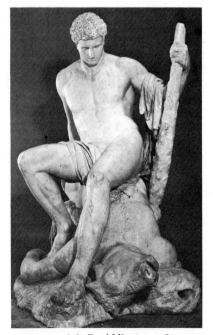

9. *Theseus and the Dead Minotaur*, 1781–2.
Antonio Canova

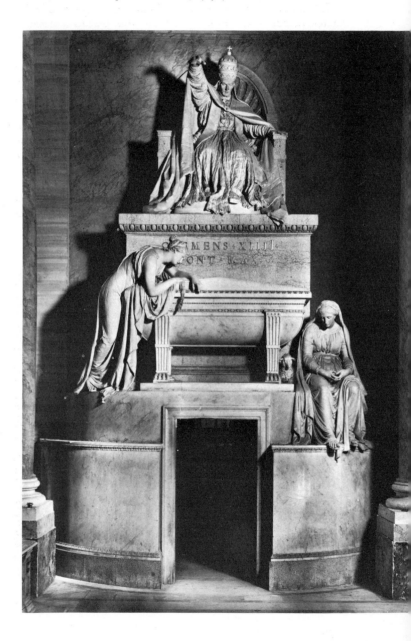

had intended to represent the two figures in combat but, partly on Hamilton's advice, decided to show the moment of calm after victory. It is tempting to see in the group a symbol of his own stylistic conversion – the corpse of his effete Venetian naturalism represented by the carefully rendered skin and entrails of the monster, and the champion of Idealism in the solidly robust, slightly abstracted young hero. Executed at a time when most sculptors in Rome were still working in the late Baroque style or else engaged in slavish imitations of ancient marbles – a practice which Canova deplored – it won him the title not merely of 'restorer' but also 'continuer' of the antique tradition. And he was promptly engaged to execute two Papal monuments – the most important commissions that could be given to any sculptor in Rome.

In his monument to Clement XIV [10], though bound to respect some of the conventions of the Papal monuments in St Peter's – notably Bernini's great Baroque masterpieces –

11. Detail from *Oath of the Horatii*, 1784–5. J.-L. David

Canova did away with their billowing draperies, their multi-coloured marbles and rich ornaments, their illusionistic devices and intricately symmetrical compositions. It was almost as if he had consciously set out to purify and correct the Baroque Papal monument with reference to Winckelmann's strictures on the 'forced' expressions, 'ignoble' types and exaggerated emotionalism of Bernini. Instead of the usual Baroque allegorical figures, Canova rendered the personifications of Humility and Temperance as mourners lamenting the death of the Pope in the silence of profound grief. And he infused the whole work with a 'noble simplicity and calm grandeur'. Not surprisingly it won plaudits from all the more forward-looking artists and critics such as Milizia who declared when it was unveiled in 1787: 'The three statues appear to have been carved in the best period of Greek art, for composition, expression and draperies; and the accessories, the symbols and the architecture have the same regularity.'

David could have seen models for the Clement XIV monument in an advanced state while he was working on the *Oath of the Horatii*. Yet the similarity between Canova's seated figure of Humility and David's sisters of the Horatii is probably fortuitous [11]. More significant affinities seem to derive from identity of purpose rather than any direct dependence of one work on the other. It is not merely that both share a distaste for unnecessary ornament and a desire for simplicity, clarity and gravity; these qualities are attained by similar means. Horizontality is emphasized in both works. The figures are placed either in profile or full face. The closely integrated type of composition evolved in the High Renaissance and developed

12. Hôtel d'Hallwyl, Paris, *c.* 1790. C.-N. Ledoux

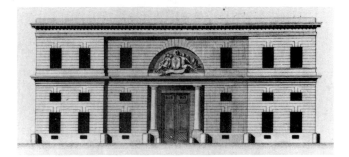

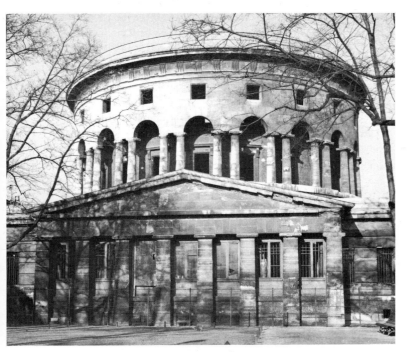

13. Barrière de la Villette, Paris, 1785–9. C.-N. Ledoux

under the Baroque has been rejected in favour of one in which the various elements are deliberately separated from one another and juxtaposed. Milizia commented on the 'few and great divisions' in the design of the monument.

A like process of dissociation and juxtaposition of parts is evident in Ledoux's design for the Barrière de la Villette in Paris – a work allied to the *Oath of the Horatii* by its austerely simplified architectural vocabulary and to the Clement XIV monument by its use of geometrically pure forms. Born in 1736, C.-N. Ledoux was almost a generation older than David and Canova. But the massively rusticated façade of his early masterpiece, the Hôtel d'Hallwyl which still dominates the rue Michel le Comte in Paris, is already of a remarkable austerity. A debt to the simple Orangerie at Versailles and the chunky military architecture of Vauban, associates it with the Louis XIV revival of the mid-century. Significantly, Ledoux simplified it still further when, some forty years later, he prepared his designs for publication [12]. The Barrière de la Villette of 1785–9 [13] is much more original. Its practical function was to provide a hall for the payment of the hated *octroi* tax; but it also served with forty-five others to mark the boundary of Paris and impress the approaching visitor. Consisting of a Greek cross surmounted by a cylinder, it relies for its imposing effect on the bold contrast between these two simple forms, between solids and voids, the square windows of the attic and the semicircular arches beneath them. The Tuscan columns and pilasters without bases and with only the most rudimentary capitals are emphatically, almost wilfully, severe – so much so that one tends to forget that they and indeed the rotunda itself have no practical function whatever. Neither utilitarian nor merely ornamental, neither anti-classical nor revivalist, this strange building is an essay in pure architectural form of a type peculiar to Neo-classicism.

2

The Vision of Antiquity

I. HERCULANEUM AND POMPEII

The stylistic change which took place in the mid eighteenth century has often been attributed to a new appreciation and better understanding of antiquity in general and, in particular, to the discovery of Herculaneum in 1738 and Pompeii in 1748. Yet such an explanation comes too pat. The cult of antiquity played as important a part in the new artistic movement as it had in the development of the Enlightenment, but as a catalyst rather than a driving force. Just as the *philosophes*, who were steeped in the culture of antiquity, found in it germs of a non-religious viewpoint from which Christians had averted their eyes, so artists brought up to pay lip-service to the antique found on closer examination that previously neglected aspects could help them to create a style of greater truth, purity and simplicity. The late eighteenth-century attitude to antiquity was as much a result as a cause of the reaction against the Rococo.

One aspect of the profound change which the vision of antiquity underwent in the eighteenth century may be seen in the shifting attitudes to pagan mythology. The gods of Greece and Rome had been condemned as demons or converted into saints by early Christians, rescued as links with Imperial Roman grandeur at the court of Charlemagne, allegorized by the schoolmen of the Middle Ages, metamorphosed into symbols by Renaissance humanists, and drummed into service of Church and State in the Baroque period – and even made to father some Italian princely families. By the time they reached the eighteenth century they were fit for nothing better than a voluptuous dream world in which, with eternal lustiness, they indulged in a most unedifying succession of amorous intrigues. But they had a new role to play in the Enlightenment. The *philosophes* observed that pagan superstition might be used as a stalking horse for Christianity. By unveiling the clay feet of the gods in whom the most intelligent nations of antiquity had put their faith, doubt could be thrown on the very idea of

divinity. The gods were thus rationalized and explained away, on good ancient authority, either as the inventions of priests and tyrants or as benefactors of mankind (inventors of bread-making, wine-making and so on), or as elemental powers or as fertility symbols.

But classical mythology was also open to attack on ethical grounds. As Rousseau wrote in 1750:

Our gardens are adorned with statues and our galleries with pictures. What would you imagine that these masterpieces of art, thus held up to public admiration, represent? The men who have defended their country, or those still greater who have enriched it by their genius? No. They are images of every perversion of heart and mind, drawn ingeniously from ancient mythology and presented to the early curiosity of our children, doubtless that they may have before their eyes models of vicious actions, even before they have learned to read.

The gods might survive in art as types of physical beauty; but, by the end of the century, only the more retrograde patrons wanted, and only a few frivolous painters and sculptors cared to produce, works of art which expressed the old voluptuous vision of antiquity.

As the gods, fauns and satyrs receded into the background, their place was taken by men – by the warriors, law-givers and great philosophers of antiquity. Attacking mythological subjects as absurd and immoral, La Font de Saint-Yenne in 1754 demanded history paintings which could provide '*une école des mœurs*', representing 'the virtuous and heroic actions of great men, exemplars of humanity, generosity, grandeur, courage, disdain for danger and even for life itself, of passionate zeal for the honour and safety of the country'. Plutarch, he said, could alone supply all the appropriate subjects; and he named Socrates, Epaminondas, Decius, Marcus Curtius and Brutus the first consul. Such paragons of virtue were, of course, more readily found in Greece and Republican Rome than in the Roman Empire. Indeed, the Empire which, since the days of Charlemagne, had been revered as the greatest era in the history of mankind, was now judged to have been an age of decadence. And this revaluation of antiquity (to be completely reversed a few years later under Napoleon) inevitably influenced and was itself influenced by works of art and artistic theory.

Several aspects of these changes in attitude to antiquity are evident in the curiously ambivalent reactions to what we now regard as the greatest archaeological event of the century – the

excavation of Herculaneum and Pompeii. Early accounts were surprisingly cool. Some writers, such as the Abbé Raynal, were even sceptical, though acknowledging that 'a city buried for more than sixteen hundred years and restored to some degree of light, has without doubt something to awaken even the most extreme indifference'. But the discovery inspired no eulogy comparable with that which Fontenelle had devoted to Bianchini's excavations on the Palatine in 1726.

The most important finds at Herculaneum and Pompeii were the large-scale wall paintings. Very few antique figure paintings (notably the *Aldobrandini Marriage* which had been found in 1606) had hitherto been known. But those found in the buried cities aroused puzzled curiosity rather than enthusiastic admiration. Of one Cochin and Bellicard wrote in their *Observations sur les antiquités d'Herculaneum* (1754): 'The Theseus is badly drawn, without knowledge and without refinement; only the head is fairly beautiful and in a good style. The other figures are no better in point of drawing; though one can say that the style of the picture is great and the brushwork easy: but the work is hardly finished and can be regarded as only an advanced sketch.' Others they found poorly drawn, incorrect in anatomy, feeble in expression or weak in composition while the colours had 'neither refinement, nor beauty, nor variety'. How were such works to be reconciled with the dogma of classical perfection? Winckelmann suggested that they must date from the time of Nero when, according to Pliny, the art of painting languished. Mengs agreed that they could not represent the flower of antique art. Among artists, Gavin Hamilton – as much an archaeologist-cum-dealer as a painter – was almost unique in his enthusiasm. And it was to the antiquaries, notably the anticomane comte de Caylus (so much despised by Winckelmann and by Diderot and his friends) that these relics of antiquity made their strongest appeal.

The newly discovered paintings were therefore accepted as reflections, very weak reflections, of the lost masterpieces of Polygnotus, Zeuxis and Apelles. And the purely decorative works were roundly condemned. A snide English writer compared the landscapes with those of the Chinese; others identified the grotesques and fantastic architectural prospects with those derided by Vitruvius. But as the excavations continued, yet more disturbing discoveries were made. Just at the moment when artistic theorists were complaining about Rococo amorality and propounding their Neo-classical vision

of a pure, noble and uncorrupted antique world, the Herculaneum Academy brought out a volume largely devoted to engravings of lamps and charms wrought in the form of furiously triumphant phalluses. They were, wrote a priggish English reviewer, 'abominably indecent'. Rome had evidently sunk to a level of luxurious depravity still lower than that from which eighteenth-century Europe was then struggling to emerge.

Contemporary works of art clearly reflect these ambivalent attitudes to the discoveries at Herculaneum and Pompeii. It was not until the very last years of the century that the Pompeiian style of decorative painting began to oust grotesques of the type devised by Raphael and his assistants. The figure paintings were used as sources for correct details of costume and décor but provided little, if any, stylistic inspiration. Mengs executed one direct imitation of Herculaneum painting, but only as a fake to deceive Winckelmann, unkindly selecting a subject peculiarly dear to his friend's heart [14].

14. *Jupiter and Ganymede*, 1758–9. A. R. Mengs

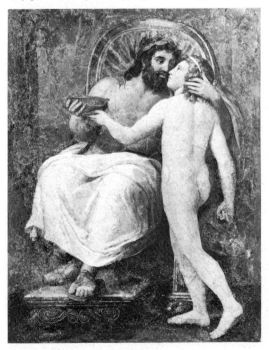

When he took over figures from antique paintings for his *Parnassus* [6] – notably the Apollo and the two dancers on the left – he 'improved' them very nearly out of all recognition by reference to Raphael. Similarly, Vien took from the antique little more than the subject and general disposition of his *The Cupid Seller* [15]. He elaborated and prettified the original by filling in the blank background, adding elegant Louis XVI-style furniture, investing the figures with a simpering sentiment and giving the cupid an obscene gesture which he probably felt to be perfectly in tune with the spirit of the antique painting. Even David, when he made a drawing from a print of the same painting in the late 1770s, could not disguise its elegance and frivolity.

Another painting by Vien, *La Vertueuse Athénienne*, included an antique altar which was to provide *ébénistes* with the design for a piece of decorative furniture thereafter called an *Athénienne*. Realized in polished wood and sparkling ormolu, objects of this type were soon adorning the more modish boudoirs of Paris. Yet despite the pervasiveness of the cult of antiquity – to which the owner of an *Athénienne* paid chic lip-service – few if any efforts were made to imitate the real furniture of Greece and Rome before the last years of the century. A chair

15. *The Cupid Seller*, 1763. J.-M.Vien

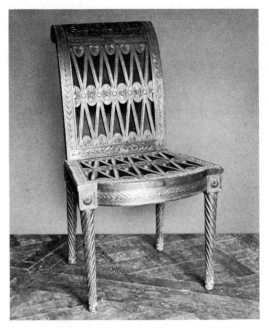

16. Chair in the 'Etruscan style', 1787. Georges Jacob

which its maker described as '*de forme nouvelle du genre étrusque*' [16] is neither strikingly new in form nor antique – let alone Etruscan – in anything but surface detail. An 'Etruscan style' pedestal designed by James Wyatt [17] combines a Roman altar with a Greek vase to provide a decorative object singularly unlike anything found in the houses of Herculaneum and Pompeii. The 'Etruscan' dinner service made at the Neapolitan porcelain factory was decorated with paintings of ancient vases [18]. Wedgwood came nearer to imitating the forms of Greek pottery in the first products of his factory – but these seem to have been no more than demonstrations that he could do what the Greeks had done. Generally he 'improved' the colour scheme by making it cooler and prettier, and had the figurative decorations applied in delicate relief.

These objects, like Vien's paintings, exploited the cult of antiquity for purely decorative ends. They really perpetuate *ancien régime* Rococo taste in antique fancy dress. Attractive

48

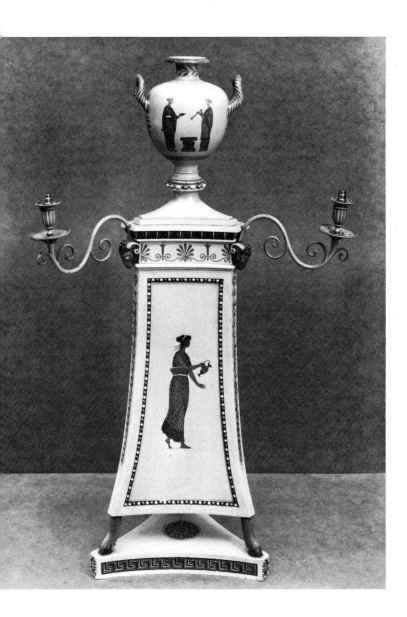

7. Pedestal and vase in the Etruscan taste, *c.* 1795. James Wyatt

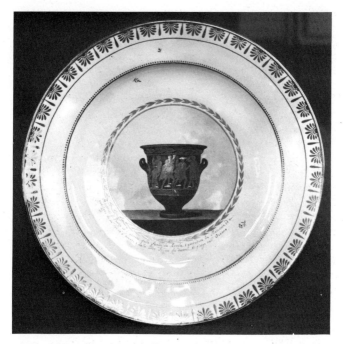

18. Royal Neapolitan Porcelain Factory plate, 1785–7

by-products of a hybrid Rococo–Neo-classicism, they represent a vision of the ancient world only superficially different from that of the earlier eighteenth century, which was modified but not radically altered by new attitudes. For a truer understanding of the part played by antiquity in the development of Neo-classicism we must turn to the prints of Piranesi and the writings of Winckelmann.

2. PIRANESI AND WINCKELMANN

Much of the artistic literature of the eighteenth century is taken up with a long, acrimonious and singularly tedious squabble about the respective merits of Greek and Roman architecture. Both sides took their main argument from Vitruvius who had said that the Greeks derived their architecture from Egypt, perfected the orders and passed them on to Rome. Those in favour of Greece (few of whom had ever seen a Greek building) declared for primitive purity and

suggested that Roman architecture was merely derivative. Others argued that the Greeks were themselves dependent on the Egyptians, and that it was the Romans who had raised architecture to its summit of perfection. In this dispute Piranesi was as furiously pro-Roman as Winckelmann was passionately Philhellene. And the fact that both exerted a profound and by no means mutually exclusive influence on Neo-classicism illustrates once again how ambiguous a part historical revivalism played in its development.

Piranesi, who was trained as an architect in Venice, settled in Rome in 1744. At this time the ruins of the city were regarded mainly as a useful source of ornamental motifs and as quarries of interesting evocative curiosities. Pathetic reminders of passing glory, the words *sic transit* seemed to be inscribed on every stone, and never more clearly than when they were depicted in pleasing decay, a playground for ragamuffins, a camping place for banditti, or – final degradation – a mere background for conversation piece groups of supercilious English *milordi*. They must have appeared to Piranesi rather as John Dyer described them in *The Ruins of Rome* (1740):

> Fall'n, fall'n, a silent Heap; her Heroes all
> Sunk in their Urns; behold the Pride of Pomp,
> The Throne of Nations fall'n; obscur'd in dust;
> Ev'n yet Majestical . . .

In a series of etchings called *Grotteschi*, he stressed the *sic transit* element, though he replaced the conventional figures with serpents slithering among the riven and crumbling marbles. But soon he came to recognize the ruins as still vivid, still grandiose records of the *gloria mundi* of ancient Rome, a source of living inspiration rather than of melancholy regret. The etched views which diffused his vision of Roman greatness throughout Europe were inspired not by pity for the fall of an empire but by awestruck veneration for the sublime magnificence of Roman architecture.

By a cunning choice of viewpoints, a dramatic use of light and shade, a ruthless process of selection and rejection, Piranesi added new dimensions to the ruins of Rome. He invested the columns of the temple of Jupiter Stator with a proud isolation. The vaulted interiors of Hadrian's villa or the nymphaeum in the garden of Sallust [22] he made more cavernously vast, more oppressively overbearing. To the neat

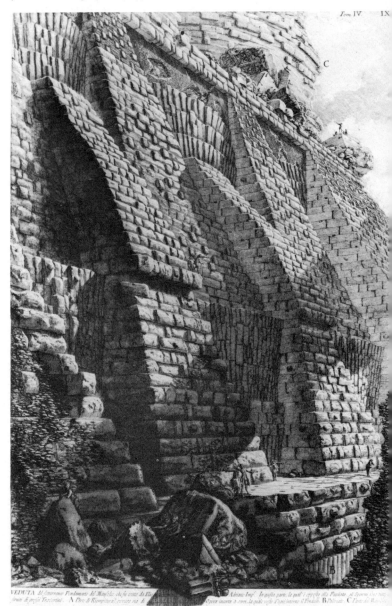

pyramid of Caius Cestius he gave the superhuman grandeur of the Pharaohs. The Castel' S. Angelo [19] he converted into a titanic mountain of masonry. Such was the force of his imagination that he compelled his contemporaries and posterity to look at Roman architecture through his eyes. Some travellers like Goethe and Flaxman were disappointed to find Roman ruins smaller in scale than Piranesi had led them to expect. But most responded to his vision, even on the spot, if not always with the emotion of Fuseli's *The Artist moved by the grandeur of ancient ruins* [20].

20. *The Artist moved by the grandeur of ancient ruins*, 1778–9. H. Fuseli

In 1755 Robert Adam wrote of Piranesi whom he had just met, that 'so amazing and ingenious fancies as he has produced in the different plans of the Temples, Baths and Palaces and other buildings I never saw and are the greatest fund for inspiring and instilling invention in any lover of architecture that can be imagined'. Piranesi had not only replaced the Rococo image of antiquity with one that was bolder and stronger, but suggested new concepts of architectural mass and space. Believing that 'Roman dignity and amplitude' was expressed by mass, he emphasized the vast solidity of walls and bastions. Rejecting delicate surface decoration, he liked to show bold ornaments deeply cut into the stone as if to stress its weight and solidity. He hankered after a megalomaniac scale – walls towering upwards and stretching far into the distance. His views of interiors imply a limitless space channelled through massive gorges of stone beneath vaults and domes which seem to be weighed down by the masonry above them. With little regard for the niceties of the orders – which had obsessed earlier archaeologists – he appears to have agreed with Goethe that the artist's aim should be to take from antiquity not just measurable proportions but that which is unmeasurable – *das Unmessbare*. And this was probably his most notable contribution to Neo-classical architecture.

Piranesi first committed his ideas on architecture to print in a polemical volume entitled *Della magnificenza ed architettura de' Romani* (1761) in which he declared that the Etruscans had brought painting, sculpture, architecture, mathematics and the technical arts to a perfection that was maintained by their natural heirs, the Romans, and debased by the Greeks. This farrago of nonsense drew from Winckelmann the oblique reply it deserved and a solemn cannonade from the French theorist Mariette. The rejoinder Piranesi published in 1765 is still more wildly misinformed but much more interesting to the student of Neo-classicism. After rebutting Mariette, he proceeded to a dialogue entitled *Parere sul' architettura* in which he attacked the idea of simplicity as an architectural virtue, stated that both Etruscan and Roman architecture was highly ornamented and condemned the Vitruvian rules. To 'prove' his argument he illustrated the book with some original inventions showing façades loaded to breaking-point with massive, angular, deeply carved reliefs which completely mask the structure. The moral of this was that architects should free themselves from the shackles of academic theory to create a

21.
Candelabr
c. 1770–78
G. B. Piran

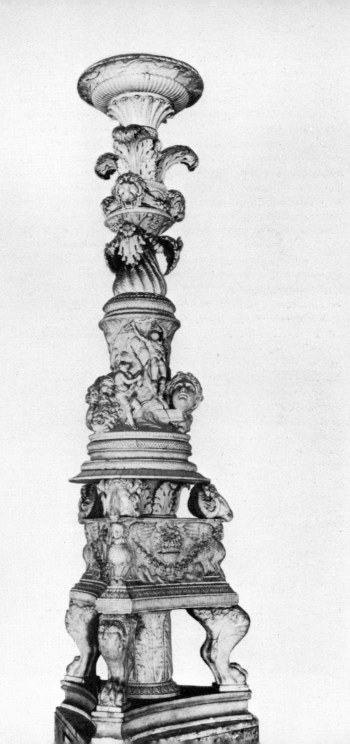

new style inspired by but not directly imitative of Roman architecture. His first illustration bears a text from Terence – 'It is reasonable to know yourself, and not to search into what the ancients have made if the moderns can make it.' While the last bears an adaptation from Sallust: 'They scorn my novelty, I their timidity.'

In this spirit he fabricated, as an ornament for his own tomb, a preposterous candlestick composed of antique marble fragments – pieces of thrones, altars, sarcophagi, vases, columns, capitals, piled on top of one another to realize a Neo-classicist's dream and an archaeologist's nightmare [21]. But he had few opportunities to put his architectural ideas into practice. His only building – the church of S. Maria del Priorato, Rome – is tame in comparison with his tragic visions of Roman grandeur in decay and the polemical diatribes that accompany them. So far as architecture is concerned, he merely sowed the wind and left others to reap the whirlwind.

His influence was disseminated mainly through his etchings of Roman ruins. Some architects took from them purely

22. *Nymphaeum in the Gardens of Sallust*, 1762. G. B. Piranesi

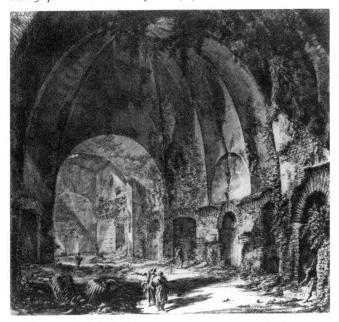

accidental elements such as the form of an archway with its base buried in the earth, giving it a low-slung emphasis and stressing the semicircular simplicity of the upper part, which appealed especially to Ledoux with his sense of the primeval. The oppressive and cavernous effects of Piranesi's views of domed interiors [22] were caught by Soane in his designs for the rotunda of the Bank of England, where Roman architecture appears stripped of all unnecessary detail, ironed out into its basic form and geometrical purity [23]. Through Soane, Piranesi's bold sense of spatial composition found expression in Latrobe's Baltimore Cathedral with its smooth planar surfaces and low domes which seem to weigh down the segmental arches supporting them [24]. And in practically every country from Russia to America there was a response to his megalomaniac and dramatic vision of architecture, as well as to his challenge of originality, from those who worked in Greek as well as Roman styles.

What Piranesi did for Roman architecture, Winckelmann achieved for Greek art. There had, of course, been no shortage

23. Design for interior, Bank of England, 1798. John Soane

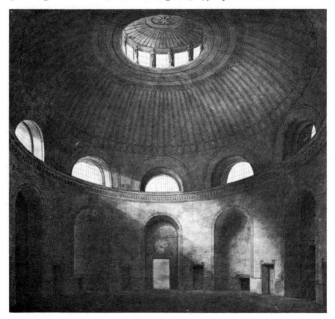

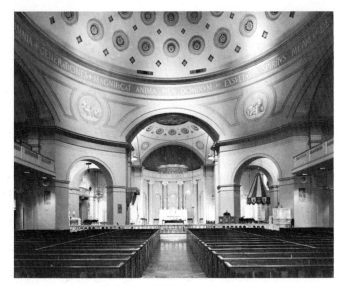

24. Baltimore Cathedral, 1805–18. Benjamin Latrobe

of books on antiquities before he published his first work in 1755. But they had been written almost exclusively by and for archaeologists and like many of the most highly esteemed archaeological publications of our own time seldom suggested that antiquities might be beautiful, still less that they might inspire. Winckelmann wrote from the point of view of an aesthete, an *Aufklärer*, and a man of sentiment. The passionate urgency and almost missionary zeal of the Enlightenment break through his pages as he stresses again and again that antique statues are not merely relics of a vanished civilization, but living works of art of relevance to his contemporaries because they embodied the essence of the Greek spirit. He was, in fact, too passionate and tremulously responsive to be a scholarly archaeologist, too poetic and unsystematic to become an aesthetic philosopher. His genius lay in interpretative writing. He taught his age to look with new eyes not only at antique statues and vases but at Greek civilization as a whole. As Goethe remarked, 'we learn nothing by reading Winckelmann, but we *become* something'.

Before Winckelmann the word 'antiquity' suggested a long period stretching from the fifth century B.C. to the reign of the Byzantine emperor, Phocas. Its artistic products were generally thought to be very much on a par with one another. The term 'antique' covered only slightly fewer and less diverse works of art than it had in the Renaissance. Winckelmann was the first to apply historical method to the study of these works. Adopting the belief that history moved in cycles of growth and decay, he conceived the history of ancient art as an organic process, dividing it into four periods, each with its own style: the early or archaic style (before Phidias), the sublime or grand (Phidias and his contemporaries), the beautiful (Praxiteles to Lysippos) and finally the long period of the imitative style which persisted until the fall of the Roman Empire. This same process was, he thought, repeated in the Italian Renaissance and he called the painters before Raphael archaic, Raphael and Michelangelo sublime, Correggio beautiful, and later masters imitative.

To account in rational terms for the superiority of Greek art at its greatest moment, he absorbed another notion that was then much in the air: the influence of 'climate' or environment on human development. Believing Greek art to be naturalistically idealistic, he concluded that the Greeks themselves had been the most beautiful race that had ever walked the earth. And this he attributed partly to the geographical climate, 'where a temperature prevails that is balanced between winter and summer' (he had never been to Greece), and partly to the political climate. 'Liberty,' he wrote, 'had always held her seat in this country, even near the thrones of kings – whose rule was paternal – before the increasing light of reason had shown to its inhabitants the blessings of entire freedom.' Conversely he appears to have seen the ugly flat-footed Egyptians as the products of a sultry clime and a despotic rule, and hence unable to develop, let alone represent, the physically perfect human form.

In his adoration of Greek statues he was doubtless influenced to some extent by his homosexuality: certainly his vision of a country populated by beautiful and often naked youths is tinged with a personal yearning. It was with an almost audible smack of the lips that he referred to the athletes in the stadium at Olympia, or dilated on the beauty of marble genitals and, more coyly, 'those parts of Bathyle's body which, much to Anacreon's grief, the painter was unable to depict'.

Emotionally drawn to effortlessly athletic, smooth-limbed youths, his ideal in life as in art was the Apollo Belvedere. Here, rather freely translated, is his account of it:

The artist created a purely ideal figure, employing the only material in which he could realize his idea. This statue surpasses all other representations of the god, just as Homer's description surpasses those attempted by all other poets. His height is above that of man and his attitude declares his divine grandeur. An eternal springtime, like that which reigns in the happy fields of Elysium, clothes his body with the charms of youth and softly shines on the proud structure of his limbs. To understand this masterpiece you must fathom intellectual beauties and become, if possible, a divine creator; for here there is nothing mortal, nothing subject to human needs. This body, marked by no vein, moved by no nerve, is animated by a celestial spirit which courses like a sweet vapour through every part. He has pursued the python and against it used his bow for the first time; with a vigorous stride he has overtaken the monster and slain it. His lofty look, filled with a consciousness of power, seems to rise above his victory and gaze into eternity. Disdain is seated on his brow and his eye is full of gentleness as when the muses caress him. . . . Like the soft tendrils of the vine, his beautiful hair flows round his head, as if gently brushed by the breath of the zephyr. It seems to be perfumed by the essence of the gods, and tied with charming care by the hands of the Graces. In the presence of this miracle of art I forget the whole universe and my soul acquires a loftiness appropriate to its dignity. From admiration I pass to ecstasy, I feel my breast dilate and rise as if I were filled with the spirit of prophecy; I am transported to Delos and the sacred groves of Lycia – places Apollo honoured with his presence – and the statue seems to come alive like the beautiful creation of Pygmalion.

No work of art, ancient or modern, had ever been described in such terms as these. Greatly admired though the Apollo Belvedere had been since its discovery in the fifteenth century, it had never provoked such an ecstatic tribute. No one had seen that it was clothed with eternal springtime or been aware of the faint fragrance blown from its soft hair. Nor had any other aesthetic experience previously been recounted in such terms. Indeed, the only precedent for this passage is to be found in the Christian mystics. And it is with Winckelmann that art begins to replace religion and the aesthetic experience the mystical revelation. It is clearly no coincidence that in terminology, tone and even rhythm, this description should seem to anticipate by a century Walter Pater's celebrated dithyramb on the *Mona Lisa*.

Phrases from Winckelmann are echoed in Byron's stanzas on the Apollo Belvedere in that eminently Romantic poem *Childe Harold*. Nor is this surprising. For Winckelmann had opened the door to subjective criticism and impressionistic verbal evocations. He had replaced the mimetic with an expressive theory of art, and this was to have far-reaching consequences. Similarly the conception of art as a manifestation of the *Zeitgeist* was first expounded in his interpretation of Greek art as embodying the spirit of Periclean Athens. And these new insights were only to be gained, Winckelmann held, by a quietist emotional response to the soul of the artist as expressed in his work – to 'that strength of spirit which he imprinted on his marble'. As Hegel later put it succinctly in a passage quoted, significantly enough, by Pater: 'Winckelmann by contemplation of the ideal works of the ancients, received a sort of inspiration, through which he opened a new sense for the study of art. He is to be regarded as one of those who, in the sphere of art, have known how to initiate a new organ of the human spirit.'

For Winckelmann the adoration of Greek art was a religion, and he wrote and spoke of it with the zeal of a proselytizer. 'For us,' he declared, 'the only way to become great and, if possible, inimitable is by imitation of the ancients.' Believing that 'the opposite of independent thought is the copy, not the imitation', he did not recommend the slavish copying of antique figures. He advocated a return to the spirit, not the letter of antiquity. In a famous phrase he summarized the outstanding qualities in antique art as '*eine edle Einfalt und eine stille Grösse*' – noble simplicity and calm grandeur. They were spiritual as well as aesthetic qualities, to be found in Laocoön's nobly silent heroic suffering, no less than in the statue which represented it. A vision of antiquity based on such a concept differed as much from that of the Renaissance as from that of the Baroque and Rococo. But such was the force of Winckelmann's writing that it was destined to persist into periods when such qualities were seen as weaknesses (the words could easily be mistranslated as precious emptiness and lifeless bombast) of Classical, or for that matter, Neo-classical art.

Winckelmann's direct influence was probably stronger on writers and patrons than artists. It is felt even in the writings of some who were violently opposed to his beliefs. For Herder was surely inspired by him when he wrote, in the full fury of *Sturm und Drang*: 'In the history of mankind Greece

will eternally remain the place where mankind experienced its fairest youth and bridal beauty ... noble youth with fair anointed limbs, favourite of all the Graces, beloved of all the Muses, victor in Olympia and all the other games, spirit and body together one single flower in bloom.' In another passage he rhapsodized: 'Greece, type and exemplar of all beauty, grace and simplicity! Youthful blossoming of the human race – Oh would that it could have lasted for ever.' Such passages as these bear witness to the excitement inspired by Winckelmann's revelation. For it was his achievement to clothe with an eternal springtime not the Apollo Belvedere only but the whole of Greek art and literature. He has often been condemned as the theoretical pedant of the Neo-classical movement: he was, in fact, its poet and visionary.

3. HOMER

The revaluation of Homer which took place in the eighteenth century illustrates and, to some extent accounts for, a still more profound change in the attitude to antiquity and, by extension, to the value and purpose of all works of literature and art – a change which goes to the roots of Neo-classicism. At the beginning of the century Homer was regarded as one of the great ancient poets, to be compared favourably or unfavourably with Virgil. By the end of the century he towered above the ancient world. Dante and Shakespeare, the two 'modern' giants were his only peers. Such was his stature

25. *Achilles lamenting the death of Patroclus*, 1793. John Flaxman

that he could no longer be translated into contemporary language.

One aspect of this change is evident if a Gobelins tapestry of an Homeric scene – all plumes and flounces and pretty colours – is compared with one of John Flaxman's illustrations to the *Iliad*, with motionless figures drawn in the most archaic style of pure outline against a plain background [25]. But translations are no less revealing. The famous passage from the third book of the *Iliad* in which the elders comment on Helen's appearance was translated by Pope in about 1715 as:

> They cried, No wonder, such celestial charms
> For nine long years have set the world in arms;
> What winning graces! What majestic mien!
> She moves a goddess and she looks a queen!

Here are the same lines rendered by William Cowper seventy years later:

> Trojans and Grecians wage, with fair excuse,
> Long war for so much beauty. Oh, how like
> In feature to the Goddesses above!

Pope rendered Homer into the poetic idiom of his day – his Achilles sometimes seems to be on the point of taking snuff – though he was less high-handed than his French contemporary La Motte Houdar who frankly declared: 'I decided to change, cut and if need be invent and do what I imagined Homer would have done if he had lived in our time.' Pope did not scruple about expanding epithets, or sketching in conventional pastoral landscape backgrounds lacking in the original. Cowper, so far from wishing to modernize Homer, emphasized his antiquity by translating him into Miltonic blank verse – he had even thought of translating him into Chaucerian English! His comments on his own work are revealing:

I have two French prints hanging in my study, both of *Iliad* subjects; and I have an English one in the parlour, on a subject from the same poem. In one of the former, Agamemnon addressed Achilles exactly in the attitude of a dancing-master turning miss in a minuet: in the latter, the figures are plain, and the attitudes plain also. This is, in some considerable measure, I believe, the difference between my translation and Pope's . . .

He strove to render the original as truthfully and starkly as did his German contemporary J. H. Voss whose translations

of the *Odyssey* (1781) and the *Iliad* (1793) into megalithic hexameters enthralled both Goethe and Schiller and were destined to exert a profound influence on German literature and life for more than a century.

To Pope the Homeric poems were a wilderness of savage beauties which could be improved by the use of the sickle and the shears. He was promptly pounced on by a French translator, Mme Dacier, who said that nothing could be more mischievous and unjust: 'So far from the *Iliad* being an untended wilderness it is the best laid out and most symmetrical garden that ever was. M. Le Nôtre, who led the world in this particular art, never achieved a more consummate regularity in his gardens than did Homer in his poetry.' But it was Pope's view that was to prevail, with a significant modification when untended savage beauties, in poetry as in the garden, came to be appreciated for their own sake. Thomas Blackwell's *Inquiry into the Life and Writings of Homer* of 1735 and Robert Wood's *Essay on the Original Genius and Writings of Homer* of 1769 (translated into German in 1773 and French in 1775), held the *Iliad* and *Odyssey* to be expressions of the poetic genius at the golden moment when the Greeks had just emerged from barbarism but before their purity and spontaneity of feeling had been corrupted by civilization. 'While manners were rude, when arts were little cultivated and before science was reduced to general principles, poetry had acquired a greater degree of perfection than it has ever since obtained,' Wood declared.

This reappraisal of Homer as the supreme primitive coincided with, if it did not lead to, a new appreciation of other early poetry, notably the stark elemental tragedies of Aeschylus, first translated into French and English in the 1770s (though earlier available in Latin translations), the 'iron age' works of Hesiod and Pindar and, very significantly, Dante, Shakespeare and the German *Nibelungenlied*. And it also produced the most extraordinary forgery of the century – *Fingal* and other prose poems published by James Macpherson in 1762–3 and ascribed to the mythical Gaelic bard, Ossian. The success of this work was as immediate as it was widespread. Klopstock was so overwhelmed that he claimed Ossian as a German. 'Ossian has replaced Homer in my heart,' wrote Goethe's Werther in 1774. Hamann and Herder were no less enthusiastic. Even in classic Italy the Abbate

Cesarotti turned from commenting on Homer to translating Ossian. In France the young *Primitifs* in David's studio took Ossian with Homer and the Bible as their sacred texts. 'Homer? Ossian?' one of them remarked. 'The sun? the moon? That is the question. In truth I believe that I prefer the moon. It is simpler, larger, it is more primitive.'

The conjunction of Homer and Ossian is no coincidence. Ossian was regarded as the northern equivalent of the Greek poet (on one occasion a painter represented him with all the Homeric attributes). And it is hard to resist the conclusion that Macpherson had intended this to be so. Supposedly written in the third century A.D. (Fingal being a contemporary of Caracalla who figures in the epic), the poems depict a society on the point of emerging from barbarism. They abound in Homeric devices rendered in the suitably archaic language of the Authorized Version of the Bible. And 'they pay scant attention to the more restrictive classical rules. But Macpherson also sought to improve on Homer and set to right what, in the 1760s, were thought to be his failings.

Though Wood had presented him as a Deist, Homer was generally supposed to have been woefully superstitious. Ossian, in contrast, had no Olympus of amoral gods. In his work the supernatural element, so essential for primitive poetry, was represented by spirits who, like Shakespeare's ghosts, may be construed as memories, dream visions and premonitions playing no decisive role in the lives of men. On sexual matters Homer was often frank and sometimes nasty: of the six hundred pages of Ossian there is not one that could bring a blush to the cheek of the demurest maiden. Homer's heroes are frequently deceitful or childishly petulant: Ossian's behave with a decorous nobility of soul which suggests that they have been brought up on the precepts of Cicero and Marcus Aurelius. Obeying no laws save those of nature, they are shown in triumphant conflict with evil men and with the elements.

'In point of humanity, magnanimity, virtuous feeling of every kind,' wrote Macpherson's chief dupe and defender, the Rev. Hugh Blair, 'our rude Celtic bard should be distinguished to such a degree, that not only the heroes of Homer, but even those of the polite and refined Virgil are left far behind by those of Ossian.' Even the urbane Gibbon was struck by the contrast with Imperial Rome:

If we could, with safety, indulge the pleasing supposition, that Fingal lived and Ossian sang, the striking contrast of the situation and manners of the contending nations might amuse the philosophic mind. The parallel would be little to the advantage of the more civilized people, if we compared the unrelenting revenge of Severus with the generous clemency of Fingal; the timid and brutal cruelty of Caracalla, with the bravery, the tenderness, the elegant genius of Ossian; the mercenary chiefs who from motives of fear or interest, served under the Imperial standard, with the freeborn warriors who started to arms at the voice of the king of Morven; if, in a word, we contemplated the untutored Caledonians, glowing with the warm virtues of nature, and the degenerate Romans polluted with the vices of wealth and slavery.

The poems of Ossian present primitive poetry – and, indeed, primitive life – as the later eighteenth century wished to see it: simple, rugged, unsophisticated and, at the same time, moral, rational and touched with sentiment. This attitude is exactly paralleled in Neo-classical renderings of Homeric themes. Licentious or even mildly erotic subjects are spurned. Artists and patrons prefer those which illustrate grandeur of soul, heroic deeds, simple, powerful passions. When David painted *Paris and Helen* for the Comte d'Artois he was at pains to make the subject as unlascivious and give it as strong an appeal to sentiment as he could. But he was clearly happier and much more successful in showing Andromache mourning the dead Hector [80]. In a drawing of Achilles at the pyre of Patroclus, Fuseli shows the Homeric hero so much larger, so much nobler than life, rendering the emotion of grief in its purest and most primitive form [26], that one is reminded of another of his drawings in which he showed himself with a bust of Homer inscribed with the words: 'For the cure of the soul.'

All the trappings of 'period' costume have been banished from Fuseli's drawing of Achilles. Were it not for the Greek inscription, it might be taken to represent an Ossianic subject (just as some of his Shakespearean and Ossianic drawings might easily be mistaken for illustrations to Homer). He went to Homer not for picturesque subjects but for noble themes – themes which expressed the unaffected simplicity of primitive emotions, the natural nobility of heroic deeds. Similar themes were, of course, to be found in the work of other 'primitive' writers. It is significant that Flaxman chose to illustrate only Homer, Aeschylus, Hesiod and Dante.

The qualities which distinguished ancient poetry could be visually represented only by a style of equally primitive simplicity. For the literary and artistic cults of the primitive were two manifestations of a more profound urge to purify society and re-establish natural laws which were based on reason and recognized the dignity of man.

3
Art and Revolution

I. ART AND POLITICS

'Liberty,' wrote Winckelmann in the 1760s, 'only liberty has elevated art to its perfection.' This association of art with politics and social conditions had first been proposed in the early years of the eighteenth century by Lord Shaftesbury to whom Winckelmann owed many of his ideas. Although it rapidly gained currency it was also attacked. The debate has continued ever since. And it is hardly surprising that it has raged most fiercely around the late eighteenth century when it might be supposed that the political sympathies of artists and the political content of their work would be overt and unambiguous. There were, as we have seen, strong links binding Neo-classicism to the Enlightenment and it is tempting to extend this to include that climate 'of critical analysis and doubt, of unrest among the educated classes, and of guilt-consciousness in the rulers' which, in Namier's words, preceded the Revolution of 1789. But the closer we look at individual artists and works of art, the more difficult it becomes to associate, let alone identify, the artistic with the political revolution.

When discussing the possible political motives of artists, it is as well to bear in mind the precise sequence of events in the Revolutionary years. A long struggle for power between the French Crown and certain sections of the privileged classes culminated in the so-called *révolte nobiliaire* of 1787. Matters came to a head over proposals to tax the aristocracy and the Church as a means of righting a disastrous financial situation aggravated by the expenses France had incurred in the American War of Independence. In 1788 the King capitulated to the aristocracy by agreeing to summon the States-General for the first time since 1614. When it met in May 1789 it brought to the fore the prosperous professional men and minor government officials of the *Tiers État* who, demanding popular sovereignty, met in the Tennis Court on 17 June and constituted themselves the National Assembly. In the

meantime bread and grain riots had broken out all over France. Lefebvre has shown this peasant revolt to have been an autonomous movement quite separate and distinct from the *révolte nobiliaire* and the subsequent bourgeois revolution of the *Tiers État*. It was a revolt against specific practical grievances and had, of course, no political theory behind it, nor did it need any. These disturbances culminated in the revolt of Paris, the storming of the Bastille on 14 July and of Versailles on 6 October 1789. Yet despite all this, the assembly, dominated by Robespierre, still voted for a constitutional monarchy rather than a republic and continued to do so even after the King's abortive flight to Varennes in 1791. It was not until September of the following year, under the impact of the Austrian invasion and attempts at a counter-revolution, that the monarchy was finally abolished and not until 21 January 1793 that the King was executed.

The French Revolution was a complex series of events, in fact a succession of overlapping revolutions with different origins and aims. It cannot be reduced to a simple causal sequence. Nor can any direct causal relationship between it and the Enlightenment be implied, since political theory seems to have had little influence on the Revolution's course and became useful mainly to justify it after the event.

Artists were not involved in the *révolte nobiliaire* and their political affiliations before 1789, if they had any, are now unknown. Their reactions to the events of 1789 are seldom explicit and can usually be implied only from negative evidence. (Though on 7 September a group of eleven wives and daughters of artists – including Mmes David, Moitte, Peyron and Vien – who sympathized with recent events, dressed themselves in white, stuck tricolour cockades in their hair and publicly gave their jewellery to the National Assembly.) But it is certain that some of the most artistically progressive were politically either indifferent or reactionary. Ledoux, for example, who built the toll houses for the farmer-generals' wall round Paris [13] – *'le mur murant Paris rend Paris murmurant'* – was, not unnaturally, imprisoned during the Revolution. Two other advanced architects seem to have sided with the *ancien régime*: Gondouin went into prudent hiding, Thomas de Thomon followed the Comte d'Artois into exile and then chose to work for the most reactionary courts in Europe, first Vienna, then St Petersburg [48]. Many progressive artists were financially ruined, like Greuze, whose

fortune vanished in *assignats* and who failed to find new patrons. On the other hand, the middle-of-the-road Vestier, though impoverished, found the hope of the new political order 'a joy which consoles me for my losses'. Many, of course, sided with the Revolution, whether from conviction or expediency. And as the Revolution pursued its tumultuous course, attitudes to it changed as rapidly (mainly as a result of the Terror) both in and outside France. André Chénier, Schiller and Vittorio Alfieri were among many who, like Wordsworth, greeted it with joy but were soon thrown 'out of the pale of love'. Flaxman, who seems to have shown little interest in politics even in the 1790s, later declared himself against the Revolution and refused to meet David because his hands were 'dyed beyond purification'.

David has been called 'the perfect political artist', but the connexion between his art and politics is much less straight-forward than might be supposed. By his contemporaries he was represented both as a lifelong revolutionary and as a mere opportunist who attached himself to the leading party of the moment. His early *Belisarius* [7] has been described as a denunciation of kings in general and Louis XVI in particular. The same work, and other paintings he executed for the Crown, were cited in about 1793 as evidence of his complaisant support of the *ancien régime*. Reactionaries later found his works stained by the blood of the Terror and reported (on no evidence) how he would cry to his students 'let us grind enough *red*' while the tumbrils rattled past his windows. The left wing has generally seen in his pre-Napoleonic works a reflection of their own beliefs. On the eve of the Russian Revolution the Menshevik, Georgy Plekhanov, exhorted young Russians to go and bow before David's *Brutus* in the Louvre. More recently David has been artistically and politic-ally condemned by the Marxist, Daniel Guérin, as a cynical bourgeois betrayer of the proletariat.

The painting around which discussion has raged most fiercely is the *Oath of the Horatii* of 1784 which has often been construed as an appeal to 'republican virtues and sentiments' and therefore as a manifesto of the Revolution [8]. Yet this work was commissioned for the Crown by the Comte d'Angi-viller and won his official approval even though the canvas was not of the size required. It does not, in fact, represent a Roman Republican scene. Nor were there Republicans – in any meaningful sense of the word – in France at this date. Nor yet

does it suggest any general criticism of society such as is evident in Beaumarchais's *Le Mariage de Figaro* which had aroused widespread comment when it was first produced in 1784. None of the many comments made on the *Oath of the Horatii* when it was first exhibited in Rome – where princes of Church and State flocked to admire it – or in Paris, suggests that it contained any allusions, overt or otherwise, to any of the political issues of the day. As Prud'hon remarked in a letter of 1786, the Horatii swear with absolute steadfastness to shed their blood to the last drop for their *patrie*. And in France at this date patriotism still implied loyalty to the King. The painting is no more a celebration of Republicanism than David's *Death of Socrates* is a condemnation of demagogy.

For his *Brutus* [27] begun in 1788, David did choose a Roman Republican theme – the expulsion of a tyrant – though this was not the aspect of the story he chose to illustrate. And it is perhaps significant that in the very same year Alfieri, who was also in Paris, dedicated his tragedy *Bruto Primo* to George Washington with the words: 'Only the name of the liberator of America can stand on the opening page of the tragedy of the liberator of Rome.' But David took up the story where Alfieri had left off, showing Brutus – '*L'uom più infelice, che sia nato mai*' – seated in the atrium of his house while the lictors carry in the bodies of the sons he has condemned to death for treason. This illustration of stoic patriotism and sense of public duty at its most austere was, like the *Oath of the Horatii*, bought for the Crown by d'Angiviller. David himself, writing in 1789 to Wicar (who also became a Republican firebrand), described the work purely in terms of the passions it represented without hinting at any political overtones. When the picture was begun the Revolution was still in its first phase. But while David was at work on it there was a dramatic change in the political climate: and by the time it was completed for the Salon of 1789, the oath had been sworn in the Tennis Court, the *Tiers État* had taken over and the Bastille had been stormed.

David also presented for the 1789 Salon the *Paris and Helen* he had painted for the King's brother, the Comte d'Artois, and a portrait of Lavoisier and his wife [28]. Anxious lest the exhibition should inflame further disorders, the authorities decided not to exhibit the portrait of Lavoisier, then better known as a farmer-general than as a scientist. There was a brief delay before they put the *Brutus* on show but whether

27. *Brutus*, 1789. J.-L. David

28. *Antoine Lavoisier and his wife*, 1788. J.-L. David

this was diplomatic is not known. Nor is it known whether the painting had any precise political significance for those who saw it in the Salon in 1789. Of course, the cult of Brutus – though of the assassin of Caesar as much as Brutus the first consul and opponent of Tarquin – later became the centre of the imagery of the Revolution.

In the following year David was commissioned by the Jacobin club, of which he was himself a member, to execute the commemorative painting of 'the act of formal disobedience to the King', the oath in the Tennis Court. Announcing this decision, Dubois-Crancé declared: 'To immortalize our thoughts we have chosen the painter of the *Brutus* and the *Horatii*, the French patriot whose genius anticipated the Revolution.' This is the first recorded instance of any specifically political meaning being read into David's works – and it is significant that it should not occur until after he had begun to engage in active politics.

This is not to suggest that a revolutionary meaning was seen in his paintings only because he later became a politician. David was not the only genius, nor were his the only works, that were supposed to have anticipated the Revolution. Voltaire also was hailed as a prophet and his tragedy of *Brutus* (first performed sixty years earlier) was revived in the autumn of 1790 with David's picture staged as a *tableau vivant* at its close. Schiller's *Die Räuber*, published in 1781, was similarly interpreted as an expression of revolutionary sentiments and in 1792 he received, much to his embarrassment, a certificate of honorary French citizenship. And many prominent revolutionaries said in retrospect that a youthful reading of Plutarch's *Lives* had fired their souls with a passion for liberty. By 1795 the Comte de Volney was putting the blame for the Revolution on the whole cult of antiquity.

In painting the *Oath of the Horatii* and the *Brutus*, David expressed the mood of those French intellectuals who, like himself, were to be swept along on the wave of the Revolution. He rendered in artistic terms their stern morality, their idealism, their faith in reason and the rights of man, their willingness to sacrifice their friends, their relations and themselves to their new concept of patriotism. But he had also appealed to those who (like d'Angiviller) were to turn horror-stricken from the first practical application of these beliefs, and to those who were to be disillusioned by the course the Revolution took – like his friend André Chénier who lost first his

faith then his head. In 1789 no one could have realized the full implications of enlightened ideas, no one could have predicted how soon and how inexorably the moral lessons implicit in the *Oath of the Horatii* and *Brutus* were to be forced upon them.

David, who became a deputy and for a while chairman of the Convention, followed his beliefs through politically and artistically. In his paintings of the *Oath in the Tennis Court* and the three martyrs of the Revolution – Le Peletier, Marat and Bara – he was to adopt a still more severely uncompromising style. These works develop as logically, one might almost say inevitably, out of those that preceded them as the politician David of the 1790s out of the intellectual David of the 1780s. Yet he seems never to have become a fanatically doctrinaire Jacobin. His drawing of Marie Antoinette on her way to the guillotine reveals his tenderness for the woman, however much he may have hated and despised the Queen for whose execution he had voted [29]. It reminds one of Baudelaire's phrase – that David had '*quelquechose de tendre et poignant à la fois*'. And the large painting of the *Intervention of the Sabine*

29. *Marie Antoinette on the way to the guillotine*, 1793.
J.-L. David

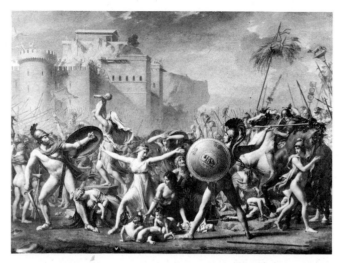

30. *The Intervention of the Sabine Women*, 1799. J.-L. David

Women [30], which he began to sketch when imprisoned (as a friend and supporter of Robespierre) seems to have been intended as a plea for peace and reconciliation. It reflects the mood of revulsion from terror and blood-letting which marked the Directoire. Soon David, like the majority of his compatriots, was to see Napoleon – however mistakenly – as the one man capable of leading France out of the impasse of the Revolution without sacrificing the principles of 1789.

David must occupy the centre of any discussion of art and politics in this period. But there were other artists who engaged in politics and other works of art to which political significance was attached. Neo-classical paintings could also be hailed as counter-revolutionary statements. In 1799 one of David's best followers, P.-N. Guérin, exhibited in the Salon a painting of the *Return of Marcus Sextus* [31] – a man who, exiled by Sulla, had returned home to find his wife dead and his daughter distraught with grief. The *emigrés* who had just come back to France naturally saw this as an allegory of their own plight, though whether this was Guérin's intention when he began the picture in 1797 is extremely doubtful. (It was painted in Rome and could equally well refer to a revolutionary driven from his home by the Papal government.)

A story which Canova tells in a letter of 1799 provides an instance of how easily and plausibly – and how mistakenly – a

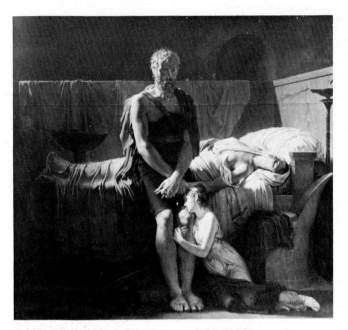

31. *The Return of Marcus Sextus*, 1797–9. P.-N. Guérin

topical meaning may be read into a work of art. Some French-
men who visited his studio much admired his colossal group
of *Hercules and Lichas* [32]. It clearly represented, they said, the
French Hercules casting Monarchy to the winds, to which
Canova replied that he would never have represented such a
theme for all the gold in the world and asked whether the
figure of Lichas might not equally well be identified with
'licentious liberty'. He had, in fact, considered neither inter-
pretation before. Nevertheless, the suggestion, a few years
later, that the group should be raised as a monument to the
Austrian army in Italy was vetoed by the Emperor, possibly
because he thought its meaning too ambiguous.

A truly political work of art must necessarily be unam-
biguous. Such straightforward statements as caricatures and
documentary records of notable events – the fall of the Bastille
or the storming of the Tuileries – leave one in no doubt as to
their purpose and meaning. But so closely are they involved
in the passions of the moment that they can rarely move us
today. Indeed, they serve to reinforce the Neo-classical belief

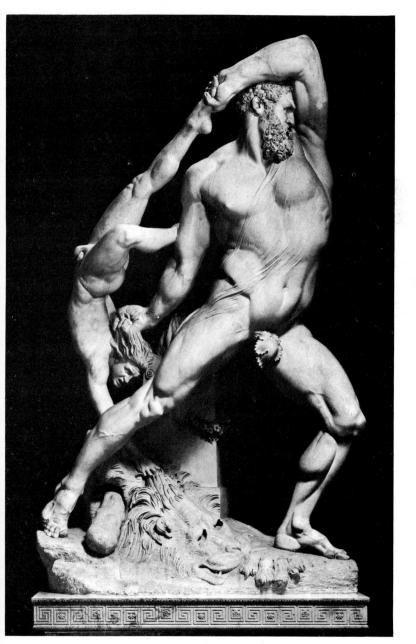

32. *Hercules and Lichas*, 1795–1802. Antonio Canova

that a great work of art should be devoted to a theme of universal significance. Goya's prints and paintings survive with terrifying force because they castigate not merely the superstitions of eighteenth-century Spaniards but all the malevolent powers of bigotry, the horrors not merely of the Napoleonic war in Spain but of all wars in all countries. In a rather different way, David lifted the revolutionary heroes out of the circumstances of their time, depicting the dead Marat [83] and the dying Bara not just as martyrs of the Revolution but as ennobling examples of those who die for their beliefs. In both works, contemporary allusions are reduced to their barest minimum, to the letter in Marat's hand and the tricolour cockade the young Bara clutches to his heart. And it is no coincidence that in the *Oath in the Tennis Court* David repeated the gesture with which the Horatii had sworn to shed their blood for their country even to the last drop.

2. EDUCATION

In 1793 Léopold Boilly, one of the most charming French painters of the day, was called before the *Société populaire et républicaine des arts* and accused of painting pictures of 'revolting obscenity to republican morals, the obscenity of which dirties the walls of the Republic'. He was no pornographer; his paintings were rarely more than delicately erotic. But he was never highly serious. Even his *Triumph of Marat*, which he cited in his defence, is unmistakably, if to modern eyes agreeably lighthearted. And it was to his incorrigible frivolity that the *Société populaire* objected. One of its members, Jacques Lebrun, described as 'counter-revolutionary' pictures not only those of overtly anti-civic or immoral subjects but also such frivolous and insignificant paintings as 'can serve at most merely to charm the boredom of our luxurious sybarites'.

A belief in the educative mission of artists, which found extreme expression in these remarks, was embedded in eighteenth-century theory. The *Encyclopédie* article 'Intéressant' states that a work of art owes its interest to its moral and social content and the artist must therefore be both '*philosophe et honnête homme*'. And Diderot summed up his philosophy of art in the famous sentence: 'To make virtue attractive, vice odious, ridicule forceful: that is the aim of every honest man who takes up the pen, the brush or the chisel' [33]. Nor were such ideas confined to France. In England Daniel Webb recommended paintings which 'melt the soul into a tender

33. *The Drunkard's Return, c.* 1780. G.-B. Greuze

participation of human miseries . . . give a turn to the mind advantageous to society . . . and quicken us to acts of humanity and benevolence'.

The corollary, that the arts might also deprave, was applied not only to representations of licentious or merely unedifying subjects but also to the 'impure' in style. 'There is a close analogy between the love of beauty in external objects, and a mind truly disposed to feeling all the softer and most amiable sensations,' wrote John Baptist Jackson (1754), who argued that a taste for bizarre Chinese or chinoiserie wallpapers indicated a love of the 'crooked, disproportioned and ugly . . . the ill Formation or Perversion of that mind which approves of preternatural Appearances'. Similar criticisms were applied to architecture by J. G. Sulzer in 1771: 'Bad buildings which have been planned or constructed without order or intelligence or which are overladen with foolish, grotesque, or exuberant decoration necessarily have a bad effect on the mentality of the people.' This revival of Platonic notions reflects the Enlightenment's preoccupation with education at a time when the power of the Churches was declining. A change in attitude to the rewards and penalties of the after-life was necessitating the substitution of an extra-Christian ethical code based on reason

and the 'law of nature'; or, in Diderot's words, substituting 'doing good' and 'doing harm' for religious concepts of virtue and vice.

The effect of these notions is clearly evident in the official programme of Crown patronage of mid eighteenth-century France. As we have already seen, greater emphasis was placed on the intellectual training of artists and the painting of serious moralizing history pictures was encouraged. This programme was to a large extent inspired by nostalgia for the *grand siècle*. But in one respect the paintings it produced differed markedly from those of the Louis XIV period. Le Brun and the artists he employed had almost invariably celebrated the virtues, the power and the glory of Louis XIV himself. If abstract virtues were illustrated they were those associated with monarchy – justice, clemency, magnaminity, wisdom. Even religious pictures seemed to suggest that the King who ruled by right divine was the eldest and 'most beloved' son of the Church. But the works commissioned by d'Angiviller from 1774 onwards rarely refer to Louis XVI. The virtues they celebrate are those expected of the nation at large – courage, sobriety, continence, respect for the laws and, above all, patriotism. Their aim was not to reflect the glory of the Crown but to educate the people. It was to contribute to this series of educative works that David painted both the *Oath of the Horatii* and the *Brutus* which are the outstanding products of the programme – as stylistically pure as they are morally elevating and uncompromising.

When commissioning paintings in 1776 d'Angiviller very significantly placed the moral theme before the subject: 'Example of the encouragement of work among the Romans: Cressinus displaying his agricultural implements. . . . Example of disinterestedness among the Romans: Fabricius refusing the presents of the ambassadors of Pyrrhus. . . . Example of heroic resolution among the Romans: Portia proving to her husband Brutus that she has the courage to kill herself if the plot against Caesar fails.' Livy and Plutarch, those breviaries of the enlightened moralist, were scanned for suitable subjects. Others were found in French medieval and later history. And when commissioning sculptors to execute a series of statues of great Frenchmen, d'Angiviller included not only men of action like the Maréchals de Tourville and de Catinat but also Poussin and La Fontaine. Indeed, he remarked of Maréchal de Catinat that he was *'non moins recommendable par ses talents*

militaires que par son humanité et son esprit philosophique'.

Houdon, who carved the statue of de Tourville, wrote some years later: 'one of the finest attributes of the difficult art of sculpture is truthfully to preserve the form and render imperishable the image of men who have achieved glory or good for their country.' The idea that such statues and busts could serve as educative moral exemplars had been well established in ancient Rome and propounded by Cicero. But after the Renaissance the honours of civic statuary had been reserved almost exclusively for dynastic rulers. Others had been commemorated, if at all, only above their tombs. In the mid eighteenth century a desire to praise famous men, especially writers and philosophers, in imperishable marble or bronze, manifested itself in all parts of Europe. Monuments were raised to those long dead – to Galileo in S. Croce, Florence (1737), to Shakespeare in Westminster Abbey (1740), to Newton in Trinity College, Cambridge (1755), to Descartes in Stockholm (1780), to Grotius in Delft (1781). This cult was particularly strong in England where Queen Caroline in 1732 raised busts of Locke, Newton, Wollaston and Clarke in the Hermitage in her garden at Richmond. A large semicircular 'Temple' enshrining busts of 'British Worthies' was built in the park at Stowe, also in the 1730s. Indeed, in 1767 a French writer remarked that 'the practice of honouring men of talent with statues is still vigorously kept up by the English, emulators of the Greeks and Romans in their esteem of talent as in their love of liberty'. Westminster Abbey was, he said, '*comme le sanctuaire de la gloire nationale*'. And, in Rome, from 1776 onwards busts of artists and writers (of whom Winckelmann was the first) were accumulated in the Pantheon which was thus transformed into a temple of fame. In 1775 Andrea Memmo began to lay out the Prato della Valle in Padua as a garden adorned not, as would have been the case a few years earlier, with marble gods and goddesses, but with statues of the most famous men connected with the city. In France the architect Desprez designed a vast complex of sepulchral buildings to commemorate and house the remains of the greatest Frenchmen – he sent a print to Voltaire who said he could hardly wait to be buried in it.

Towards the end of the century this abstract generalizing tendency was carried a stage farther with the architectural (i.e. abstract) monument and with the erection (or more usually just the design) of monuments dedicated to general ideas as

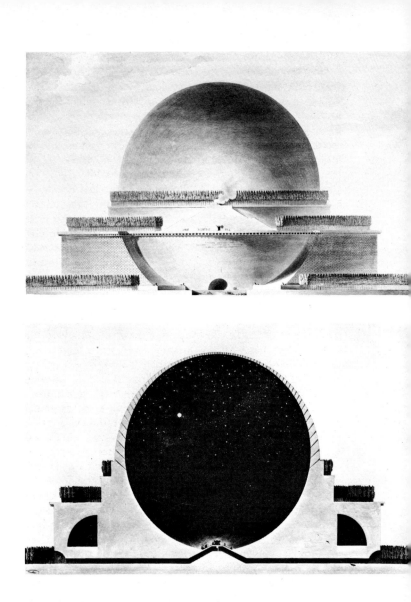

34. Designs for a monument to Newton, *c.* 1780–90. E.-L. Boullée

well as individuals. The most notable were those to Newton – discoverer of order in infinity and thus a great Neo-classical hero – especially that drawn by Boullée [34]. 'O Newton,' wrote Boullée, 'as by the extent of your wisdom and the sublimity of your genius you determined the shape of the earth; I have conceived the idea of enveloping you in your own discovery.' The same idea lies behind Janus Genelli's designs for architectural monuments to Kant and Herder of 1808. In the newly founded United States those who petitioned for the purely architectural monument to George Washington – a simple column – claimed that its erection was in the public interest since 'trophies to the memory of great and good men are an encouragement to victorious and heroic deeds. They stimulate the young to emulation, to noble and honourable actions.' We are here as far from the world of the Baroque dynastic monument as from the notion that history is concerned more with the conquests of kings than the achievements of the human spirit.

The enlightened belief that the greatness of rulers – Pericles, Augustus, Julius II or Louis XIV – was to be judged less by their territorial conquests than by the works of art and literature produced under them acted as a further stimulus to the improvement of the arts. Academies began to proliferate (in 1720 there were only nineteen, few of which were actively engaged in artistic instruction; by 1790 there were more than a hundred from Philadelphia to Leningrad). As these institutions began to replace the master's studio as the main schools for young artists, so their attention was directed more to theory and less to craftsmanship. And it was this attitude that led to a demand for the public museum – the temple of art.

Great royal collections of works of art which had hitherto been regarded mainly as status symbols, as important adjuncts to a monarch's regalia, now came to be seen in a different light. In 1747 La Font de Saint-Yenne issued the first of a long series of pleas for the establishment of a royal museum in Paris as a remedy for the decadence of history painting. Three years later, more than a hundred paintings and drawings were hung in some rooms of the Luxembourg Palace, open to the public twice a week and to the protected students of the École Royale at practically any time. In Germany the Landgrave Frederick of Cassel began in 1769 what was to be the first museum ever built as such in Europe, the Fredericianum, to house antique statues, a library and a natural history collection. It was

designed in an appropriately, but for Germany at this date unusually severe and correct classical style. Still more advanced stylistically were the new rooms which, between 1772 and 1781, Pope Pius VI added to the Vatican for the display of antiquities [35].

35. The Rotonda, Museo Vaticano, Rome, 1776–80. M. Simonetti

Though open to the public, these museums were still essentially private collections like the Galleria degli Uffizi in Florence. A new and revolutionary idea about the role of the museum was, however, already in the air. In 1779 Christian von Mechel, a friend of Winckelmann, was appointed to arrange and catalogue part of the Austrian Imperial collection in the Belvedere Museum in Vienna. 'The purpose was to use this building,' he wrote, 'so that the arrangement should be as far as possible a visible history of art. Such a large, public collection intended for instruction more than for fleeting pleasure, is like a rich library in which those eager to learn are glad to find works of all kinds and all periods.' The same idea underlay the establishment of the Louvre as a public museum in 1792 and the opening in 1793 of Alexandre Lenoir's museum of medieval works of art removed from churches. Finally, in 1798, a memorandum which Aloys Hirt, historian of ancient architecture, sent to the King of Prussia, established the basic conception of the museum as an instrument of education in the

widest possible sense. Believing that it was 'beneath the dignity of an ancient monument to be displayed as an ornament', he declared that works of art should be kept not in palaces but in public museums. 'They are a heritage for the whole of mankind. . . . Only by making them public and uniting them in display can they become the object of true study; and every result obtained from this is a new gain for the common good of mankind.' This is not the least of the legacies that the modern world has inherited from Neo-classicism.

3. ARTISTS AND PATRONS

Though written into the policy of official patronage in late eighteenth-century France, the idea of art as education was not imposed on an unwilling public by a despotic administration – rather the reverse. It certainly seems to have been readily accepted by the intellectuals of the middle class with their demands for greater seriousness and purer morality in the arts as in life. It is their voice that we hear in the pleas of Rousseau and Diderot.

The cautious historian may hesitate to mention a body as ill-defined as the middle classes. Yet there can be little doubt that they played a part of some importance in the formation of late eighteenth-century taste in literature and the arts. The most important art form brought to maturity in this period, the novel, found its main public among and expressed the sentiments of those who belonged neither to the nobility nor to the proletariat. Horace Walpole saw the works of Richardson as 'pictures of high life as conceived by a bookseller, and romances as they would be spiritualized by a Methodist preacher' – and that possibly accounts for much of their success. Grimm and Diderot thought they were 'sublime'. Goethe's *Werther* and *Wilhelm Meister*, whose heroes are snubbed by the *Hochgebornen*, were similarly addressed to middle-class readers. For, by this time, they had become the core of the reading public – a serious-minded body which expected to be edified and improved rather than entertained. Impatient of empty frivolity, it welcomed the serious novel. Equally impatient of pedantry (the frivolity of the erudite), it rejected the mindless disquisitions of the *Académie des Inscriptions* and took Winckelmann and Gibbon to its heart. It produced not only the readers but also most of the writers.

In the visual arts the direct patronage of the middle classes could not be very lavish. Few merchants and professional men

had either the money to buy or the space to house large-scale history paintings and heroic statues. But they did visit exhibitions. And in Paris, London and various Italian cities, public exhibitions grew more numerous and popular as the century drew to its close. The Paris Salons sometimes attracted as many as 700 visitors a day among whom were many bourgeois, intellectuals and even some of the grander lackeys. Indeed, the *grands seigneurs* complained in the 1770s that they were jostled by '*des habits gris galonnés*' and arranged to make their visits on days when the Salon was not open to the general public. It would be difficult to exaggerate the importance of the part these exhibitions played in extending the artist's public from a small circle of men of taste to the larger intellectual world in which delicacy of touch counted far less than seriousness of content.

Even more significant than the increase in public exhibitions was the enormous rise in popularity of the print – to some extent the visual counterpart of the novel and like it indicative of the vast new public that was then emerging. The Homeric paintings of Gavin Hamilton were diffused throughout Europe by engravings. Greuze owed most of his fortune to the engraved reproductions of his moralizing pictures which illustrate the eminently middle-class virtues of domesticity, industry, thrift, abstinence and personal responsibility. Later, Flaxman's illustrations to Homer were to enjoy a still larger circulation. But the most popular prints seem to have been those of contemporary events. Chodowiecki's *Adieux de Calas* enjoyed a huge success, appealing as much to the philosopher as to the man of feeling with its biting attack on religious intolerance. It was more effective and, in Catholic countries, more likely to escape the censor than any pamphlet. In England, for rather different reasons, prints after West's *Death of Wolfe* and Copley's *Death of Chatham* were no less widely diffused and did much to encourage the development of modern history pictures (which were, indeed, often commissioned mainly with an eye to the print market).

This widening of the public interest inevitably affected the standing of the artist and his own conception of his role in society. The artist who, unless very successful indeed, had previously been regarded as a superior type of craftsman producing luxury goods for a few wealthy patrons, now saw himself as a public figure and a professional man. And the change in the artist's status – reflected in the establishment of official

academies – led to a greater sense of independence and a corresponding change in his relationship with patrons. Here he had the full support of the theorists.

Looking back to Greece, Winckelmann had observed nostalgically, 'the homes of the citizens were marked by moderation and simplicity; the artist was not obliged to descend to little things to fill the gaps in a house, nor lower his genius to the shabby taste of an opulent patron'. Similarly, the Cavaliere d'Azara attributed the decline of the arts in ancient Rome 'not so much to the artists as to the amateurs and rich men who patronized them, ignorantly and barbarously making them renounce their high ideals'. Contemporary patrons were seen in the same harsh light. Diderot in 1767 deplored the way in which artists were still expected to consider the whims of individuals instead of the interests of the nation as a whole, compromising their talents with a preoccupation with prettiness because people would not tolerate serious subjects. It is important to remember that his remarks were addressed not to the public at large, nor to the *beau monde* of Paris but to the very limited circle of subscribers to Grimm's *Correspondance littéraire* – Catherine the Great, the King of Poland, the Queen of Sweden and a few German princes – that is to say those by or through whom official patronage was dispensed. For it was to the world of official patronage that these reformist ideas were initially directed.

So far as original works of art were concerned, the direct patronage of the middle classes was limited mainly to the portrait which underwent a transformation as a result. Hitherto, painters had generally shown middle-class sitters aping the manners of the aristocracy. When aristocratic manners unbent in the Rococo period, they were pictured in the more obliging attitudes of *noblesse*. It was not until the later eighteenth century that the middle-class sitter could be represented as he really was. Reynolds shows us Baretti engrossed in the book he is myopically reading [36]. David reveals the obstetrician, Alphonse Leroy, at work among his scientific apparatus and manuals [37]. It is hardly surprising to find that these, and indeed most of the best of such works, represent personal friends of the artists. These solidly composed portraits are downright statements of fact, as devoid of flattery as of grace and affectation. The products of a frank, rather than ruthless vision, they convey the intimacy of human contact. No posturings, no rhetorical

6. (Opposite) *Giuseppe Baretti*, 1774. Sir Joshua Reynolds

7. *Dr Leroy*, 1782–3. J.-L. David

gestures are allowed to disturb the atmosphere of candid familiarity or to create a barrier between subject and spectator. A similar candour breaks through even in the more restrictive medium of the portrait bust. Houdon's *Diderot* [38], wearing his own hair, is rendered as he must have appeared to Sophie Volland, looking at us with the same humorously perceptive gaze that he turned on his *confrères*.

This style of portraiture was not, of course, reserved for professional men. Many members of the upper classes soon wished to be represented in the same way. Before long it could

38. *Diderot*, 1771. J.-A. Houdon

also be applied to the lower classes, as in the extraordinarily vivid group of a father and his children at Le Mans [39]. Here no trace remains of the old type of proletarian portrait executed to divert or comfort the rich. The rags, the bare feet, the horny hands, the wrinkles and the ingratiating smiles have gone and we are left with an unforgettable record of solid, forthright, independent individuality. Everything is simple and un-affected: its dignity derives from human warmth and candour.

Although the portrait belonged to a low category in the academic hierarchy of genres, it was in a sense elevated by this

39. *A father and his children, c.* 1794–1800. Anonymous

typically Neo-classical concentration on essential truths rather than superficial appearances. And it was at this period that Lavater claimed in his *Essays on Physiognomy* (1775–8): 'Each perfect portrait is an important painting since it displays the human mind with the peculiarities of personal character. In such we contemplate a being whose understanding, inclinations, sensations, passions, good and bad qualities of mind and heart are mingled in a manner peculiar to itself.' His study was, of course, an attempt to impose order on an aspect of nature and, as such, a characteristic expression of the Enlightenment.

Lavater's was but one of numerous scientific and pseudo-scientific publications which appeared in the later eighteenth century and enjoyed great popularity, ranging from vulgarizations like Algarotti's *Newtonisme pour les dames* to original contributions to knowledge like Réaumur's work on insects and Buffon's *Histoire naturelle*. Never before had scientific studies been so widespread. They found expression not only in books but in the creation of museums of natural history (the Prado in Madrid was built for this purpose in 1787 and only later converted into an art gallery). They also created a demand for what may be called scientific pictures – scientifically exact representations of animals, plants, geological formations – like Wolf's extraordinary landscape with a glacial rainbow [40]; the heavens – notably John Russell's *Face of the Moon* 'painted from nature' [41]; such natural phenomena as volcanic eruptions, views of distant lands and their inhabitants [94], and also of mines and factories and forges.

The new intellectual middle-class world for which such pictures were painted can be seen in microcosm in the Birmingham Lunar Society of the 1770s and 1780s – an informal association of friends who met periodically (on nights when the moon was full, so that they could ride home safely) to conduct scientific experiments and exchange ideas on philosophy, literature, politics and the arts. Its members included Josiah Wedgwood, Matthew Boulton and James Watt, the poet-naturalist Erasmus Darwin and the chemist-philosopher Joseph Priestley. In politics they were advanced, in religion unorthodox or sceptical. They were humanitarians and among the first to demand the abolition of slavery (Wedgwood appealed to both reason and sentiment in a jasper-ware medallion of a kneeling slave inscribed: 'Am not I a man and a brother?'). In artistic matters they favoured the rationalizing, simplifying Neo-classical style

40. *Alpine landscape*, 1778. Caspar Wolf

41. *The Moon, c.* 1795. John Russell

42. Sauce tureen, 1776. Boulton and Fothergill

and were quick to realize its suitability for industrialized production. Boulton's factory made gilt bronze and silver objects designed by or in the manner of Robert Adam [42]. Wedgwood led Europe in the production of flawless pottery of a simple, sober dignity that perfectly fitted the Neo-classical interior [51]. Appreciating that work in the new style depended on a uniform texture and almost mechanical precision of form which suppressed the individual sensibility and freedom of hand of the craftsman, he took pains to find able designers and to school artisans who could reproduce their models exactly. And it was he who first discovered the genius of the young John Flaxman.

The artist most closely associated with the Lunar Society was, however, Joseph Wright of Derby who portrayed several of its members and expressed in paint their wide-ranging interests in natural phenomena, science, industrial progress and the arts. He was particularly fascinated by and drawn to subjects which enabled him to investigate the problem of light – the fire of a forge, the eruption of a volcano, the scintillation of fireworks over Rome, a candle illuminating an antique statue, torches in a subterranean cavern, moonlight streaming through a ruin [91], the curious effect of light reflected from water in a cave on the Neapolitan coast. In these works he not only revealed his intellectual interests but made his own contribution to the science of representation. And he was also, just as characteristically, a man of feeling. Even when painting a scientific experiment, he introduced the figure of a girl weeping at the fate of a bird in an air-pump [43]. For him, as for his friends and patrons in the Lunar society, man was still the most interesting, still the most important product of nature.

43. *Experiment with the Air Pump*, 1768. Joseph Wright

4
The Ideal

I. NATURE AND THE IDEAL

Canova's terracotta sketches provide at first sight a very striking contrast with his exquisitely chiselled marbles [44 and 45]. They have a boldness, an immediacy and spontaneity, an almost palpitating vitality which might seem to anticipate Rodin. To modern eyes they are more appealing than the finished works, so cool, so tenderly and fastidiously calculated, so tranquil: those more hostile might say so vapid, affected and inert. And, indeed, they have been cited as evidence of a schizophrenic split in Canova's personality. Yet his was not an isolated case. Sergel, Flaxman, Chinard, Dannecker and others executed clay models just as free and finished works in marble just as thoughtfully restrained as Canova's. A pair of lovers sketched by Sergel [46] – executor of highly polished marbles – are not only freely drawn but embrace with an ecstatically passionate abandon which might seem to flaunt every classic rule. He would appear to have taken to heart Winckelmann's advice to 'sketch with fire and execute with phlegm'.

In another passage Winckelmann remarked, 'just as the first pressing of the grapes gives the most exquisite wine, so the soft medium of the modeller and the sketch on paper of the draughtsman affords us the true spirit of the artist; to such an extent that in the finished painting or statue, the talent of the artist is to some extent hidden by the finish which he sought to give his work'. A few years later Diderot took up the same idea and developed it at greater length. Wrenched from their context, such remarks might be quoted as evidence of a precociously romantic preference for the sketch rather than the finished work. And in fact Canova's *bozzetti* and Sergel's drawings have been included in an exhibition of Romantic art, as examples, presumably, of a romantic spirit struggling to emerge from the strait-jacket of Neo-classicism. Nothing could be more misleading. For a belief in the Ideal – a very un-Romantic conception – underlies the Neo-classical attitude to the sketch no less than to the finished work of art.

44. *Cupid and Psyche*, 1787. Antonio Canova

A *bozzetto* by Canova represents his first attempt to realize an ideal form. That for the *Cupid and Psyche* [44] shows him struggling to solve the basic problem of the composition – the relationship between two embracing recumbent figures. It is a first, *a priori* statement on which the logic of the final solution will depend. In fact, so abstract and generalized is it that it might equally well be a sketch for his group of *Venus crowning Adonis* on which he was working at about the same time. Yet the problems with which Canova wrestled in these *bozzetti* were not limited to the abstract and formal – to attaining a perfect balance and unity without any loss of verisimilitude and variety. For the *Cupid and Psyche*, like all great works of art, perfectly unites form and idea and moreover was conceived on more than one level of meaning: as a three-dimensional composition of interlocking forms and contrapuntal harmony, revolving through a series of mellifluous and apparently effortless transitions; as an idyllic representation of young love – of slim adolescence and limbs as tender as eyelids – with all its dewy innocence and purity; and, on a deeper, more symbolic level as a 'love–death' image of that moment of perfect reciprocity in the transport of physical passion when a state of almost mystical union is experienced 'at the still point of the turning world'.

Canova's practice was to execute a number of such *bozzetti* and then proceed by way of further exploratory sketches and

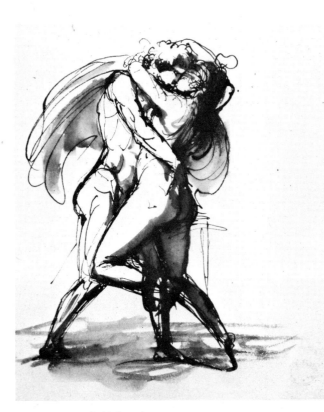

46. *Lovers*, 1780. J. T. Sergel

experiments, each slightly more elaborately defined and articu-
lated than the last, until a final full-sized *modello* was reached.
The method corresponds very closely with that advocated by
Goethe in 1789. The artist should begin by studying the differ-
ences between individuals, Goethe wrote, then by a leap of the
imagination, subsume each individual in one act of vision or
intuitive synthesis and thus, rising from abstraction to abstrac-
tion, finally represent the type or universal seen in its indivisible
harmony and purity *sub specie aeternitatis*. The artist in search of
such ideal forms sought to fathom eternally valid truths under-
lying the superficial diversities and accidents of nature: and
neither his sketches nor his finished works can be appreciated

on their own terms without some understanding of the Neoclassical attitude to Nature and the Ideal.

'The sacred word "nature" is probably the most equivocal in the vocabulary of the European peoples,' wrote A. O. Lovejoy who isolated more than sixty distinct meanings of it. Practically every eighteenth-century belief, whether religious, moral, philosophical, economic or artistic, was supported by an appeal to the law of nature. The bewildering width of interpretation ultimately reached may be judged by comparing Bernardin de Saint-Pierre's famous story of *Paul et Virginie*, brought up according to natural laws, with de Sade's justification for his perversions – 'Nature granted these urges to me and to resist them would be to outrage it'. But its primary connotation was 'uniformity' and 'universality' and it was this meaning that made 'nature' a sacred word for the Enlightenment. Since the reason is, it was assumed, identical in all men, anything of which the verifiability or intelligibility is limited to particular periods or conditions must necessarily be without truth or value, at any rate to the man of reason. Similarly, all differences in opinion or taste are mere deviations and imply error. That which is 'according to nature' therefore meant, first of all, that which corresponded to this assumption of uniformity and universality of appeal.

To determine the special meaning placed on 'nature' by artists, antonyms are of greater help than definitions. Nature was opposed to deformity, to any departure from the norm, to affectation ('nothing could she talk of but Dear Nature and nothing abuse but Odious Affectation', wrote Fanny Burney) and hence to a mannered artistic style. We thus find Fuseli writing: 'By *nature* I understand the general and permanent principles of visible objects, not disfigured by accident, or distempered by disease, not modified by fashion or local habits. Nature is a collective idea, and, though its essence exists in each individual of the species, can never in its perfection inhabit a single object.'

'By the ideal,' wrote Mengs, 'I mean that which one sees only with the imagination, and not with the eyes; thus an ideal in painting depends upon selection of the most beautiful things in nature purified of every imperfection.' The artist must rise above the accidental and transient, and to achieve this Mengs recommended a close study not only of nature but also of those works of art in which a selection from nature had already been made. Reynolds was similarly explicit in his advice:

It is from a reiterated experience and a close comparison of the objects of nature, that an artist becomes possessed of the idea of that central form, if I may so express it, from which every deviation is deformity. But the investigation of this form, I grant, is painful, and I know of but one method of shortening the road: this is, by a careful study of the ancient sculptors; who, being indefatigable in the school of nature, have left models of that perfect form behind them, which an artist would prefer as supremely beautiful, who has spent his whole life in that single contemplation.

Thus the apparent dichotomy between Nature and the Ideal was resolved by a naturalistic interpretation of classical art.

In essence, this notion of the idealization of nature in art, by a rational process of selection and combination of its most perfect parts, goes back to antiquity itself – to Socrates (in Xenophon's *Memorabilia*), to Pliny and to Cicero's famous account of how Zeuxis painted Helen by combining the best features of five different models. A somewhat naïve 'Identikit' version of the process was endlessly repeated, and the idealist conception of art recurs in all classical theory from Alberti onwards, most notably in the seventeenth century with Bellori ('The idea, originating in nature, supercedes its origin and becomes the origin of art' [1664]) and in the mid eighteenth century with Batteux and *la belle nature*. But it was given a new and more subtle formulation by Goethe in reply, significantly enough, to the Romantic realists who professed scorn for the antique.

'Classical art is part of nature and, indeed, when it moves us, of natural nature,' wrote Goethe. 'Are we expected not to study this noble nature but only the common?' As Professor Panofsky has pointed out in a penetrating discussion of this passage, Goethe here substitutes for the notion of idealism normally applied to classical art a new concept of naturalism – of a 'noble nature' which differs from 'common nature' not in essence but only by a higher degree of purity and, as it were, of intelligibility. Thus classical art, so far from repudiating nature, becomes itself the highest and 'truest' form of naturalism: for it reveals nature's true intentions by extracting from common nature what *natura naturans* had intended but *natura naturata* had failed to perform. In all this Goethe was, presumably, following Kant's well-known definition of nature as 'the existence of things in so far as it is determined by general laws'.

Goethe's statement is more than just a subtle re-formulation of the classical doctrine of the *beau idéal*. It makes an important

qualification to the concept of the classical style. For, by ennobling 'common nature' classical art attempted to do justice to nature as such and might therefore, Goethe implies, be characterized as 'naturalistic idealism' in contrast to other idealizing styles which make no attempt to do justice to nature at all.

The sharp distinction drawn by Neo-classical artists between the 'copy' and the 'imitation' followed from their idealistic conception of classical art. To copy nature led inevitably to such base products as Dutch *genre* and still-life painting, while to copy the antique resulted in a 'marble style' typical of artists who, according to Fuseli, were content to be the lame transcribers of the dead letter instead of the spirit of the ancients. Imitation, on the other hand, involved the artist's higher faculties, especially his inventive powers. So far from having anything of the 'servility' of the copy, the practice of imitation was, according to Reynolds, 'a perpetual exercise of the mind, a continual invention'. Mengs also was careful to emphasize the distinction between copying and imitating:

But he who effectively studies and observes the productions of great men with the true desire to imitate them, makes himself capable of producing works which resemble them, because he considers the reasons with which they are done . . . and this makes him an imitator without being a plagiarist.

Hence the contempt with which Canova and other Neo-classical sculptors regarded the practice of copying even the greatest of antique statues. It was work beneath the dignity of a creative artist – though many had been compelled by poverty to fabricate them during the eighteenth century to satisfy the demands of wealthy connoisseurs who wished to have, literally to hand, the touchstones of artistic excellence. For similar reasons architects had occasionally erected copies of antique buildings – the replicas of the Choragic monument of Lysicrates, the Arch of Hadrian and Temple of the Winds built by James Stuart at Shugborough in the 1760s or the copy of the Hephaesteum built by Ehrensvärd at Mälby in 1795 – almost invariably in landscaped parks and as illustrations of the history of architecture. But such reproductive buildings were to be distinguished from imitations.

The State Capitol at Richmond, Virginia [47], for example, was inspired by the little Maison Carré at Nîmes; but it was far from being a copy (even the order was changed from Corinthian

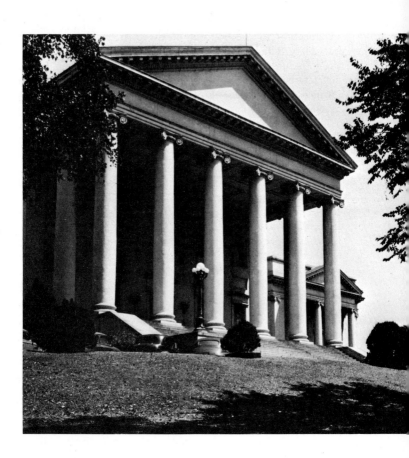

47. The State Capitol, Richmond, Virginia, 1785–96. Thomas Jefferson

48. The Bourse, Leningrad, 1804–16. Thomas de Thomon

to the more chaste Ionic). As Jefferson's assistant Clérisseau had remarked in 1778: 'Let us learn from the ancients how to submit the rules to genius. Let us wipe out that mark of servitude and mimicry which disfigures our works.' Similarly, de Thomon's Bourse in Leningrad is a free essay in temple architecture, not a piece of historical revivalism [48]. The Neoclassical architect wished to design in the spirit of the ancients and was ready to invent new orders for new types of building – as Latrobe designed his tobacco-leaf and corn-cob capitals for the Capitol in Washington [49]. And in the more extreme and absolute forms of Neo-classical architecture, especially the pure spheres, cubes, cylinders and pyramids of Ledoux [67], all traces of servitude to the ancients are erased and the supposed

49. Corn-cob capital in the Capitol, Washington, 1809. B. Latrobe

origin of architecture in nature becomes quite explicit. For these Platonic ideals of architectural form were thought to partake of natural laws. Ledoux repeatedly emphasized his belief in nature as the source of architectural law and his inspiration in the geometric purity of natural phenomena (*'Toutes les formes sont dans la nature . . .'* and *'La forme est pure comme celle qui décrit le soleil dans sa course'*). He would surely have agreed that 'Euclid alone has looked on beauty bare'.

These lofty ideals may seem far above the everyday world of the decorative arts but here too we find a distinction drawn between the imitation and the copy. Designers and craftsmen who abandoned wayward Rococo motifs and responded to demands for greater simplicity, sobriety and solidity by seeking inspiration in Greek and Roman objects, seem to have taken an almost perverse pleasure in transferring motifs from one medium to another. Silversmiths were more ready to take ideas from ancient pottery and marble urns than from Roman silver – a tureen by Boulton [42], for example, combines the forms of the Greek kantharos and kylix with Roman sculptural decoration. Wedgwood derived the form of a soup tureen from an antique marble urn which provided a shape of beautiful simplicity [51]. Cabinet-makers resorted to the architecture rather than the furniture of antiquity [50], and only very rarely were

50. Writing-table, *c.* 1780–90. David Roentgen

51. Wedgwood pottery soup tureen, *c.* 1780

chairs and tables copied after antique prototypes before the last years of the century [52].

For Neo-classical artists the imitation of the antique was not an end in itself but a means of creating ideal works of universal and eternal validity. Wishing to become as inimitable as the

52. Chair designed by N. A. Abildgaard, *c.* 1790

53. *The Origin of Painting*, 1775. David Allan

ancients, they saw themselves not as mere Greek or Roman revivalists but as restorers of the true style. In order to lay bare the truth that lay beneath the surface of nature, they concentrated, like earlier idealists, on form rather than texture, on line rather than colour. Their approach to the Ideal was cerebral, with none of the mystical overtones of Renaissance neo-Platonists, and derived from a belief that art should appeal to the mind as well as the sense perceptions and that artistic problems could be solved by a rational process. Thus, they rejected the notion of 'a grace beyond the reach of art' and artistic criteria based on an individually perceived *je ne sais quoi*, in favour of an ideal that was amenable to intellectual analysis. They seem to have been wary of colouristic and textural effects not only because they were superficial but also because they could be apprehended only through the senses and therefore appeared differently to different people. Illusionistic tricks and atmospheric subtleties were alike to be deplored.

In antique statues Neo-classical artists saw not only 'noble simplicity and calm grandeur' but, to quote Winckelmann again, 'precision of Contour, that characteristic distinction of the ancients'. They were even more strongly attracted to the crisp, unambiguously clear, rudimentary linear paintings on Greek black- and red-figure vases. And they also responded to the linear purity of the Italian primitives (Goethe commented on Flaxman's 'gift of immersing himself in the innocent mood of the earlier Italian schools'). In all such works they found a preference for the conceptual to the merely visual similar to their own.

Outline drawing was thought to have been the earliest means of pictorial representation – and pictures of the invention of painting by a Corinthian potter's daughter who drew her lover's profile by tracing his shadow on the wall, enjoyed great popularity [53]. But in addition to being the 'antique style' *par excellence*, the linear style was thought to be the purest and most natural. Reynolds, echoing Pliny and other classical theorists, declared that 'a firm and determined outline is one of the characteristics of the great style in painting', displaying 'knowledge of the exact form which every part of nature ought to have'. And Blake, who thought that Reynolds had not sufficiently emphasized the superiority of the linear Florentine to the colouristic Venetian school, wrote beside this passage: 'A Noble Sentence! Here is a sentence which overthrows all his Book.' Against another passage in which Reynolds said of

earlier artists 'their simplicity was the offspring not of choice, but of necessity', Blake angrily wrote: 'A Lie.' For him as for Flaxman [54] and Carstens [55], simplicity was not just 'the noblest ornament of truth' but an essential attribute of truth. The moral basis underlying this aesthetic preference was often made quite explicit, as by Schiller in his reported comments on the paintings in the Dresden gallery: 'All very well; if only the cartoons were not filled with colour . . . I cannot get rid of the idea that those colours do not tell me the truth . . . the pure outline would give me a much more faithful image.' And in this Spartan attitude the Neo-classical artist had the support of Kant who stated (*Kritik der Urteilskraft*, 1790) that drawing alone, even unshaded outline, sufficed for the true representation of an object: colour was superfluous. Indeed, colour came to be thought deceptive. It masked the purity of essential forms, just as clothes disguised and disfigured the human body.

2. THE NEO-CLASSICAL NUDE

'The gymnasia and places where completely naked youths wrestled and played other games were schools of beauty', wrote Winckelmann of ancient Greece. 'It was there that artists contemplated the perfect development of physique: the daily sight of the nude warmed their imagination and taught them how to represent the beauty of forms.' The late eighteenth-century

4. (Opposite) Illustration to the *Iliad*, 1793. John Flaxman

5. Illustration to *Les Argonautes*, 1799. A. J. Carstens

artist must have looked back even more nostalgically to the Greek palaestra, for in his time nude models were rare and often most unsatisfactory. The model employed by the Academy in Paris had the rank of a minor civil servant, an apartment in the Louvre and a salary that passed to his widow at his death. Unfortunately there was no retiring age. He may have begun as a lithe young Mercury but, after more than forty years yeoman service, he was good for nothing but Jupiter or Charon. Artists who sought out private models were sometimes faced with unexpected obstacles. The eminently respectable Bouchardon, seeking a model for his *Cupid*, went to watch boys bathing in the Seine and approached the most suitable with an offer – only to have his intentions misconstrued and be summoned by the police. There were no female models in the academies. Prostitutes were, of course, available. But they naturally had little appeal for those who admired the human form only in so far as it revealed the quality of the soul. Thus the Neo-classical artist with his high moral purpose found himself in difficulties – difficulties that artists like Fragonard or Clodion or such frank pornographers as Schall did not encounter.

An adjunct to the life-class was, however, provided by the collection of casts of antique statues which was an essential appurtenance of every academy of art. The functions of the life-class and the antique class were, in fact, complementary. For models were usually posed in the attitudes of antique statues (a drawing by Canova, apparently of the Borghese Gladiator, is inscribed: 'This is Giacomo de Rossi not the gladiator'). The postures of antique statues were thus so indelibly impressed on the young artist's mind that he came to think, as it were, in this classical language. It became a second nature – sometimes with embarrassing results. In Zoffany's *Death of Captain Cook* [56], for example, Cook is placed in the attitude of the dying Gaul in the Capitoline Museum, the figure on the right is derived from the Discobolos in the Townley collection, others from a dying gladiator, a statue of a faun and so on. Zoffany can hardly have wished to ennoble these particular savages: he was just incapable of conceiving nude figures in any other terms.

But antiquity provided the artist with much more than a stock of postures. As we have already seen, antique statues were regarded as an almost infallible guide to the difficult process of selecting from nature to create ideal works of art. Winckelmann, a connoisseur of the nude in life as well as in art, was not alone in observing how ancient sculptors had modified

56. *The Death of Captain Cook* (detail), *c.* 1789–97. J. Zoffany

the proportions of the human body, flattening and diminishing the stomach, for instance, simplifying the muscles and ignoring the veins. He also pointed out how successful they had been in finding the perfect form for every part of the anatomy. Nothing, he said, was more difficult to find in nature than young men with beautiful knees. They were still rarer in modern art (though he would make an exception in favour of the Apollo of Mengs's *Parnassus* [6]). Only in antique statues could one be sure to find perfect knees 'with the joint and articulation lightly indicated in such a way that the knee forms, between the thigh and the shin, a gentle swelling which links the two parts and which is not broken by any cavity or convexity'. One is reminded of such remarks by the annotations which a young English sculptor, John Deare, made on his drawings of antique statues in Rome in the 1780s. On one he wrote:

the muscles swell very much but they run quick or sharp against each other with great attention to contrast such as small nipples and navel, the sides full of small muscles opposed to the large masses of the breast, small knees, long threads of drapery opposed to the mass of the body or limbs.

In rendering the nude, the Neo-classical artist's aim was to be natural, not naturalistic. He wished to cleanse it of the erotic overtones which had made even the unpriggish Diderot complain: 'I have seen enough of bosoms and bottoms . . . these seductive objects contradict the emotions of the soul by exciting the senses.' He stressed the innocence, the unadorned simplicity, the essential purity of the nude. Even so, his purpose was often misrepresented. David shocked many in Directoire Paris by his *Intervention of the Sabine Women* [30] for which he was dubbed the '*Raphael des sans-culottes*'. And a few years later the Jury of the Institut made a revealing comment when refusing to award it a prize: 'Is that which is permissible in sculpture also permissible in painting, where the objects which can wound decency, presented with the forms and in the colours of nature, provide an intolerable degree of truth?' The nude was accepted only at its farthest remove from the naked human body.

No such intolerable degree of truth marks the Neo-classical nude statue. A flatterer once told Canova that he had been deceived into thinking one of his statues was alive. The sculptor acidly replied that he was sorry. He had not, he said, intended to produce wax-works. Disturbingly life-like *trompe l'œil* effects were avoided in sculpture as in painting. The nymph which Pierre Julien carved for the Laiterie at Rambouillet provides an instance of this approach [89]. Whereas a Rococo sculptor would certainly have decorated the grotto with a highly realistic figure, seeking to surprise the visitor by his virtuosity, Julien provided what was unmistakably a marble statue. Similarly, Dannecker's beautifully carved *Sappho* [57], Canova's *Hercules and Lichas* [32] or his *Cupid and Psyche* [45] could not be mistaken for live figures. Representing an ideal vision derived from a study of nature and the antique, these bodies, marred by no accidental blemishes of common nature, are neither naturalistic nor unnatural.

An element of idealism entered into the Neo-classical conception of the nude. As Lessing remarked in the *Laocoön*, 'necessity invented clothing, and what has art to do with necessity? I grant you that there is also a beauty of drapery; but what is it compared with the beauty of the human form?' It was not merely that contemporary clothes were thought to be both ridiculous and unnatural – flesh more beautiful than fabric. In rendering figures nude, Diderot declared, '*on éloigne la scène, on rappelle un âge plus innocent et plus simple, des mœurs plus sauvages, plus analogues aux arts d'imitation*'. The nude represented man

stripped of all deceptive externals, as nature made him; freed from the trammels of time, as if against a background of eternity.

These ideas clearly influenced Diderot and the other members of an illustrious group of men of letters – including Grimm, Marmontel, d'Alembert, Helvétius, Raynal and Morellet – who commissioned Pigalle to carve a statue of the seventy-six-year-old Voltaire in 1770 [58]. For he was to be shown naked save for a wisp of drapery across the loins. If there were no modern precedents for such a rendering, plenty could be found in antiquity. Pliny, in his account of sculpture, had remarked: 'In the old days they used to set up statues of people just wearing a toga. They also liked to set up nude figures holding spears, figures which are modelled on the statues of ephebes in Greek gymnasia and which are called "Achilles". The Greek custom is to cover nothing, whereas the Roman custom is to add a military breast-plate.' This passage which enshrines the tag 'Graeca res nihil velare', would have been familiar to Diderot and his friends. So also would an antique statue of an elderly nude man in the Villa Borghese, Rome, then thought to represent the dying Seneca – a highly naturalistic work which Jonathan Richardson had eulogized as 'Prodigious Expression of a Weak Old Man!' Pigalle therefore rendered Voltaire, not only nude but with the withered shanks and scrawny torso of a septuagenarian (only the head being modelled from Voltaire himself). To modern eyes this powerful image seems to represent the triumph of the spirit over the frailty of the body and to provide a truer portrait of the writer than any of those that depict his wizened features – the sunken eyes and grotesque toothless mouth – above a body swathed in a toga or neatly dressed with jacket and lace jabot. But by contemporaries it was sometimes misunderstood. Reynolds (in 1776) cited it as an example of a sculptor's 'not having that respect for the prejudices of mankind which he ought to have had'.

Pigalle's *Voltaire* was, however, only the first of a long series of nude portrait statues, and the 'contemporary nude' became one of the most characteristic forms invented, or rather reinvented, by Neo-classical artists. It was discussed at length in various essays by Quatremère de Quincy who had been a student in Pigalle's studio when the *Voltaire* was being carved. Surprisingly, he condemned it for being too naturalistic. He would have preferred the body to have been more 'heroic' and recommended the Roman practice of grafting portrait

heads on to the idealized bodies of recognizable types of heroes and divinities – Achilles, Ceres, Ariadne, etc. – '*pour assimiler les hommes célèbres aux personnages divins*'. Such heroic or metaphorical nudity would lift the person portrayed to a higher order of being. As David remarked in the 1790s, the painters, sculptors and poets of antiquity had represented in the nude not only the gods but 'those heroes and other men whom they wished to make illustrious'. And a few years later Canova carved his nude Napoleon – heroic in its scale as well as in its nudity – endowing the Emperor with the flawless body of a Greek god just as the Romans had represented the deified Augustus.

But like so many Neo-classical forms the 'contemporary nude' portrait eventually declined into an academic cliché with such late nineteenth- and early twentieth-century absurdities as Max Klinger's *Beethoven* and Eugenio Baroni's *Garibaldi*, though still inspiring occasional masterpieces such as Rodin's *Balzac* and *Victor Hugo*.

3. IF REASON BE THE ARCHITECT

The Neo-classical preoccupation with universally valid truths, discoverable by the pure light of nature and reason, tended necessarily to push all artistic ideals farther and farther backwards historically in the search for ever purer and more primary forms. But it was only in architecture, the most abstract of the visual arts, that this tendency reached its logical conclusion in a thoroughgoing primitivism of the most extreme and uncompromising kind. Ledoux's ideal architecture of absolute forms – pyramidal, cubical and spherical – was consciously inspired by the geometrical purity of natural phenomena. It was felt to partake of natural laws. And, moreover, it also accorded well with those functionalist theories of beauty widely current in the mid eighteenth century. 'Architecture,' wrote Burke in 1756, 'affects by the laws of nature, and the laws of reason; from which latter result the rules of proportion, which make a work to be praised or censured, in the whole or in some part, when the end for which it was designed is or is not answered.'

Such appeals for a rational architecture, combined with the startling geometric austerity and structural clarity of its more extreme results might seem prophetic of the Bauhaus School, the International Modern style of the 1920s and the dogma that 'form follows function'. Significantly enough it was in the

heyday of Le Corbusier and the Bauhaus that Ledoux and Boullée were rediscovered. Yet to construe their work in twentieth-century terms is to misunderstand it.

The mid eighteenth-century attitude to the architecture of reason was neatly put in *Some thoughts on building and planting* addressed by the Rev. John Dalton to Sir James Lowther of Lowther Hall:

> When stately structures Lowther grace,
> Worthy the owner and the place,
> Fashion will not the works direct,
> But reason be the architect.

Dalton goes on to describe, with footnote acknowledgements to Vitruvius, each of the 'beauteous orders' which stand ready to execute what reason commands and, at the same time, 'fancy's wanton freaks controul'. He then proceeds to a brief eulogy of the informally landscaped park, with woods so 'sweetly wild' that 'Nature mistakes them for her own' and concludes with the apophthegm:

> Who builds or plants, this rule should know
> From truth and use all beauties flow.

To cleanse architecture of the artificialities and wanton freaks of fancy introduced by the Rococo was one of the aims of the first generation of Neo-classical architects. They therefore returned with draughtsmen and measuring rods to the ancient buildings of Rome and to other, sometimes unexplored sites such as Spalato, Palmyra, Baalbeck, Paestum and Agrigentum. The results were published in folios of engravings from which architects could gain fresh evidence on how to correct and purify their style. At first, however, they were used less as a chastening and invigorating source of new architectural forms – noble, lucid, sober and severe – than as a vocabulary for modish decorations *all'antica*, quite as fanciful as any Rococo caprices and even more effete in their self-indulgent nostalgia for a lost and glorious past. But already some architects, such as Soufflot in Paris and Robert Adam in England, where evocative interpretations of Graeco-Roman architecture resulted mainly in hybrid styles of classical allusion grafted on to traditional forms, were beginning to hint at the new and lucid geometric architecture that was to come.

In Sainte Geneviève, Soufflot put into practice Laugier's theory of the natural virtues of post and lintel construction –

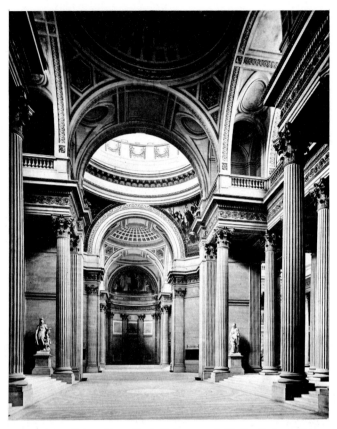

59. Panthéon (Sainte Geneviève), Paris, 1757. J.-G. Soufflot

natural because of its origin in the primitive wooden hut – and supported everything except the central dome on columns carrying straight entablatures [59]. The vaulting above was constructed on Gothic principles for Gothic too could be associated (though not by Laugier) with natural building origins in its resemblance to trees and branches. Thus strict classical regularity and monumental Roman detail were combined, in Soufflot's words, with the 'lightness which one admires in some Gothic buildings'.

No such close dependence on current aesthetic theory is to be found in Adam's work, yet he could be even more austerely and uncompromisingly Roman [60], especially in some of his late

and much misunderstood Scottish castles [61]. In these brutal buildings a new response to the classical past can be sensed, as if he had resolved to eradicate, once and for all, the diminutive elegancies and pretty artificialities of his earlier manner and had gone back to the stark abstemious simplicity and blocky four-square clarity of Roman military architecture, in much the same spirit as did David for the background of his *Intervention of the Sabine Women* [30].

Rome was, however, no more than a half-way house for those who wished to return to the fountain-head of architectural

60. Entrance Hall, Syon House, 1761. Robert Adam

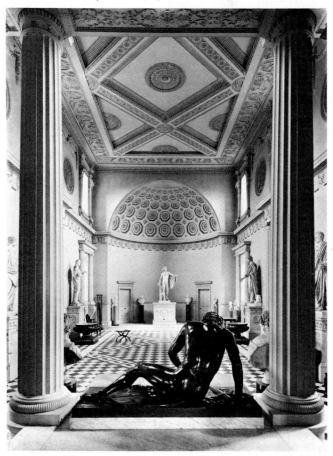

61. Seton Castle, 1789–91. Robert Adam

purity – Greece. Archaeological activity of the mid century made available the first accurate drawings of Doric temples. To many who had paid lip-service to Greek architectural supremacy, they came as a rude surprise. When James Adam visited Paestum in 1761 he found the temples 'of an early, an inelegant and unenriched Doric, that afford no details'. And it is revealing that the first Doric building to be erected in northern Europe was no more than a garden folly – a little temple which joined a Neo-Gothic ruin (recently decked out with 'the true rust of the Barons' wars') in the park at Hagley. William Chambers said that Doric columns looked 'gouty' and 'excited no desire for more'. But he was appalled to note in 1793 that 'the *gusto greco* has again ventured to peep forth, and once more threaten invasion'. The reasons for this are not far to seek.

The Doric order had come to be seen as the product of an uncorrupted people living close to nature, and thus the purest expression of an architectural ideal – the equivalent of Homeric poetry and Greek vase painting. Primitive, masculine, unencumbered by superfluous ornament, and of a crystalline integrity, it could be admired for the very qualities that James Adam had found so uncouth and distasteful. And it is significant that Brongniart and other Parisian architects of the 1780s turned for inspiration not so much to the Parthenon as to the burly, big-boned temples of Paestum whose almost primeval virility was emphasized by the weathering that had stripped them of all enrichments. For the more fundamentally inclined, even this was not savage enough. Ledoux and Weinbrenner [68]

simplified the order still further by removing the fluting. And in Sweden, Karl August Ehrensvärd, in search of the ultimate in primitive architectural masculinity – what he called the 'natural' and 'original' order that had preceded the Doric – invented one of Aeschylean intensity and dramatic power for the entrance to the naval dockyard at Karlskrona [62].

Another approach to the architectural ideal was made through geometry. The essential beauty of the cube, pyramid, cylinder, sphere and cone had led to the quest for architectural principles in pure geometry long before Du Fourny, in 1793, issued the catch-phrase: '*L'architecture doit se régénerer par la géometrie.*' Sir Christopher Wren, mathematician as well as architect, had remarked that 'geometrical figures are naturally more beautiful than any other irregular; in this all consent, as to

62. Model for dockyard gateway, Karlskrona, *c.* 1785. C. A. Ehrensvärd

63. Geometrical solids, 1754. Joshua Kirby

64. (Opposite) Altar of Good Fortune, Weimar, 1777. Designed by Goethe

a law of Nature'. And in the 1730s the English architect and theorist Robert Morris became obsessed with simple cubic forms as a basis for building. But for such men geometry was a means rather than an end in itself. A curious plate in Joshua Kirby's manual of perspective of 1754 shows a number of geometrical solids arranged like ornaments in a garden [63] – not in anticipation of Battersea Park but to suggest how the

draughtsman who had mastered the representation of such pure forms might advance to irregular and more complicated ones. There is a world of difference between this and the Altar of Good Fortune [64] which may at first sight look like a Brancusi but was in fact designed by Goethe in 1777 for his garden at Weimar. Here two visual symbols – the ever-moving sphere of restless desires immobile on the cubic block of virtue – have been stripped of their Renaissance and Baroque allegorical accretions and rendered starkly as pure forms, as Platonic essences placed very suitably in an idealized natural landscape. Goethe, who held all great art and poetry to be an unfathomable symbol – *ein unergründliches Symbol* – represented a complex idea in the simplest possible terms of timeless geometry.

Architects were never to reach such absolute simplicity and purity even on paper, though a few came surprisingly near it. The end blocks of Zakharov's Admiralty in Leningrad, for instance, are almost essays in solid geometry: a fraction of a sphere upon a cylinder, resting on a massive cube broken only by a semicircular arch [65]. Gondouin's anatomy theatre in the École de Médecine in Paris is a half cylinder and quarter sphere, that is to say a half Pantheon [66]. And several other semicircular, half-domed rooms built around the turn of the century as debating chambers were similarly conceived: the Chambre des Deputés in Paris and Latrobe's original Senate Chamber in the Capitol in Washington. But it was, of course, Ledoux who pushed these tendencies to their farthest extreme, extracting from antiquity and nature a new kind of architecture of pure spheres, cubes, cylinders and pyramids which he set in an ideal landscape almost as if they were demonstrations in inorganic chemistry by some divine crystallographer [67].

Architects who were much less fundamentalist than Ledoux were also obsessed by the inorganic nature of geometrical forms and the complete autonomy of their art. It should need, they thought, no help from the painter or sculptor. They seem to have delighted in stressing the contrast between the pure form of the building and the organic roughness of the surrounding landscape as between the clean planar simplicity of the Laiterie at Rambouillet – a combination of sphere and cylinder of almost machine-tooled precision – and the rugged grotto attached to it [88]. A similar effect is achieved in Caspar Wolf's view of a perfect glacial rainbow in an Alpine landscape [40].

The Baroque conception of architectural composition as a

65. The Admiralty, Leningrad, 1806-15. A. D. Zakharov

66. (Opposite) Anatomy theatre, Paris, 1780. J. Gondouin

67. Design for a house, *c.* 1790. C.-N. Ledoux

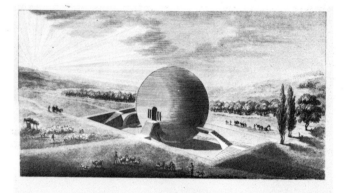

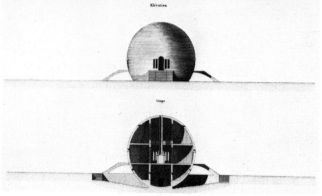

Élévation

Coupe

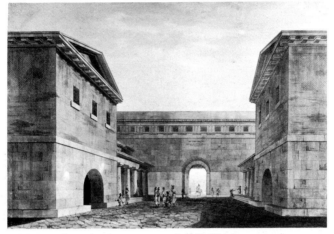

68. Design for a city gateway, 1794. J. J. F. Weinbrenner

process of fusing and interlocking parts so that one would run almost imperceptibly into those adjacent to it – the wings into the *corps de logis*, the main storey into those above and below – was rejected together with the mesh of decoration which had made such an organic unification possible. Neo-classical architects emphasized the stark contrasts between the various masses of a building or group of buildings, as in Weinbrenner's design for a city gate with its frontal opposition and detachment of

69. Design for a theatre in Berlin, 1798. F. Gilly

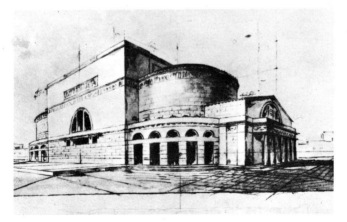

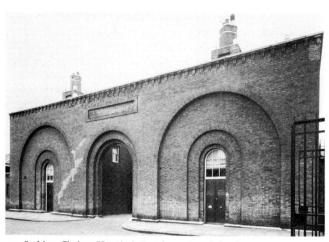

70. Stables, Chelsea Hospital, London, 1814. John Soane

identical forms [68], or in Friedrich Gilly's design for a theatre with its juxtaposition of cube and half cylinders [69]. Contours are unbroken, lines are clear cut, angles are sharp, openings are punched into the walls with no surrounds to soften the impact, and the interior volumes are clearly expressed on the exterior. For openings the simplest shapes, based on the square and the circle, were naturally preferred, and often they are the only elements used to articulate a façade. The east front of Soane's stables at Chelsea, an extreme example, is broken only by round-headed arches, subtly receding in a manner that stresses the solidity of the wall – and, incidentally, reminds one that this austerity was more than utilitarian [70].

The insistence on purity, simplicity and volumetric clarity in architecture corresponds with the painter's preoccupation with outline drawing. Paintings of architecture similarly stress the contrasts between juxtaposed masses, as in Abildgaard's vision of ancient Athens [71] or, indeed, Koch's distant view of a little town in a pastoral landscape [93]. The two ideas are clearly combined in an engraving by Carstens [55] showing a room of crystalline purity in which the columns are reduced to simple cylinders capped with rectangular blocks, subtly but distinctly divided from the wall surface by the recession of the drum and projection of the capital.

The ideas underlying this new conception of architecture had been propounded in Venice in the 1740s and 1750s by the

Abbate Carlo Lodoli whom his admirers called the 'Socrates of architecture' from his urge to question all *idées reçues*. A disciple of Vico and an acquaintance of Montesquieu, he is among the more notable figures of the Enlightenment in Italy. It is interesting to find that he was also among the first collectors of Italian primitives. But as he published no statement of his theories it is more than a little difficult to discover exactly what they were. The account of them diffused by Count Algarotti in 1756 was attacked by a more devoted disciple of Lodoli, Andrea Memmo, thirty years later. It appears that Lodoli wished to exclude from architecture all those parts that were meaningless, unsuitable or implied a structure different from that actually used. 'Ornament is not essential but accessory to proper function and form,' is one of the few comments he committed to paper. 'Proportion, convenience and ornament can take shape only through the application of mathematics and physics guided by rational norms.' But Algarotti, who seems to have been too muddle-headed to grasp the concept of pure architectural form, represented him as little more than an opponent of ornament *per se*. Yet even in Algarotti's presentation, Lodoli's ideas must have come as something of a challenge. It was not, however, until the last years of the century that, through the writings of Memmo and Milizia, they could be widely understood and gain general currency.

When Lodoli began to criticize a design for a church on logical grounds its architect replied: 'If I were to submit some totally new conception, however reasonable, I could be quite sure that the plans of some other architect, imitating for example a façade by Palladio or Vignola, would be chosen instead of mine. And then who would support my family?' The same dilemma was to face fundamentalist architects of a later age. Even in the rational atmosphere of the late eighteenth century purist architectural ideals met with a somewhat chilly reception from private patrons: they might appeal to pure reason but hardly to common sense. It is not so very surprising that the most notable manifestations of Neo-classical architecture are to be found in public buildings which could be given an austerely monumental character – city gateways, hospitals, theatres, stock-exchanges, barracks, prisons and, of course, sepulchral and commemorative monuments. But in a period that was not economically propitious for vast architectural schemes such public commissions were rare. And many of the most interesting projects never got off the drawing board.

71. *Scene from Terence*, 1802. N. A. Abildgaard

72. Design for a library, *c.* 1780–90. É.-L. Boullée

As the possibilities for building decreased, so the architect's imagination expanded, encouraged by the numerous new academies which required students to produce enormous and elaborate prize drawings. The projects which won awards at the French academy in the 1770s and 1780s provide a fascinating record of the Utopian ideals of the time and also a revealing contrast with earlier imaginative schemes in which the architect's fancy had run riot in marble courts and endless colonnades, bevies of statues and thick incrustations of reliefs, sweeping staircases leading to painted and tapestried halls. In Neoclassical designs both decoration and function are dominated by purely architectural form, however impractical from the point of view of the builder and user (the pure sphere beloved of Ledoux is, indeed, an atectonic form which few would wish to inhabit).

Function was suggested by form rather than decoration – but not in any twentieth-century functionalist's sense. A brothel (or, more reconditely, a temple) might be given a phallic-shaped plan, the house of the Surveyors of the River the form of a bridge over a waterfall. A hoop-shaped house was devised for some unfortunate cooper. It was to projects of this type – an increasingly expressive or *parlante* architecture as he called it – that Ledoux returned when deprived by the Revolution of both public and private commissions. Boullée who had always been more active as a teacher of theory than as a practising architect, engaged himself in designs still more fantastic and megalomaniac – a spherical cenotaph to Newton [34], a vast library conceived as a monument to learning rather than a repository for books [72], and a monument to nothing in particular in the form of a truncated cone some 700 feet high. This is the architecture of reason only in the sense implied by Wordsworth's definition of:

> Imagination, which in truth,
> Is but another name for absolute power
> And clearest insight, amplitude of mind,
> And reason in her most exalted mood.

5
Sensibility and the Sublime

David, describing the Republican army going out to fight, told the Convention: 'I have seen you shed tears, magnanimous people! Don't stop: they do honour to your courage. Achilles wept also. The Romans wept. . . .' But no one had ever wept quite as persistently or profusely as the late eighteenth-century man of feeling. A readiness to weep was the mark of true sensibility. An ability to call forth the 'sympathetic tear' indicated high artistic merit. Boswell's only criticism of Johnson's writing was a suggestion that *Irene* did not make the reader cry. And if few works of literature or art were deliberately submitted to a trial by tears, there can be no doubt that sentiment played an unprecedented and increasingly large part in eighteenth-century criticism. Nearly all the 'best sellers' of the period paid tribute to the cult – *A Sentimental Journey*, *The Man of Feeling*, *Clarissa*, the poems of Ossian, Gessner's Idylls, *The Sufferings of Young Werther*, *Paul et Virginie*, even *Les Liaisons Dangereuses*. And not only fiction. It was with an appeal to sentiment that Rousseau began his *Contrat Social*. Sentiment proved a more effective weapon than reason to attack slavery and social injustice or, in the hands of Burke, the principles of the French Revolution.

The cult of sensibility might seem incompatible with the rational ideals of Neo-classicism. But this is not so. The power of a work of art to touch the heart as well as to instruct and be morally improving was easily accepted by those who agreed with Lessing that 'the most compassionate man is the best man . . . and he who makes us compassionate makes us better and more virtuous'. (While David was painting his *Death of Socrates* he would break off every now and again to read a few pages of Richardson's *Clarissa*, the greatest eighteenth-century work of moral sensibility.) And as it was also supposed that the 'language of the heart' was at all times and in all countries the same, the work of art that appealed to sensibility naturally acquired universal validity. Speaking of the painter's choice of

subject, Reynolds declared that none 'can be proper that is not generally interesting. It ought to be either some instance of heroick action or heroick suffering. There must be something either in the action, or in the object, in which men are universally concerned and which powerfully strikes upon the publick sympathy.'

Such themes were not, of course, to be found in the bizarre loves and metamorphoses of Greek and Roman gods. As Grimm remarked in 1755, pagan mythology was of service to the painter in furnishing voluptuous subjects – 'but what a tiny advantage compared with that of depicting the pathetic!' Sceptic though he was, he thought Christian history might be a better source, though it was from Homer alone that Diderot derived his list of suitable subjects for painters which was appended to Grimm's essay. Homer had not only paid more attention to men than to gods but also described human emotions in their most primitive, that is to say, purest and simplest form. Ancient history as interpreted by Livy and Plutarch provided further, and still more explicitly moralizing subjects for the pencil of sensibility; nor were the poems of Ossian, the plays of Shakespeare and even medieval and later history neglected whenever they could provide appropriate subjects illustrating, especially, the uncorrupted manners and emotions of those living close to nature.

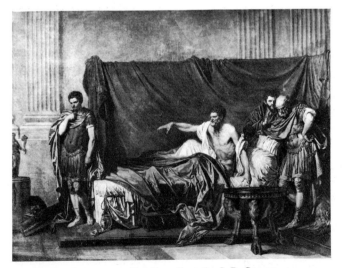

73. *Septimus Severus reproaching Caracalla*, 1769. J.-B. Greuze

From whatever period in history the subject was derived it was treated stylistically in much the same manner. Greuze's *Septimus Severus* on his death-bed accusing his son Caracalla of wishing to assassinate him [73] and his *Mauvais Fils Puni* [74] are rendered in a strikingly similar way and differ only in costume and setting. In both works he sought to appeal to morality by way of sentiment. And in both the general theme is of more importance than the particular subject. Sometimes, indeed, the tendency to generalize and universalize makes it difficult for us now to identify the historical subject depicted. John Deare's relief of a woman sucking a poisoned wound in a man's arm [75] might at first sight be supposed to illustrate some antique exemplar of conjugal selflessness, but in fact represents King Edward I and Queen Eleanor at the Siege of Acre. An anecdote from medieval history has here been given general significance as the illustration of a story both touching and morally improving.

In this moral and sentimental mood artists revised their attitude to subjects which had often been painted before. As we have already seen, David converted the legend of the aged Belisarius into a theme of profounder and wider meaning. Greuze, in his *Drunkard's Return* [33] rendered a subject (hitherto the province of the comic genre painter) with a combined appeal to morals and sentiment – 'a comedy to those who

74. *The Wicked Son Punished*, 1778. J.-B. Greuze

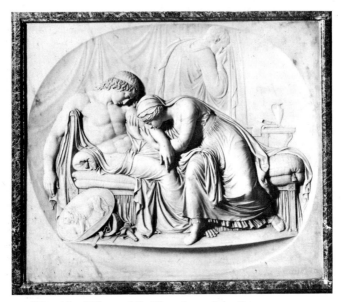

75. *Edward I and Eleanor of Castille*, 1789–95. John Deare

think, a tragedy to those who feel' – that seems to anticipate the Band of Hope preacher. But perhaps the most remarkable transformation is that of the Roman Charity. This subject had been treated by innumerable Baroque and Rococo painters, sometimes as an allegory of youth and age, often with lascivious overtones, generally as an exercise in painterly ability. But Gottlieb Schick painted it simply and starkly as an example of filial piety [76].

These works share that moral tone and sentimental appeal which had found expression in Diderot's *drame bourgeois*. They attempt to inject a dose of *vérité commune* into the inflated rhetoric of history painting in the same way that Diderot, in M. Seznec's phrase, tried to 'stuff the empty nobility of classical tragedy with the substantial simplicity of everyday life'. And it was, indeed, Diderot who demanded of painters in 1765: 'Move me, astonish me, break my heart, let me tremble, weep, stare, be enraged – you will delight my eyes afterwards, if you can.' David similarly insisted that a painting ought to 'make the soul of the spectator vibrate', characteristically identifying the soul with the reason. In 1793 he wrote:

It is not only in charming the eyes that great works of art have attained their aim, it is in penetrating the soul, it is in making on the spirit a profound impression akin to reality. The artist must therefore have studied all the springs of the human heart. He must in a word be a philosopher. Socrates, able sculptor, Jean-Jacques, a good musician, the immortal Poussin tracing on the canvas the sublime lessons of philosophy, are witnesses who prove that the genius of the arts can have no guide other than the torch of reason.

This concern with the affective qualities of works of art – as notable in Winckelmann's descriptions of ancient statues as in Diderot's of paintings by Greuze – underlies the numerous discussions of the most confused and confusing aesthetic notion of the time: the sublime. For sublimity was found less in objects themselves than in the emotions they induced. It was a subjective quality, unlike beauty which was absolute. The word 'sublime', itself, which had originally been used to describe an oratorical style, was applied by 'Longinus' to other types of literature (notably Homer), revived by the arch-classicist Boileau in the late seventeenth century and transferred to the visual arts and natural phenomena in the eighteenth. It generally signified an emotion of awe, bordering on terror, inspired by natural phenomena. But it was also applied to works of art expressive of a super-human grandeur which could not be accounted for by the normal critical criteria – though with emphasis, it must

76. *Roman Charity, c.* 1800. G. Schick

be noted, on the noble and lofty rather than the turbulent and supernatural. The vast literature on the subject sprang from a typically Neo-classical desire to derive rules from what was above the rules – to define the indefinable.

The concept of the sublime was also closely linked with that of genius. The *Encyclopédie* article on *'génie'*, written largely by Diderot, states:

For something to be beautiful according to the rules of taste, it must be elegant, finished, studied without showing it: to be of genius it must sometimes be careless and have an irregular, rugged, savage air. Sublimity and genius flash in Shakespeare like streaks of lightning in a long night, and Racine is always beautiful; Homer is full of genius and Virgil of elegance . . .

Admiration for sublimity and genius did not, however, imply – as was to be the case in the Romantic period – hostility to the rules of art. For it was commonly understood that the rules formed a solid foundation above which genius might soar, but beneath which incompetence could only flounder. And it is significant that the debate on sublimity ceased in the early nineteenth century with C. D. Friedrich's pronouncement that 'the artist's will is law'. Similarly the cult of sensibility was balanced by a stoical respect for the virtue of self-control. In the highly civilized atmosphere of late eighteenth-century Europe, tippling might be permitted as a pleasure but emotional alcoholism was prohibited.

2. THE NEO-CLASSICAL WAY OF DEATH

In death, every man meets the sublime, however urbane or sequestered the tenor of his way may hitherto have been. A death-bed scene could hardly fail to draw the word 'sublime' from a favourable critic in the late eighteenth century – Diderot found Greuze's *Malédiction paternelle* '*beau, très beau, sublime*', and Grimm thought David's *Andromache mourning Hector* '*la scène le plus attachant, le plus sublime, le plus pathétique*'. Seldom had death proved such a popular literary subject. One thinks of the deaths of Clarissa Harlowe, Julie, Werther, la Présidente de Tourvel, Virginie – not to mention Young's *Night Thoughts* (1742–5), Blair's *The Grave* (1743) and Hervey's *Meditations among the Tombs* (1746). In painting there are deaths of Hector, Socrates, Miltiades, the sister of the Horatii, the sons of Brutus, Virginia, Septimus Severus, the Chevalier Bayard, General Wolfe, Lord Chatham, Marat and many others. Death is an

image which finds a mirror in every mind: the death scene abounds in 'sentiments to which every bosom returns an echo'. And the artist in search of a universal theme, either heroic or elegiac, could find it in the nobility and tranquillity of the expiring hero.

Many earlier artists had, of course, been 'much possessed by death', ever aware of the 'skull beneath the skin'. But the Neo-classical artist's treatment of the death scene differed in several respects from that of his predecessors. First, and most obviously, the sexual overtones are removed. The *Rape of Lucretia* so popular in the sixteenth and seventeenth centuries, gives way to the *Death of Lucretia* with Brutus and Collatinus vowing vengeance [77]. But that is not all. The figure of the dead man or woman is represented peacefully at rest without any of those hints of orgasmic exhaustion which Baroque painters had so deftly introduced. (Conversely the Neo-classical love scene often suggests the love–death synthesis, as in Canova's rendering of Psyche swooning in the arms of a Cupid who is barely distinguishable from the Genius of Death [45].)

'Death, my son, is a blessing for all men,' says the narrator in *Paul et Virginie*. 'It is the night of this unquiet day called life. In the sleep of death the sicknesses, the sorrows, the chagrin, the

77. *Brutus swearing to avenge Lucretia's death, c.* 1763. Gavin Hamilton

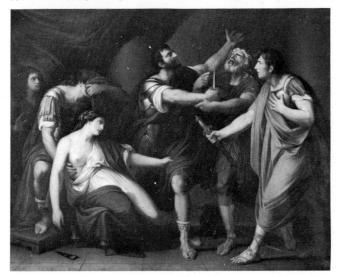

beliefs which never cease to disturb unhappy living men, repose
for ever.' Many years earlier Winckelmann had described an
antique gravestone carved with figures of Death and his brother
Sleep as two beautiful youths with reversed torches. Before
long this appealing image had begun to drive the rattling
skeletons and rotting cadavers from tombs and churches. 'I do
not see what should prevent our artists from abandoning the
hideous skeleton and again availing themselves of a better
image,' wrote Lessing. 'Scripture itself speaks of an angel of
death: and what artist ought not rather to aim at portraying an
angel than a skeleton?' And Goethe recorded how he was

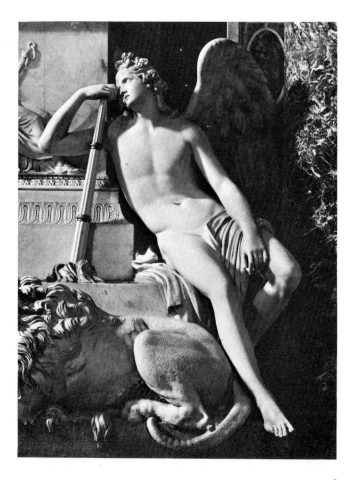

'delighted by the beauty of the thought that the Ancients acknowledged death as the brother of sleep and formed both of them alike to the point of confusing them, as is proper with twin brothers. In this theme we could now really celebrate the triumph of beauty in lofty terms.'

Similarly Schiller, in *The Gods of Greece,* recorded that in antiquity,

> . . . no ugly skeleton came
> To the bed of the dying. A kiss
> Drew the last breath of life from his lips;
> A Genius lowered his torch . . .

78. (Opposite) *Genius of Death,* 1787–92. Antonio Canova

79. *Endymion,* 1793. A.-L. Girodet

Though on another occasion he was bound to confess that,

> *Lieblich sieht er zwar aus mit seiner erloschenen Fackel;*
> *Aber, ihr Herren, der Tod ist so ästhetisch doch nicht.*

(He looks charming with his extinguished torch;
but, gentlemen, death is not really so aesthetic).

The idea appealed to Christians as much as to sceptics. The Protestant Herder welcomed the notion that 'our last friend is no horrifying spectre, but an ender of life, the lovely youth who puts out the torch and imposes calm on the billowing sea'. Roman Catholics were equally susceptible and the most notable representation of this figure is to be found in the very centre of the Catholic world – on Canova's monument to Clement XIII in St Peter's [78]. This languorous youth with drowsy limbs and caressing gaze, an image of transient adolescent beauty that must itself perish, and of the tranquillity of sleep and death, is one of the most perfect realizations of Winckelmann's artistic ideal. Contrasting strangely with the turbulent shrouded skeletons of Bernini's and other Baroque monuments, Canova's Genius expresses a longing for the perfect peace of eternity and the ultimate certainties and for an everlastingly valid artistic form. For the synthesis of beauty and death lies at the heart of the classical tradition which has found so many of its finest expressions in the elegiac mood. One is reminded of the legend of Endymion, most beautiful of mortal youths, sent into an eternal sleep on Mount Ida by the moon goddess, Selene. And it is perhaps more than a coincidence that Girodet's painting of Endymion [79] seems to owe so much to Canova's Genius of Death.

But painters generally contrasted the calm of death with the restlessness of life. In the several renderings of the *Death of Socrates*, a popular death-bed scene of the time, the calm fortitude of the philosopher drinking poison is emphasized by the agonized grief and despair of his disciples. Similarly, in David's *Andromache mourning Hector* [80] the perfect tranquillity of the dead hero is stressed and made more poignant by the grief of his wife and the bewildered anxiety of the child. The same effect could be obtained more strikingly in battle scenes which show the hero attaining immortal rest while the ignorant armies clash round him.

In his *Death of Wolfe* of 1770 [81], Benjamin West depicted the hero of Quebec expiring at the moment of his triumph and

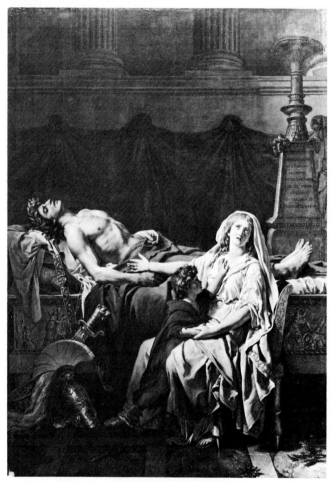

thus attaining immortality in a double sense. Such a death pro-
vided a 'classic' theme of universal validity. Somewhat to the
surprise of conservative critics, West rendered it not as an
allegory but with the same attention to truth in details of land-
scape and costume as he would have given – and was, indeed,
soon to give – to the deaths of Epaminondas or Bayard. As
much, and no more – for he placed the scene in the open air, not
in a tent, and included a Red Indian and other figures who were
not in fact present at Wolfe's death. But all the figures were

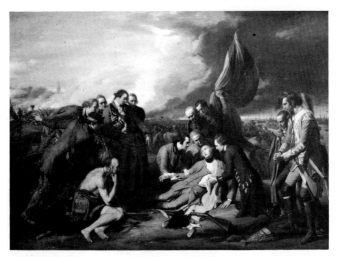

81. *The Death of Wolfe*, 1770. Benjamin West

ennobled with eloquent postures, Wolfe himself being derived from a Deposition of Christ. The picture is at once a secular commemorative icon and a moral exemplar.

The *Death of Wolfe* also illustrates the a-Christian rather than anti-Christian element in the new attitude to immortality. It makes no more explicit reference to Christian doctrine than other Neo-classical death scenes or, indeed, Gray's *Elegy*, that most enduring monument to eighteenth-century attitudes to death, which Wolfe is said to have recited on the eve of his last battle. In Gray's poem the dogmas of the Church appear only as the 'pious texts' which 'teach the rustic moralist to die'.

> For who to dumb Forgetfulness a Prey,
> This pleasing anxious Being e'er resigned,
> Left the warm Precints of the chearful Day,
> Nor cast one longing ling'ring Look behind?
>
> On some fond Breast the parting Soul relies,
> Some pious Drops the closing Eye requires;
> Ev'n from the tomb the Voice of Nature cries,
> Ev'n in our Ashes live their wonted Fires.

Even the orthodox Dr Johnson found these deistic lines the most notable in the whole poem. Under the impact of the Enlightenment the concept of eternal life in another world was giving way to one of immortality on earth: the Christian day of

doom was beginning to seem less real than what Macaulay was later to call judgement at the 'bar of history'. This process of secularization is complete in Diderot's prayer:

O posterity, holy and sacred! Stay of the unhappy and the oppressed, thou who art just, thou who art incorruptible, who avengest the good man, who unmasketh the tyrant, may thy sure faith, thy consoling faith, never, never abandon me! Posterity is for the philosopher what the other world is for the devout.

Thus we find in Neo-classical death scenes and sepulchral monuments, the emphasis being shifted from the problematical joys of the blessed in paradise to the more tangible love, admiration and grief of the survivors on earth. The hero takes the place of the saint in the iconography of death. One might almost suggest that in the *Death of Wolfe* the messenger crying 'They run, I protest they run' has the function of an angel bearing a crown of martyrdom to a Baroque saint. The other figures are representatives of those in whose memory Wolfe will continue to live. And through them the story of Wolfe's heroic death will be transmitted to posterity.

The figures surrounding the dead or dying have a double function. Sometimes they occupy the central place. In Peyron's *Kimon* [82], the emphasis is not on the dead Miltiades but on the son who has surrendered himself to prison so that his father's

82. *Kimon, son of Miltiades*, 1782. J.-F.-P. Peyron

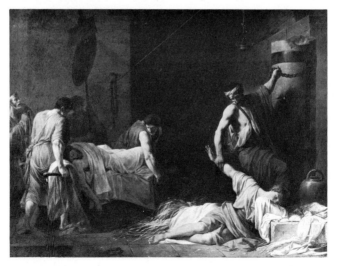

83. *The Dead Marat*, 1793. J.-L. David

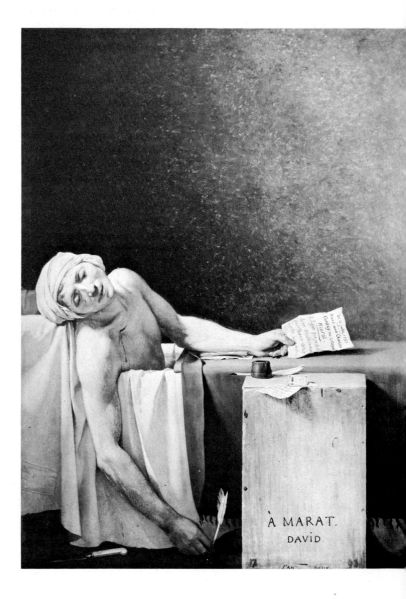

body may be given proper burial. It is his noble fortitude and filial piety that is extolled – as an example for the living. In David's *Brutus* [27] the emotional drama is concentrated exclusively on the reactions of the father, mother and sisters: only one of the dead youths appears in the picture. David made his intentions plain in a letter of 1789: 'I am painting a picture wholly by my invention. It is Brutus, man and father, who is deprived of his children, sitting in the hall whence his two sons are being brought for burial. He is at the feet of the statue of Rome, distracted from his grief by the cries of his wife, the fear and fainting of his eldest daughter.' The conflict of emotions and stoic strength of will – echoing his earlier conflict between paternal affection and patriotic duty – is expressed in every muscle of Brutus's body from the agonized face to the tensely twisted feet.

It was with different motives in mind that David painted his greatest picture, the *Dead Marat* [83]. Here there are no subsidiary figures to set the scene or point the moral. The bare fact of death dominates the work. As the bold inscription on the tombstone-like packing case reveals – *À Marat David l'an deux* – this is a tribute to the man whom David regarded as a revolutionary martyr. It is not, like earlier death scenes, an exhortation to face death bravely but an image to provoke meditations – a secular *Pietà*. And the reverential silence it compels is already suggested by the blank upper section of the canvas. But, of course, no allusion to Christ was intended – another Jacobin said that to compare Marat with Christ was to slander Marat! The nudity of the figure recalls, rather, the statues of classical heroes and dying philosophers, especially Socrates and Seneca (who had committed suicide in his bath). 'Plato, Aristotle, Socrates,' David exclaimed, 'I have never lived with you, but I have known Marat and admired him as I do you.'

David included the minimum of detail necessary to re-create the historical moment: Charlotte Corday's self-condemnatory letter, the knife that was the instrument of Marat's martyrdom and, as emblems of his vocation, the inkwells and quills – '*sa plume*', as David declaimed in a speech of 24 Brumaire, '*la terreur des traitres, sa plume échappe de ses mains! O désespoir! Notre infatigable ami est mort*'. By the use of such details, with the packing case and patched sheets, he not only provided the essential information about the simplicity of Marat's life and the cruelty of his death but also rendered him as a saint of the new religion of rationalism. Depicting the absolute solitude and stark finality

of death, he hints at no possibility of immortality in another world. The rigid horizontality of the composition, broken by the downward accent of the right arm, removes any suggestion of apotheosis in the heavens. This overpoweringly grave and noble image has, as David intended, immortalized Marat. It is familiar to thousands who know little about him apart from his murder. The painting is thus both an example of the Enlightenment's view of immortality and a demonstration of its truth.

These paintings are all secular. But sepulchral monuments erected in churches in the late eighteenth century also reflect new attitudes to death and immortality. Christian symbols were given little prominence and often omitted altogether. The complicated allegories beloved of Baroque sculptors were eschewed. Milizia, who believed that 'the life of the dead is in the memory of the living', said that a monument should 'demonstrate in its simplicity the character of the person commemorated and bear no symbols that are not immediately intelligible'. And, as we have seen, he was among the most enthusiastic admirers of Canova's first Papal monument [10].

Canova's ideal of the monument was not, however, fully realized until he executed that to Maria Christina, Duchess of Saxe-Teschen, erected in the Augustiner-Kirche, Vienna, in 1805 [84]. The design is as simple and the symbols are as readily intelligible as Milizia could have wished. A group of clearly articulated figures are ranged in front of a pyramid and, by a master-stroke of technical virtuosity, given the appearance of moving through its door. The horizontal arrangement of these figures emphasizes the gravity-bound nature, rather than the upward thrust, of the pyramid – itself the most ancient form of sepulchral monument. Above the door of the pyramid a figure of Happiness holds a portrait of Maria Christina framed by a snake eating its tail – an archaic emblem of immortality. To the right a Genius of Mourning, similar to a Genius of Death, rests against the lion of Fortitude. On the other side Piety is shown carrying the urn of ashes into the tomb chamber, followed by a group of figures representing Beneficence.

Yet, like all images that are the result of profound searching, this monument has multiple layers of meaning and implication. It might alternatively be read as the representation of an ancient funeral ceremony with the mourners following the ashes of the dead to the tomb – an illustration of the great Roman virtue Pietas. And the figures on the left are subtly distinguished from the Genius of Mourning who seems to belong to another

. Maria Christina monument, 1799–1805. Antonio Canova

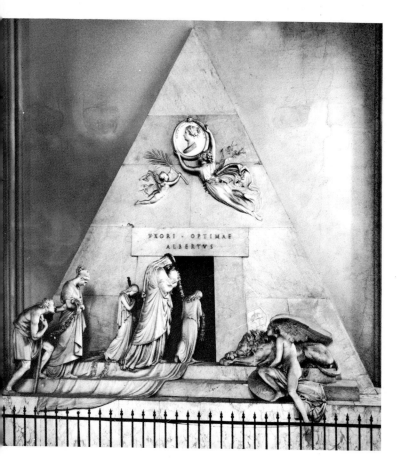

element. But there is a third and deeper level of meaning. The group on the far left, consisting of a child, a young woman and an old man, represents the three ages of man, all paying homage to the dead and all slowly moving towards the tomb, towards the open door which poses the eternal and unresolved question of what may lie beyond.

Unlike most memorials, this great monument is composed neither as an obituary nor as an epitaph, but as an elegy. Like *Lycidas* or *Adonais* it begins as a threnody for a particular death; by classical allusion this is given a timeless quality and elevated into an emotionally touching yet stoical lament for the mortality of all humanity.

Where the Maria Christina monument reminds one of an elegy, Canova's smaller monuments recall the tersely poignant epigrams on death in the Greek Anthology. They are, indeed, inspired by the *stele* which lined the roads leading out of Greek cities. Significantly, he chose this type for the memorials he

85. Giovanni Volpato monument, 1807–8. Antonio Canova

ANNO · DOMINI · MDCCCVII

raised at his own expense to two close personal friends [85]. A low relief shows a mourning woman seated by the garlanded bust of the dead man, with his name and a brief inscription on the plinth. That is all. The importance of the subject is to be inferred from the fact of the monument itself, the nobility of his character from his portrait and not from any allegorical device or 'lapidary scrawl'. Emotional emphasis is placed solely on the grief of the survivor, the most eloquent of all tributes to the dead. In the presence of such works one recalls Ugo Foscolo's greatest poem, *Dei Sepolcri* (1807) with its central message in the lines:

> *Ahi! su gli estinti*
> *non sorge fiore, ove non sia d'umane*
> *lodi onorato e d'amoroso pianto . . .*
>
> 'Alas, no flowers grow by the dead
> save where they are honoured
> by human praise and loving tears.'

3. THE NEO-CLASSICAL LANDSCAPE

A commemorative portrait of Mme Lucien Bonaparte, painted by A.-J. Gros shortly after her early death in 1800 [86], shows her in the full flower of her youth and beauty, standing by a cascade with her eyes fixed wistfully on a rose which is being carried away on the rushing water as if by the inexorable stream of life. Though rank and overgrown, the shady dell in which she stands seems to be not a piece of wild country but part of a late eighteenth-century landscape garden where nature has been improved and idealized by art. It reminds one of the 'melancholy walk' in the *jardin anglais* at Beloeil, laid out by the Prince de Ligne so that 'those with sad thoughts will be able to give themselves up to the little miseries which often afford pleasure, and to which one must yield without a struggle'. In such a corner of a late eighteenth-century park one would expect to find, just where Mme Lucien stands, a column or perhaps an urn inscribed to the memory of some sentimental friendship. For the landscape park represented a vision not only of purified nature but also of the elegiac classical scene. It might well be called the garden of sensibility.

It is often said that the landscape gardens laid out in England in the eighteenth century were attempts to realize with trees and lawns and lakes the ideal landscapes of Claude and Poussin. But this is a misleading over-simplification. They are, rather,

86. *Mme Lucien Bonaparte, c.* 1800. A.-J. Gros

attempts to recreate the literary landscape which had been sketched by Homer, elaborated and populated with love-sick shepherds by Theocritus and the other bucolic poets, and given classic expression by Virgil who transferred it from Sicily to the more remote Arcadia and Vale of Tempe. Later European poets – notably Dante, Ariosto, Tasso, Shakespeare and Milton – evoked the same scenes in their descriptions of glades which consciously recall Virgil's numinous awe-inspiring forest of the Golden Bough, and of idyllically pleasant fertile plains, with streams rippling through meadows among clumps of mixed trees, surrounded by a wild wood of conifers (Dante's *'selva selvaggia ed aspra e forte'*) – the Vale of Tempe. Claude captured this ideal on canvas in the seventeenth century and the English landscape gardeners who transformed their parks into Arcadian elysiums shared his aims rather than copied his paintings.

At Stourhead, for example, Henry Hoare assembled nearly all the elements of the Virgilian landscape, including a grotto inscribed with the forbidding words, *'Procul, o procul este profani'*, which the priestess in the cave of Avernus addressed to Aeneas. With its groves of mixed trees, its running brooks and temples reflected in still waters, this park is the realization of an ideal that is poetical and literary rather than pictorial [87]. It enforces the truth of Archibald Alison's contention, in his *Essays on the Nature and Principles of Taste* (1790), that the

87. The Park at Stourhead, 1743–4

appreciation of landscape was initially derived from the study of Greek and Latin poets:

How different, from this period, become the sentiments with which the scenery of nature is contemplated, by those who have any imagination! The beautiful forms of ancient mythology, with which the fancy of poets peopled every element, are now ready to appear to their minds, upon the prospect of every scene.

The classical landscape of the park, like the paintings of Claude sent 'the imagination back to antiquity' – to the uncorrupted world of piping goatherds and melancholy poets living in the bosom of nature. It was to recreate a portion of this world that the Neo-classical dairy was built for Marie Antoinette in the *jardin anglais* of the Château de Rambouillet in 1785. For this was not merely a place where the Queen and her courtiers could savour the charms of a simple life, churning milk and patting butter as they played at being dairymaids. It was designed as an Arcadian dairy rich in the sentimental overtones of bucolic poetry. The door in the severely simple rusticated façade opens into a domed circular room of exquisitely smooth, cool geometrical perfection – an expression of architectural purity to match the archaic simplicity of Arcadian life [88]. Leading out of this is a room with a coffered vault apparently built against a sublime tumble of vast natural rocks

89. Grotto in Queen's Dairy, Château de Rambouillet, 1785–6

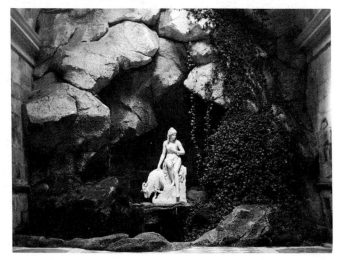

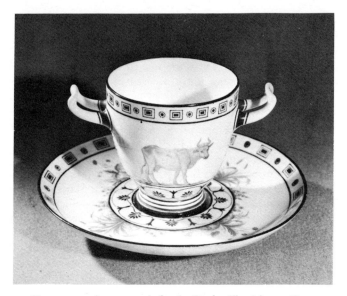

90. Sèvres cup and saucer made for the Rambouillet dairy, 1788

enclosing a grotto with a statue of the nymph Amalthea – the shrine of the nymphs who were protectors of Arcadian shepherds [89]. It presents, of course, a highly sophisticated vision of pastoral simplicity. What could be more chicly primitive than the Grecian-shaped porcelain cups which take the place of Thyrsis's oaken stoup? [90].

Such buildings were admired both for their own sakes and for the emotions they aroused in the heart of the spectator. They were full of literary and historical echoes and reverberations, revealing the past within the past. A Roman ruin (even if artificial) both recalled the glory of Rome and provoked meditations on the fall of Empires, just as a medieval one brought to mind, in Alison's words, 'the awful forms of gothic superstition', and its dilapidated state might thus appear pleasantly symbolic. Landscape paintings could evoke a similar range of emotions. Joseph Wright's moonlight view of Virgil's ruined tomb [91] includes the figure of Silius Italicus, a first-century admirer of Virgil who bought the land on which the tomb stood. It thus provides a comment both on the transience of human glory and on immortality achieved in the memory of posterity.

The aims of the painter who depicted the classical landscape

91. *Virgil's Tomb*, 1779. Joseph Wright

92. *The Vale of Narni*, 1770–71. Richard Wilson

93. (Opposite) *Ideal Landscape*, 1805. J. A. Koch

are perhaps best summed up in the comments of the poet-painter Salomon Gessner on Nicolas Poussin, Gaspard Poussin and Claude:

It was in their works that I found the truly great and beautiful: not a servile imitation of nature, but a selection of all the most beautiful objects she affords. A poetic genius, united in the Poussins, all that is great and noble. They carry us back to those times, for which history and especially poetry, fill us with veneration. They transport us into those countries where nature is not wild but luxuriant; and where under the happiest climate, every plant acquires its utmost perfection. Grace and tranquillity reign throughout all the scenes which the magic pencil of Claude has created. . . . His plains are luxuriant without confusion and variegated without disorder: every object soothes us with the idea of repose and tranquillity. The scene of his landscapes is placed amid a delightful soil, which lavishes on its inhabitants its bounteous and spontaneous gifts; under a sky ever bright and serene, beneath whose mild influence all things bloom and flourish.

To the landscape painter these seventeenth-century artists stood very much as did antique sculptors to the figure painter – as guides for the attainment of the ideal. Richard Wilson, so one of his pupils records, 'finding the light and airy manner of Zuccarelli pleased the world, changed his style, but, disgusted with what he considered as frivolity, he soon returned to his old pursuit formed in the school of Rome'. As the drawings reveal, his generalized and idealized visions of nature were based on a minute study of natural forms, and Cézanne's remark about wanting 'to do Poussin again, from Nature' might well be applied to Wilson's attitude to Claude. Some contemporaries thought that he had surpassed Claude. 'The Frenchman often fatigues by the detail,' one wrote; 'he enters too far into the minutiae of nature; he painted her little-nesses. Wilson, on the contrary, gives a breadth to nature, and adopts those features that more eminently attract attention.' Though the comparison now seems absurd, it helps to illuminate Wilson's aims. He wished not so much to depict the beauties or the elements of nature, still less to record the appearance of a particular landscape, but to induce an elevated mood by evoking the elegiac tone of classical poetry [92]. Similarly, if with a rather heavier hand, Joseph Anton Koch sought to capture both the beauty of the ideal landscape and the simplicity of Arcadian pastoral life [93].

94. *Easter Island, c.* 1774. William Hodges

For less subtle and original artists, of course, the Claudean landscape provided little more than a handy formula for painting ideal views. William Hodges adhered to the pattern so carefully that one might almost suppose his view of Easter Island [94] to be an Aegean scene and mistake the primitive, primeval Oceanic monoliths for the columns of an ancient temple. Yet the effect was not entirely inappropriate. Contemporary literary descriptions of the South Seas were often coloured by allusions to the Fortunate Isles of the classical poets and their inhabitants were identified with the noble savages of antiquity.

95. *Cupid and Psyche*, 1798. François-Pascal Gérard

6
Epilogue

The Jacobins adopted Neo-classicism as their official artistic style and the cult of antiquity almost as a religion. The stoic virtues of Republican Rome were upheld as standards not merely for the arts but also for political behaviour and private morality. *Conventionels* saw themselves as antique heroes. Children were named after Brutus, Solon and Lycurgus. The festivals of the Revolution were staged by David as antique rituals. Even the chairs in which the committee of *Salut publique* sat were made on antique models devised by David. Antiquity was to be no less frequently evoked under the Empire – in architecture, painting, sculpture, interior decoration, costume and pageantry. In fact Neo-classicism became fashionable. David was made Napoleon's *premier peintre* and Canova the darling of the whole Imperial family. Yet so far from being, as is sometimes supposed, the culmination of the Neo-classical movement, the Empire marks its rapid decline and transformation back once more into a mere antique revival, drained of all the high-minded ideas and force of conviction that had inspired its masterpieces. It became a purely decorative style comparable with the *goût grec* of fifty years earlier though now evocative of Imperial luxury and grandeur. The revivalist shell was retained and the Neo-classical kernel thrown away.

By the later 1790s the debilitating effects of inbreeding which almost inevitably follows on the official establishment of an artistic style, had already begun to manifest themselves. François Gérard's *Cupid and Psyche* of 1798 [95], for example, is a variation on two themes by Canova. But whereas Canova's statues were the result of a passionate quest for ideal forms in which to express almost abstract concepts – in this case the innocent purity of young love – Gérard's painting is decorative and coyly suggestive. He took over Canova's solution ready-made and converted it into a picture of a pretty girl and still prettier boy, charged with sultry erotic overtones. Nearly everything that Neo-classical artists had condemned in the Rococo is here revived in superficially Neo-classical terms.

96. Empire clock, *c.* 1810

A still more striking example of artistic devaluation is provided by an Empire clock [96] decorated with gilt bronze statuettes of the main figures in David's *Oath of the Horatii*. A noble idea has been divorced from its original context, trivialized and reduced to the level of a drawing-room ornament. What had originally been a deeply felt testimony to the courage and nobility of man has been transformed into a symbol of private affluence and 'good taste'. Few objects could better illustrate the relationship of the Empire style to Neo-classicism.

Where Neo-classical artists had sought inspiration in the purest and most primitive forms of antique art, those of the Empire period turned to the florid opulence of Imperial Rome. The abstemious severity of Doric was replaced by Corinthian richness and splendour. The polychromatic, richly sculptured Arc du Carrousel of 1806–7 [97], a more elaborate version of the arch of Septimius Severus in Rome, characterized the new style in architecture. Pomp and extravagance were now the order of the day, to be expressed in abundance of columns, statues and

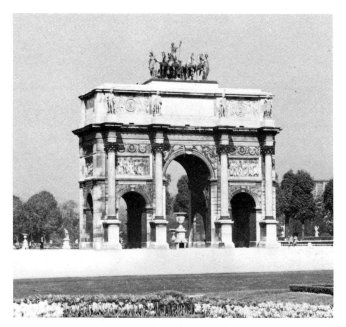

97. The Arc du Carrousel, Paris, 1806–7. C. Percier and P.-F.-L. Fontaine

reliefs and the use of rich substances. Surfaces are left blank, in buildings as in furniture, only to emphasize the beauty and costliness of materials or to set off the lavish workmanship of the decorations. The linear style acquired chic and was used by Percier and Fontaine to create intricate arabesque patterns of filigree ornament [98]. For them, as for Rococo artists, architecture and decoration became synonymous. They veiled the naked simplicity of geometrically shaped rooms and upholstered the walls with elaborate draperies swathed over doors and windows, sofas and beds, hung from the cornices and sometimes gathered up into the ceiling to simulate a tent.

The Imperial Roman style of architecture and decoration appealed to Napoleon for symbolic as much as artistic reasons. And symbols dominate the architecture and decorative arts of his Empire. Roman imperial eagles and lions combined with bees and giant capital 'N's pepper the walls and furnishings of the Napoleonic residences. Egyptian motifs, which had made their appearance before the Revolution, took on a new significance as records of Napoleon's campaign on the Nile. Lotus

columns raised their heads in Paris. A Sèvres dinner service was made with little sugar-bowls fashioned like Egyptian cinerary urns, a coin cabinet reproduced in silver and ebony the architecture of the pylon at Ghoos [99]. But symbols wrenched from antiquity were more popular. On a cradle designed by Prud'hon for the infant King of Rome they run berserk [100]. It rests on cornucopias of plenty with genii of justice and strength in front of them. At the foot a little eagle perches looking up at the canopy which falls from a laurel wreath of glory held by the goddess of Fame with the world at her feet. On one side a relief shows Mercury consigning the baby into the arms of the Seine river-god: on the other Tiber ponders on a newly-risen star. This *de luxe* confection of silver-gilt, mother-of-pearl, silk and velvet was not, of course, intended for daily use. It was a throne cradle, almost a symbolic cradle, made for the issue of a symbolic union between the Bonaparte and Habsburg families, created at birth a symbolic king of the many times more deeply symbolic city of Rome.

The use of symbols even for the decoration of furniture recalls the Versailles of Louis XIV. And it is of the Louis XIV programme of official patronage that one is reminded by the *grandes machines* commissioned on behalf of Napoleon. Once again, painting is devoted to illustrating the virtues of the monarch. A series of pictures commissioned by Denon showed Napoleon haranguing his troops, visiting their encampments, seeing that the wounded are cared for after battle, visiting the sick, receiving the defeated and riding in triumph through their cities, thus depicting his power of leadership, his humanity and magnanimity as well as his glory. By inference these paintings also provided Napoleon with spiritual ancestors in Alexander and Trajan – indeed, the series of reliefs on Trajan's column inspired the whole programme. And it is no coincidence that the column of the *Grande Armée* crowned by a statue of Napoleon, which was erected in the Place Vendôme, Paris, was similarly derived.

Under the Empire the idea of art as education was transformed into that of art as propaganda, centred on the cult of the Emperor's personality. Even David devoted himself to magnifying Napoleon. A grand clamour of trumpet fanfares rings through the pictures in which he showed Napoleon crossing the Alps, crowning Josephine in a glory of gold and silver, silk and satin, or distributing the eagles to generals who swear loyalty with the gesture of the Horatii – now reduced to a

99. Coin cabinet in the Egyptian taste, c. 1800–14. M.-G. Biennais

100. Cradle of the King of Rome, 1811. P.-P. Prud'hon

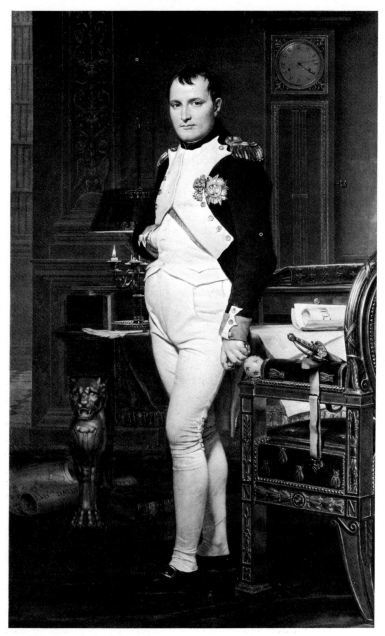

101. *Napoleon*, 1812. J.-L. David

merely rhetorical flourish. Though more restrained in tone, David's brilliant and deeply penetrating portrait of *Napoleon in his Study* is loaded with similar propagandist overtones [101]. The candles have burnt low, the clock shows that it is 4.13 in the morning and the Emperor stands by the writing table where he has been working on the legal code, with a volume of Plutarch at his feet. 'You are right, my dear David, to show me at work while my subjects sleep,' Napoleon remarked. But this noble portrait speaks less of the Emperor than of the heir to the Revolution. It goes far to explain why David, who had sworn at the time of Robespierre's fall to trust no more in men but only in ideas, had succumbed to the personality of Napoleon from the moment of their first encounter. 'O! My friends, what a beautiful head he has. It is pure, it is great, it is as beautiful as the antique. There is a man to whom altars would have been raised in ancient times,' he told his pupils. '*Oui, mes amis! oui, mes chers amis! Bonaparte est mon héros.*'

Painted and carved portraits of Napoleon were diffused throughout the Empire. Marble busts after those by Canova and Chaudet were produced on an industrial scale at Carrara, where workshops organized by Napoleon's sister Elisa turned out as many as 500 a year. Yet as symbols of Imperial dominion these busts were less conspicuous than the almost equally numerous buildings put up in the Empire style. Wherever the rule of the Bonaparte family extended, palaces were swiftly raised, decorated and furnished – in Naples, Milan, Venice, Lucca, Haarlem, Cassel. Elsewhere old palaces were refurbished, painted with simulated hangings, provided with luxuriously cool bathrooms [102], furnished with rectilinear mahogany chairs, tables and commodes, adorned with porcelain from Sèvres [103] and silver by Thomire and Biennais. The Bonapartes also set about the improvement of their capital cities, laying out wide squares and long straight boulevards, setting up triumphal arches and providing new public buildings on a generous scale – in Naples the San Carlo Opera House, in Milan the largest arena to be built since the fall of the Roman Empire.

These buildings, like those in Paris (the first blocks of the rue de Rivoli, the arc du Carrousel, the arc de Triomphe, the Bourse, the north wing of the Louvre), have considerable merits – a cool precision of line, delicacy of detail, attractive contrasts of textures, above all an opulent simplicity and easy elegance. Yet they come as an anti-climax to the period of bold experiment which preceded the Empire. The search for pure

form has been abandoned. Surface decoration, however sparse, has regained its importance. The barracks built by Peter Speeth in Würzburg, capital of the satellite Rhenish Confederation, may seem at first sight to echo Ledoux [104]. But the massively rusticated base, the primitive schematized Doric columns, the pure geometrical circles and half-circles, no less than the absurd Piranesian lion mask which looks like a gigantic door-knocker, are used in a purely decorative fashion. Speeth clearly aspired to give an impression of megalomaniac scale but the result seems to owe more to the art of the cabinet-maker than the architect. It is akin to the San Carlo Opera House in Naples [105] where the paper thinness of the rustication, which seems to be

102. (Opposite) Empire bathroom, Palazzo Pitti, Florence, 1811–12

103. Sèvres porcelain vase, c. 1805

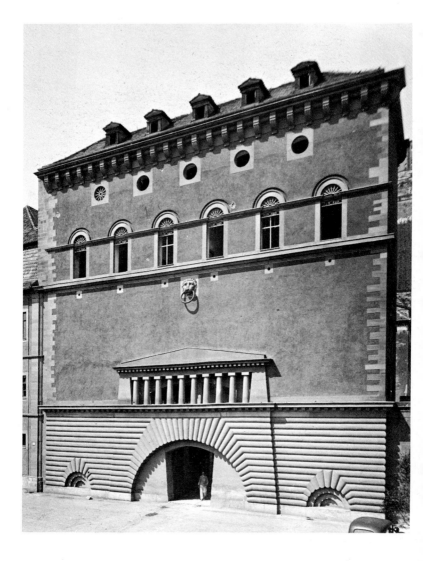

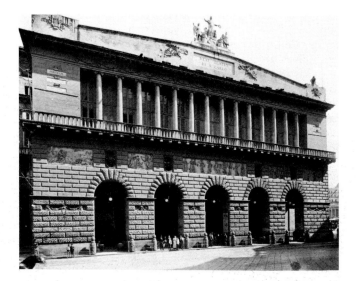

wrapped round the lower storey, is emphasized by the reliefs which peep through it and the course of plain ashlar at the base.

Outside the Empire the weight of symbolism lay less oppressively on the arts. But in England, America and Russia there was a similar change in style, hastened if not wholly occasioned by the influence of French models. Even before the Peace of Amiens briefly re-established artistic links with France, English cabinet-makers and silversmiths had begun to produce objects very similar to those in the Empire style. At the same time a greater desire to copy antique prototypes – Grecian chairs and Roman silver – manifested itself. Thomas Hope, who was in touch with Percier and Fontaine and who studied Denon's folio which reproduced the first accurate drawings of Egyptian furniture, merely developed revivalist tendencies to their logical conclusion in the meticulously accurate imitations of Egyptian, Greek and Roman furniture he designed for his own houses and reproduced in his book. The Neo-classical hostility to the copy had died down and soon Europe was to be flooded with reproductions not only of antique objects but also of medieval buildings and furnishings. The age of historical revivalism had begun.

2. NEO-CLASSICISM AND ROMANTICISM

The propagandist function of the Empire style cannot alone be held to account for the widespread abandonment of Neo-classicism in the early years of the nineteenth century. Yet it is hard to resist the conclusion that a new attitude to the arts had, like the Empire itself, been brought about by the French Revolution. Neo-classicism had been the visual expression of those enlightened ideas which helped to shape, if they did not inspire, the early development of the Revolution. But the Revolution itself, as Sir Isaiah Berlin has remarked,

threw into relief the precariousness of human institutions; the disturbing phenomenon of change; the clash of irreconcilable values and ideas; the insufficiency of simple formulae; the complexity of men and societies; the poetry of action, destruction, heroism, war; the effectiveness of mobs and of great men; the power of chance; the feebleness of reason and the power over it of fanatically believed doctrines; the unpredictability of events; the part played in history by unintended consequences and the ignorance of the workings of the sunken two-thirds of the great human iceberg, of which only the visible portion had been studied by scientists and taken into account by the ideologists of the great Revolution.

The course taken by the Revolution between 1789 and the establishment of the Consulate in 1799 was as disillusioning to those who had accepted its premises as to those who rejected them. The dawn when it was bliss to be alive was soon overcast. David's revolutionary paintings are suffused by its clear light. But in Goya's *Caprichos* (1799) thundery clouds already eclipse the sun. David had shown the nobility of which man is ideally capable, Goya the degradation to which he can sink in the terrible sleep of reason which produces monsters [106]. Others,

106. *The Sleep of Reason,* 1796–8. Goya

like Blake, who had sympathized with the revolutionaries, retreated into private visionary worlds.

A very striking instance of the disruptive effect of the Revolution may be seen in the work of a minor Swiss painter, J.-P. Saint-Ours. He was the author of several idyllically calm pictures of Grecian subjects. But, a biographer tells us, he was so disillusioned by the result of the French Revolution that in 1799 he executed his *Greek Earthquake* [107] and painted several other versions of it during the next few years, as if he had become obsessed by the disaster. The picture certainly reveals a disturbed attitude of mind. Showing a group of men and women fleeing from a Greek temple which is crashing in ruins, it illustrates no particular event in Greek literature or history. It is simply a record of cataclysmic destruction overwhelming humanity and ideal works of art. Just as the Lisbon earthquake of 1755 had shaken faith in the benevolence of a deity governing the best of all possible worlds, so the excesses of the Revolution under the Terror and the betrayal of its principles under the Empire overturned belief in the possibility of establishing an ideal society, or art, based on human reason.

Yet the stylistic change from Neo-classicism to Romanticism was not entirely due to external events, nor was it the result of a reaction comparable with that which had led to the rejection of the Rococo fifty years earlier. The Neo-classical movement contained within itself the seeds of most of the Romantic forces that were to destroy it. And it was from the *atelier* of David himself that the first true Romantic painters began to emerge in the later 1790s. A.-L. Girodet, for example, began as one of the most promising and faithful of David's pupils. His *Hippocrates refusing the gifts of Artaxerxes* is in the tradition of moralizing Neo-classical pictures. In the *Endymion* of 1793 [79] some trace remains of David's form but his earnest seriousness of purpose has been abandoned. The breach is complete in the very extraordinary painting of *Ossian receiving the generals of the Republic* executed 1800–2 for Malmaison [108]. Here we plunge into realms of allegory and phantasmagoria in which universal darkness covers all. In this Nordic Valhalla we are as far from the Enlightenment's concept of immortality as from the Neo-classical vision of an ideally ordered world. The pure and primitive Homeric Ossian has given place to a rhapsodist of the mysterious and the supernatural. This work also marks a return to the unifying compositional techniques and painterly

qualities of the Baroque in general and Rubens in particular. 'I don't understand that painting. No, my good friend, I don't understand it at all,' David told Girodet. And later he remarked to Delécluze: 'Either Girodet is mad or I no longer know anything of the art of painting. Those are figures of crystal he has made for us. With his fine gifts he will never produce anything but stupidities: he has no common sense.'

David was no better pleased with another group of his pupils, the *Primitifs* who, in the later 1790s, stretched to breaking-point the beliefs that underlay the Neo-classical doctrine of the Ideal. Their passionate yearning for line and simplicity was combined with an aggressive abhorrence of colour, modelling, compositional integration, any suggestion of illusion or even technical competence. It is hardly surprising that only one of their paintings survives – a vast Ossianic scene by P. Duqueylar in the Musée Granet, Aix-en-Provence. Trusting to their own genius, they held the general public in utter scorn and were probably the first artists who consciously sought to *épater le bourgeois*, by growing beards (hence their nickname, the *barbus*), by wearing curious Greek cloaks over their clothes and by bathing naked in the Seine. Despising the arts of the age of Pericles as much as those of the Renaissance, they admired only the most primitive Greek vase paintings and Paestum Doric architecture. The only books that won their approval were Homer, Ossian and the Bible. Euripides was mentioned to the leader of the group, Maurice Quaï. 'Euripides?' he replied. 'Vanloo! Pompadour! Rococo! He is like M. de Voltaire.' And the same scornful words were applied to David's *Intervention of the Sabine Women*.

By following some Neo-classical ideas to, if not beyond their logical conclusion, the *Primitifs* were bound to renounce others. By their fanaticism they deliberately upset the nice balance which had been struck between respect for the rules and admiration for genius, belief in the value of imitation and desire for originality, appeals to the mind or heart and to the eye. Like Girodet, though by diametrically opposed means, they signalled the death of Neo-classicism as a vital force in European art.

The *Primitifs* would be of little more than marginal interest were it not for their influence on another of David's pupils, J.-A.-D. Ingres. He is often seen as the last of the Neo-classical artists, in opposition to the Romantic Delacroix. Yet his

107. *The Greek Earthquake*, 1799–1806. J.-P. Saint-Ours

108. (Opposite) *Ossian receiving the generals of the Republic*, 1802.
A.-L. Girodet

Oedipus and the Sphinx of 1808 [109] demonstrates how far he stands from the Neo-classical ideal of David. It depicts the crucial moment in the Oedipus legend. Having already, unknowingly, killed his father, Oedipus ponders the riddle of the Sphinx. By giving the correct answer he will cause her destruction, and receive from the grateful people of Thebes his own (unrecognized) mother as wife. The subject is certainly serious but hardly of a type that would have appealed to David: it is not ennobling, nor does it reveal any truths of universal validity or even, one hopes, of occasional applicability. It has, rather, a mysterious ambiguity which appeals to us as it appealed to W. B. Yeats who wove the image of this 'sphinx with woman breast and lion paw' into a poem. A new vision of antiquity is here beginning to emerge – very different from the cool, calm land of liberty and reason described by Winckelmann and painted by David. In this grim mountain cleft there is no sign of an eternal springtime. The dark irrational gods are once more closing in.

Catalogue of Illustrations

ABBREVIATIONS:

Art Bull.: The Art Bulletin

Burl. Mag.: The Burlington Magazine

G.B.A.: Gazette des Beaux Arts

J.W.C.I.: Journal of the Warburg and Courtauld Institutes

Rosenblum 1967: Robert Rosenblum: *Transformations in Late Eighteenth Century Art* (Princeton, 1967)

1. THE PETIT TRIANON. By Jacques-Ange Gabriel, 1761–8. *Versailles.* (Photograph: Marburg.)
 The first designs date from 1761. The main work was executed in 1764, the interior 1765–8.
 Lit: L. Hautecoeur: *Histoire de l'architecture classique en France,* 1950. iii, 573–6. M. Gallet: *Demeures Parisiennes,* 1964. 183.

2. LOUIS XV. By L.-C. Vassé after Edmé Bouchardon, *c.* 1762–70. Bronze, 71 cm. high. *Paris, Louvre.* (Photograph: Alinari.)
 A reduction of Bouchardon's life-size statue executed 1748–62, erected on a base by Pigalle in the Place Louis XV, Paris, in 1763 and destroyed in 1792. Reductions were made by both Vassé and Pigalle: another of the statuettes by Vassé is in the Royal Collection, Buckingham Palace. A wax sketch by Bouchardon in the Besançon Museum (*G.B.A.* 1897. i, 195–213) indicates his debt to Girardon's Louis XIV. Grimm wrote of the finished model: 'on ne peut rien voir de plus beau, de plus noble, de plus simple, de plus savant que l'homme et le cheval dont cette statue est composée...' (*Correspondance Littéraire,* 15 January 1757.) On this statue Bouchardon minimized the wig, though he did not give the King a Roman haircut. But he had in 1727 carved a bust of Philip Stosch (Berlin) and in 1729 one of Lord Hervey (Ickworth) wholly *à l'antique,* with short hair, bare chest and *abolla* over one shoulder. These busts might seem to anticipate late eighteenth-century portrait sculpture but should rather be seen as manifestations of classical survival together with a bust of the 5th Earl of Exeter of 1701 (cf. *The Connoisseur,* May, 1958, 220).
 Lit: S. Lami: *Dictionnaire des sculpteurs de l'école française au dix-huitième siècle,* 1910. i, 111–12.

3. WRITING-TABLE AND FILING CABINET. Designed by L.-J. Le Lorraine, with bronze mounts by Philippe Caffieri, *c.* 1756. Oak veneered with ebony and gilt bronze mounts. Table 86 cm. high, filing cabinet 161 cm. high. *Chantilly, Musée Condé.* (Photograph: Giraudon.)
 Made for the Parisian amateur of the arts Ange-Laurent de Lalive de Jully probably in 1756, certainly before 1758, and recently (1961) claimed as the earliest surviving example of Neo-classical furniture.
 Lit: Svend Eriksen in *Burl. Mag.* 1961. 340–7; John Harris in *The Journal of the Furniture History Society,* 1966. 1–6; Ralph Edwards in *Burl. Mag.* 1966. 636.

4. SACERDOTESSE À LA GRECQUE. By E. Bossi after Ennemond-Alexandre Petitot, 1771. Engraving, 27 × 18 cm.

From *Mascarade à la grecque*, Parma 1771. In an account of the *goût grec* in the *Correspondance Littéraire*, 1 May 1763, Grimm remarked that M. de Carmontelle 'a voulu se moquer un peu de la fureur du goût grec, en publiant un projet d'habillement d'homme et de femme, dont les pièces sont imitées d'après les ornements que l'architecture grecque emploie le plus communément dans la décoration des édifices. Ces deux petites estampes auraient pu fournir l'idée d'une mascarade pour les bals du carnaval. C'est une très bonne plaisanterie qui a été copiée tout de suite par des singes qui ne savent que contrefaire; ils ont publié un de suite d'habillements à la grecque, sans esprit et d'un goût détestable.' It was presumably from such designs that Petitot took his idea. Most of the information on the *goût grec* is assembled by Eriksen and Harris (see No. 3 above) but see also P.-J. Grosley's comments (*New Observations on Italy . . .* translated into English by Thomas Nugent, 1769. ii, 284) which appear to date from 1759: 'The new fashion for ornaments, which we found on our return to prevail at Paris, under the name of the *Grecian taste*, is precisely, and in every particular, the manner of Florentine architecture: the transition of the Parisians from the *chantourné* to the masculine and grave, may be accounted for by the sudden change of very large hats for very small.'

Lit: P. Jessen: *Der Ornamentstich*, 1920. 329, 337.

5. THOMAS, FIRST BARON DUNDAS. By Pompeo Batoni, Rome 1764. Oil on canvas, 298 × 196 cm. *Aske Hall, Yorkshire, collection of the Marquess of Zetland*. (Photograph: Bowes Museum.)

In the background are four of the antique statues most highly praised in the eighteenth century: the Apollo Belvedere, the Laocoön, the 'Antinous' (in fact Hermes) of the Belvedere and the Vatican Ariadne. The same statues reappear in Batoni's portrait of Count Razoumowsky of 1766. (Razoumowsky Collection, Vienna.)

6. PARNASSUS. By Anton Raphael Mengs, 1760–61. Fresco, c. 300 × 600 cm. *Rome, Villa Albani (now Torlonia)*. (Photograph: Anderson.)

Lit: Kurt Gerstenberg: *Johann Joachim Winckelmann und Anton Raphael Mengs*, 1929; Dieter Honisch: *Anton Raphael Mengs*, 1965. 65–6.

7. BELISARIUS. By Jacques-Louis David, 1780–81. Oil on canvas, 288 × 312 cm. *Lille, Musée Wicar*. (Photograph: Archives.)

The full title is: 'Bélisaire reconnu par un soldat qui avait servi sous lui au moment qu'une femme lui fait l'aumone.' A reduced version by Fabre and Girodet is in the Louvre.

Lit: L. Hautecoeur: *Louis David*, 1954. 55–61; L. D. Ettlinger in *Journal of the Royal Society of Arts*, January 1967. 110–11.

8. THE OATH OF THE HORATII. By Jacques-Louis David, 1784–5. Oil on canvas, 330 × 427 cm. *Paris, Louvre*. (Photograph: Archives.)

Prud'hon in a letter from Rome of 1786 refers to the Horatii 'qui jurent avec une fermeté incroyable de verser jusqu'à la dernière goutte de leur sang pour sauver la patrie. C'est alors que le sentiment prédominant fait disparaître toute idée de peinture' (*G.B.A.* 1870. i, 153). In 1785 Girodet executed a painting of *Horatius killing his sister* now in the Musée de Montargis (G. Levitine in *Art Bull.* 1954. 40–41). An account of the conception and execution of the picture is given by A. Péron: *Examen du tableau du Serment des Horaces* (1839) who remarks that David's favourite

pupil, J.-G. Drouais, painted the arm of the third brother and the yellow dress of Sabine, and prints a letter from Drouais 14 August 1785 stating that 'David a fini son tableau depuis quinze jours' and describing the tumultuous success it was enjoying. Péron says that the gesture of the Horatii was derived from the lictor in Poussin's *Rape of the Sabines*, commenting 'C'était donc avec quelque fond de verité que David disait, en plaisantant avec son bonhomie ordinaire " Si c'est à Corneille que je dois mon sujet, c'est à Poussin que je dois mon tableau" '. (For drawing my attention to Péron I am indebted to Dr Anita Brookner, cf. Acts of the Twenty-first Congress of Art History, Bonn, 1964, *Stil und Überliefung in der Kunst des Abendlandes*, 1967, i, 187). Lit: Rosenblum 1967 contains the best analysis and discussion. For a study of the preparatory drawings see F. H. Hazlehurst in *Art Bull*. 1960. 59 ff.; for a somewhat far-fetched theory that the gestures were derived from a ballet by Noverre, E. Wind in *J.W.C.I.* 1941. 124 ff.; for an extreme statement of the view that the painting was a manifesto of the Revolution, Agnès Humbert's: *Louis David Peintre et Conventionnel*, 1936. 53–7 (the book is sub-titled 'Essai de critique Marxiste'); the supposed political significance was questioned by L. Hautecoeur, op. cit. 70–90, and demolished by L. D. Ettlinger, op. cit. 105–23; the architectural background and its similarity with works by Ledoux and Poyet's (?) rue des Colonnes in Paris is studied by René Crozet in *G.B.A.* 1955. i, 211–20.

9. THESEUS AND THE DEAD MINOTAUR. By Antonio Canova, 1781–2. Marble, 147 cm. high. *London, Victoria and Albert Museum*. (Photograph: Museum.)

Lit: H. Honour in *The Connoisseur*, 1959. 225–31.

10. MONUMENT TO POPE CLEMENT XIV. By Antonio Canova, 1783–7. Marble, *Rome, SS Apostoli*. (Photograph: Anderson.)

Lit: V. Malamani: *Canova*, 1911. 27–30; H. Honour in *The Connoisseur*, 1959. 225–31.

11. THE OATH OF THE HORATII. (Detail of 8.)

12. DESIGN FOR THE HÔTEL D'HALLWYL. By Claude-Nicolas Ledoux, *c.* 1790. Engraving from *L'Architecture de C. N. Le Doux*, 1846. 17·8 × 17·8 cm.

The building (still standing but somewhat dilapidated, in the rue Michel Le Comte, Paris) was erected in 1766. But Ledoux revised his designs slightly, probably *c.* 1790, to bring them more up to date for publication (see W. Herrmann in *Art Bull*. 1960. 202–3).

Lit: M. Gallet: *Demeures Parisiennes*, 1964. 33, 188.

13. BARRIÈRE DE LA VILLETTE. By Claude-Nicolas Ledoux, 1785–9. *Paris, Place Stalingrad*. (Photograph: Giraudon.)

Of the forty-six barrières designed by Ledoux only this (now under restoration) and three others survive.

Lit: H.-R. Hitchcock: *Architecture: Nineteenth and Twentieth Centuries*, 1958. xxiv–xxv; M. Raval and J.-Ch. Moreux: *Ledoux*, 1945. *passim*.

14. JUPITER AND GANYMEDE. By Anton Raphael Mengs, 1758–9. Fresco, 178·7 × 137 cm. *Rome, Galleria Nazionale*. (Photograph: G.F.N.)

A fake antique fresco painted to deceive Winckelmann who was entirely taken in. A somewhat garbled account of the story appears in Goethe's *Italienreisen*, 18 November 1787.

Lit: D. Honisch: op. cit. 89.

15. THE CUPID SELLER. By Joseph-Marie Vien, 1763. Oil on canvas, 95 × 119 cm. *Fontainebleau, Musée National*. (Photograph: Archives.)

The composition is derived from a Roman painting discovered at Grag-nano in 1740 and illustrated in various late eighteenth-century works on antiquities. It was later reproduced in biscuit porcelain at the Vienna factory and there are also early nineteenth-century pornographic versions, probably of German origin, which substitute winged phalluses for the cupids. Diderot commented on the gesture of Vien's Cupid who 'indique d'une manière très significative la mesure des plaisirs qu'il promet' (*Diderot: Salons*, eds. J. Seznec and J. Adhémar, 1957. i, 209–10) but Vien's frivolous attitude to antiquity is best seen in his painting of 'une jeune grecque qu'on prépare pour la couche nuptiale' about which he coyly remarked, 'Je . . . n'ai point oublié le bouton de rose qu'elle doit tenir à la main pour le comparer avec un autre' (*Correspondance des Directeurs de l'Académie de France à Rome*, eds. A. de Montaiglon and J. Guiffrey, 1904. xiii, 246).

Lit: Rosenblum 1967 contains the best discussion, including the rather different versions by David and Fuseli; F. Aubert in *G.B.A.* XXI, 1867. i, 189 ff., ii, 174 ff., contains the fullest account of Vien. The best account of eighteenth-century reactions to the finds at Herculaneum and Pompeii is by J. Seznec in *Archaeology* II, 1949. 150 ff.; C. F. Mullett in *Archaeology* X, 1957. 31 ff. includes some useful comments.

16. CHAIR. Designed by Hubert Robert and executed by Georges Jacob, 1787. Carved mahogany, 93·5 cm. high. *Versailles, Château.* (Photograph: Réunion des Musées Nationaux.)

Made for the Queen's dairy at Rambouillet, see No. 88.

Lit: F. J. B. Watson: *Louis XVI Furniture*, 1960. 145.

17. PEDESTAL AND VASE. Designed by James Wyatt and painted by Biagio Rebecca, *c.* 1795. Painted wood and metal, 120 cm. high. *Heveningham Hall, collection of the Hon. Andrew Vanneck.* (Photograph: R.A.)

Lit: R. Edwards: *Dictionary of English Furniture*, 1954. iii, 1612. For the Etruscan taste in England, see Eileen Harris: *The Furniture of Robert Adam*, 1963. 22.

18. PLATE FROM THE ETRUSCAN SERVICE. Made at the Royal Neapolitan Porcelain Factory, 1785–7. Porcelain, 23·5 cm. diameter. *Windsor Castle.* Reproduced by gracious permission of H.M. the Queen.

Each of the plates is painted with a different antique vase: some tureens and other vessels in the service are modelled on examples of ancient pottery and metal wares. On the eighteenth-century taste for Greek and Etruscan vases, see Adolf Griefenhagen in *Jahrbuch der Berliner Museem*, 1963. 84–105. Lit: A. Lane: *Italian Porcelain*, 1954. 61–2.

19. VIEW OF THE FOUNDATIONS OF HADRIAN'S MAUSOLEUM (CASTEL' S. ANGELO) ROME. By Giovanni Battista Piranesi, 1756. Etching, 69·7 × 45·6 cm.

From Piranesi's *Le antichità Romane*, vol. IV, pl. ix. For Piranesi's archi-tectural theory, see R. Wittkower in *J.W.C.I.* ii, 1938/9. 147 ff. For Le Geay and Piranesi, see J. Harris in *Essays in the History of Architecture Presented to Rudolf Wittkower*, ed. D. Fraser, 1967. 189–96.

Lit: R. O. Parks (ed.) *Piranesi*, 1961. 89.

20. THE ARTIST MOVED BY THE GRANDEUR OF ANCIENT RUINS. By Henry Fuseli, 1778–9. Red chalk and sepia wash, 41·5 × 35·5 cm. *Zürich, Kuns-thaus.* (Photograph: Museum.)

Lit: H. Hawley: *Neo-classicism Style and Motif*, 1964, no. 120.

21. CANDELABRUM. By G. B. Piranesi, *c.* 1770–78. Marble, 357·9 cm. high.

Paris, Louvre. (Photograph: Giraudon.)

The candelabrum is made up from fragments of Roman altars, candelabra and tripods with the addition of modern pieces. Piranesi, who published etchings of it in *Vasi, candelabri cippi*, 1778, pls. 102 and 103, intended it as a decoration for his own tomb in S. Maria del Priorato, Rome, and it was placed there for a while by his sons (probably removed when Giuseppe Angelini's statue of Piranesi was set up in 1780).

Lit: F. de Clarac: *Musée de Sculpture Antique et Moderne*, 1841. ii, pt. 1, 411–12.

22. INTERIORA BALNEARUM SALLUSTIANARUM. By G. B. Piranesi, 1762. Etching, 29·1 × 30·4 cm. Pl. xliii from Piranesi's *Campus Martius*, 1762.

23. THE ROTUNDA AT THE BANK OF ENGLAND. By John Soane, 1798. Ink and watercolour, 63 × 70 cm. *London, Sir John Soane's Museum*. (Photograph: Museum.)

The rotunda was built in 1796, modified in the nineteenth century and barbarously demolished in the 1920s.

Lit: A. T. Bolton: *The Works of Sir John Soane*, 1924. 32–68.

24. BALTIMORE CATHEDRAL. By Benjamin Latrobe, 1805–18. (Photograph: Blakeslee-Lane Inc.)

Lit: Talbot Hamlin: *Benjamin Henry Latrobe*, 1955.

25. ACHILLES LAMENTING THE DEATH OF PATROCLUS. By T. Pirolli after John Flaxman, 1793. Engraving, 15·2 × 26·6 cm.

From Flaxman's series of illustrations to the *Iliad*. Cowper hoped his translation of Homer might be illustrated by Flaxman whose line engravings he greatly admired (letter to William Hayley, 15 August 1793) but Flaxman did not reciprocate. The literature on the cult of Homer in the eighteenth century is surprisingly poor, though J. L. Myres: *Homer and his Critics* (1958) is useful. Recent Italian writers have credited G. B. Vico with the discovery of the 'primitive' Homer (and much else besides) and there is some truth in this, but his influence has been grossly exaggerated.

Lit: Rosenblum 1967 contains the best discussion; E. and D. Panofsky: *Pandora's Box*, 1956. 92 ff., contains a brief but penetrating passage.

26. ACHILLES AT THE PYRE OF PATROCLUS. By Henry Fuseli, *c.* 1795–1800. Pen, ink and wash, 48 × 31·5 cm. *Zürich, Kunsthaus*. (Photograph: Museum.)

27. THE LICTORS BRINGING BRUTUS THE BODIES OF HIS SONS. By Jacques-Louis David, 1789. Oil on canvas, 325 × 425 cm. *Paris, Louvre*. (Photograph: Bulloz.)

The full title was ' J. Brutus, premier consul, de retour en sa maison, après avoir condamné ses deux fils qui s'étaient unis aux Tarquine et avaient conspiré contre la liberté romaine. Des licteurs rapportent leur corps pour qu'on leur donne la sépolture'. The picture was not on show when the Salon opened on the 25 August 1789 but there is no reason to doubt the official statement that this was due merely to a formality. It was on show very soon after the opening and acquired for the Crown at a price of 6,000 livres. For its supposed political meaning see lit. below and also G. Plekhanov: *Art and Social Life*, 1953, 157–8. According to the anonymous *Notice sur la vie et les ouvrages de M J.-L. David*, 1824, 35 (repeated almost word for word in A. Th***: *Vie de David*, 1826), David had originally 'présenté les têtes séparées du corps par des licteurs. Les événements affreux de 1789 le décidérent à les cacher, telles qu'on les voit aujourd'hui '.

Lit: R. L. Herbert: *David, Voltaire, 'Brutus' and the French Revolution*, 1972.

28. PORTRAIT OF ANTOINE LAVOISIER AND HIS WIFE. By Jacques-Louis David, 1788. Oil on canvas, 254 × 193 cm. *New York, The Rockefeller University*. In a letter of 10 August 1789, about the choice of pictures for the Salon, C.-E.-G. Cuvillier, chief assistant to d'Angiviller, wrote to Vien, then *premier peintre du roi*: 'M. le Dr. Gal. pense qu'on ne peut apporter trop de précautions dans le choix de sujets qui seront exposés, relativement aux applications qui peuvent échapper à un spectateur et qui éveillent les autres. Les spectacles nous en fournissent chaque jour les exemples les plus imprévus. L'article des portraits laisse plus de facilité à se mettre en garde, car en général les originaux étant connus, on est en état de mesurer l'opinion publique et de ne rien hasarder; j'imagine à ce sujet que M. Lavoisier sera le premier à ne pas désirer l'exposition de son portrait. Ce n'est pas qu'il soit en aucun sens au rang de ceux qu'on peut mal voir; mais on peut l'en laisser juge.' After saying that Lally-Tollendal – then one of the leaders of the monarchical or 'Anglomaniac' faction – was unlikely to attempt to have his 'terrible tableau' exhibited, Cuvillier concludes: 'C'est sous ce rapport que je suis bien aise, autant que je peux l'être, de savoir le tableau de M. David encore loin d'être achevé; et à propos de cet artiste, je pense avec vous, Monsieur, que son tableau de *Paris et Hélène* peut être exposé sans laisser aucune crainte, en taisant le propriétaire.' The 'tableau de M. David' was his *Brutus* (see no. 27). The authorities wished to exclude all controversial works – hence the remark about concealing the name of the owner of the *Paris and Helen*, the uncompromising comte d'Artois. The portrait of the Lavoisiers was excluded probably because he had recently aroused the fury of the Parisian public and narrowly escaped lynching.

Lit: *Nouvelles Archives de L'Art Francais*, xxii, 1906. 264.

29. MARIE ANTOINETTE ON THE WAY TO THE GUILLOTINE. By Jacques-Louis David, 1793. Pen drawing, 14·8 × 11·2 cm. *Paris, Louvre*. (Photograph: Réunion des Musées Nationaux.)

Lit: R. Cantinelli: *Louis David*, 1930. 45.

30. THE INTERVENTION OF THE SABINE WOMEN. By Jacques-Louis David, 1799. Oil on canvas, 386 × 520 cm. *Paris, Louvre*. (Photograph: Giraudon.)

David is said to have begun to think out this composition while he was imprisoned in the Luxembourg and although the subject had been treated before (by Guercino and in 1781 by F.-A. Vincent) it is difficult not to see in it a plea for peace, after the Terror. The jingle about the picture runs:

> En habillant in naturalibus
> Et Tatius et Romulus
> Et de jeunes beautés sans fichus ni sans cottes,
> David ne nous apprend que ce que l'on savait:
> Depuis longtemps Paris le proclamait
> Le Raphael des sans-culottes.

Lit: A. Lenoir: *Examen du tableau des Sabines et de l'école de M. David*, 1810; E.-J. Delécluze: *Louis David, son école et son temps, souvenirs*, 1855, *passim*; L. Hautecoeur: *Louis David*, 1954. 165–84.

31. THE RETURN OF MARCUS SEXTUS. By Pierre-Narcisse Guérin, 1797-9. Oil on canvas, 217 × 244 cm. *Paris, Louvre*. (Photograph: Archives.) No source for this painting can be discovered in ancient literature. The

subject was presumably invented by Guérin, as was also the name Marcus Sextus which is anachronistic. The following dates are relevant to a discussion of it as a contemporary allegory: November 1795 the *emigrés* begin to return to France under the first Directory; 4 September 1797 *coup d'état* of 18 *fructidor* after which laws against them reinforced; 10 November 1799 establishment of the Consulate after which the law against them repealed and *emigrés* free to return (G. Lefebvre: *The French Revolution from 1793–1799*, 1964. 177–8, 199, 317). Guérin won the grand prix in 1797 and was sent to the École de Rome in 1798 (which hardly suggests revisionist tendencies) and on the 21 January 1799 he, like other French students in Rome, recorded his oath 'Je jure haine à la royauté et à l'anarchie, je jure attachement et fidélité à la République et à la Constitution de l'an 3'. (A. de Montaiglon and J. Guiffrey: *Corr. des Directeurs de l'Ac. de France à Rome*, 1908. xvii, 64, 175, 197, 227). It was however stated in 1801 that the picture had been honoured in the Salon by a laurel wreath and a steady stream of visitors (Rosenblum 1967. 90).

32. HERCULES AND LICHAS. By Antonio Canova, 1795–1802. Marble, *c.* 350 cm. high. *Rome, Galleria d'Arte Moderna.* (Photograph: Anderson.) Commissioned 1795, *modello* completed 1796, marble begun 1801 and probably completed 1802. Canova tells the story of the French who wished to construe the work as a political allegory in a letter of 7 May 1799, (Canova archive, Museo Civico, Bassano del Grappa). G. Giovannoni (*Bollettino d'Arte*, 1908. 39–40) mentions that the two interpretations of the group were current in the 1790s but gives, without documentation, a garbled and misleading account of them.

33. THE DRUNKARD'S RETURN. By G. -B. Greuze, *c.* 1780. Oil on canvas, 74·7 × 91·8 cm. *Portland, Oregon, Portland Art Museum.* (Photograph: Museum.)
A red chalk drawing for the drunkard is in the British Museum.
Lit: A. Brookner in *Burl. Mag.* 1956. 157–62, 192–9.

34. DESIGNS FOR A MONUMENT TO NEWTON. By Etienne-Louis Boullée, *c.* 1780–90. Pen and wash, 73·7 × 49 cm. each. *Paris, Bibliothèque Nationale.* (Photograph: B.N.)
For a discussion of monuments to 'Genius', see A. Neumeyer in *J.W.C.I.* 1938. ii, 159–63. I am indebted to Professor Haskell for information about English monuments to great men and for the quotation from Abbé del Guasco, *De l'usage des statues chez les anciens*, 1767. 267.
Lit: H. Rosenau: *Boullée's Treatise on Architecture*, 1953.

35. SALA ROTONDA. Designed by Michelangelo Simonetti, 1776–80. *Vatican, Museo Pio-Clementino.* (Photograph: Anderson.)
The earliest proposal for the arrangement of a museum on historical principles appears to be that of Algarotti for Dresden, *Progetto per ridurre a compimento il regio museo di Dresda*, 1742 (*Opere*, 1794. viii, 351–88) but it came to nothing.
Lit: H. Seling in *Architectural Review*, February 1967. 103–14.

36. PORTRAIT OF GIUSEPPE BARETTI. By Sir Joshua Reynolds, 1774. Oil on canvas, 74 × 62 cm. *London, Collection of Viscountess Galway.* (Photograph: R.A.)
Lit: E. K. Waterhouse: *Reynolds*, 1941. 64.

37. PORTRAIT OF ALPHONSE LEROY. By Jacques-Louis David, 1782–3. Oil on canvas, 72 × 91 cm. *Montpellier, Musée Fabre.* (Photograph: Archives.)
Leroy was professor of Obstetrics at the Paris faculty.

Lit: *David*, Musée de l'Orangerie, Paris, 1948, no. 12.

38. BUST OF DENIS DIDEROT. By Jean-Antoine Houdon, 1771. Terracotta, 41 cm. high. *Paris, Louvre*. (Photograph: Archives.)
For Diderot's comments on portraiture, see the passage on his own portrait by Michel Van Loo in the 1767 *Salon*.
Lit: L. Réau: *Houdon*, 1964. ii, 30. H. H. Arnason: *Sculpture by Houdon: a loan exhibition*, 1964. 26–8.

39. A FATHER AND HIS CHILDREN. Anonymous, *c.* 1794–1800. Oil on canvas, 130 × 62 cm. *Le Mans, Musée Tessé*. (Photograph: Archives.)
This painting has been attributed to J.-L. David and supposed to represent Michel Gérard and his children. M Brière showed that it does not represent Gérard and discounted the attribution to David (*Bull. de la Soc. de l'Art Fr.* 1945–6. 168–79); see also D. Cooper in *Burl. Mag.* October 1948. 280. It is likely that the two youths in the background are later additions by another hand.

40. MOUNTAIN STREAM WITH BRIDGE OF ICE AND RAINBOW. By Caspar Wolf, 1778. Oil on canvas, 82 × 54 cm. *Basel, Oeffentliche Kunstsammlung.* (Photograph: Museum.)

41. THE FACE OF THE MOON. By John Russell, *c.* 1795. Pastel on board, 64 × 47 cm. *Birmingham, The City Museum and Art Gallery*. (Photograph: Museum.)
Probably a study for Russell's large (5 ft square) map of the moon in the Radcliffe Observatory, Oxford, dated 1795. It is signed 'painted from nature by John Russell, R.A.'. Russell was a friend of Sir William Herschel who encouraged his interest in astronomy. In a letter of 1789 he remarked that in painting the moon he was anxious to obtain not only scientific accuracy but also artistic effect by choosing to represent not the full but the gibbous moon and thus exploit the light and shade of the mountains.
Lit: *The Romantic Movement*, exh. cat., 1959. no. 315.

42. SAUCE TUREEN. By Matthew Boulton and John Fothergill, 1776. Silver, 26·6 cm. long. *Birmingham Assay Office*. (Photograph: Courtesy of Robert Rowe.)
Lit: R. Rowe: *Adam Silver*, 1965.

43. EXPERIMENT WITH THE AIR PUMP. By Joseph Wright, 1768. Oil on canvas, 182 × 243 cm. *London, The Tate Gallery*. (Photograph: Museum.)
A striking contrast is provided by Amédée Vanloo's painting of his family round an air pump (*G.B.A.* 1912. ii, 149).
Lit: B. Nicolson in *Burl. Mag.* March 1954. 79.

44. CUPID AND PSYCHE. By Antonio Canova, 1787. Terracotta, 16 cm. high. *Possagno, Gipsoteca*. (Photograph: G.F.N.)
Lit: E. Bassi: *La Gipsoteca di Possagno*, 1957. 74.

45. CUPID AND PSYCHE. By Antonio Canova, 1787–93. Marble, 155 cm. high. *Paris, Louvre*. (Photograph: Bulloz.)
Lit: H. Honour in *The Connoisseur*, 1950. 225–31.

46. LOVERS. By Johan Tobias Sergel, 1780. Pen, ink and wash, 21 × 17 cm. *Stockholm, National Museum*. (Photograph: Museum.)
For Sergel's sculpture, see G. Gothe: *Johan Tobias Sergels Skulpturverk*, 1921; for a general account, R. Josephson: *Sergels Fantasi*, 1956.

47. THE STATE CAPITOL. Designed by Thomas Jefferson, 1785–96. *Richmond, Virginia*. (Photograph: E. Galloway.)
In 1785 Jefferson, then travelling in Europe, was asked to provide a design for a state capitol in Richmond. Believing that this was 'a favour-

able opportunity to introduce into the State an example of architecture, in the classic style of antiquity' he prepared with the aid of C.-L. Clérisseau a model (now in the Virginia State Library) derived from the Maison Carrée at Nimes which he considered 'the most perfect and precious remain of antiquity in existence' – but with a different arrangement of columns, vast enlargement of scale, omission of half-columns and insertion of windows, and substitution of the Ionic for the Corinthian order.

Lit: F. Kimball: *Thomas Jefferson, Architect,* 1916.

48. THE BOURSE (NOW NAVAL MUSEUM), LENINGRAD. Designed by Thomas de Thomon, 1804–16. (Photograph: Gasiloff.)

The design is in some ways similar to those with which P. Bernard in 1782 and Tardieu in 1786 won prizes at the French Academy – the former even has the flanking rostral columns (see H. Rosenau in *Architectural History,* 1960. iii, 31–2).

Lit: H.-R. Hitchcock: op. cit. 14.

49. CORN-COB CAPITAL. Designed by Benjamin Latrobe and carved by Giuseppe Franzoni, 1809. Sandstone. *Washington, D.C., the Capitol (first floor vestibule of the Old Supreme Court Chamber).* (Photograph: Architect of the Capitol.)

Lit: T. Hamlin: *Benjamin Latrobe,* 1955. 270.

50. WRITING-TABLE. By David Roentgen, *c.* 1780–90. Oak with birchwood veneer and gilt bronze mounts, 124 cm. high. *Karlsruhe, Badisches Landesmuseum.* (Photograph: Museum.)

Lit: *Badisches Landesmuseum Neuerbungen 1952–1965,* 1966. 191.

51. SOUP TUREEN. Made by Wedgwood, *c.* 1780. Cream-coloured earthenware 27 cm. high. *London, Victoria and Albert Museum.* (Photograph: Museum.)

52. CHAIR. Designed by Nicolai A. Abildgaard, *c.* 1790. Mahogany painted by the designer, 90 cm. high. *Copenhagen, Museum of Decorative Art.* (Photograph: Museum.)

The design is based on a Greek *klismos.*

53. THE ORIGIN OF PAINTING. By David Allan, 1775. Oil on panel, 38 × 30·4 cm. *Edinburgh, National Gallery of Scotland.* (Photograph: Museum.)
Lit: R. Rosenblum in *Art Bull.* December 1957. 279 ff.

54. ARES HELD IN CHAINS BY OTUS AND EPHIALTES. By T. Pirolli after John Flaxman, 1793. Engraving, 16·8 × 23 cm.

An illustration to the fifth book of the *Iliad.*

55. THE ARGONAUTS. By Joseph Koch after Asmus Jakob Carstens, 1799. Engraving, 21·5 × 25·2 cm. (Photograph: G.F.N.)

The full title of the work is *Les Argonautes | selon | Pindare. Orphée et Apollonius de Rhodes | en vingt-quatre planches | inventées et dessinées par Asmus Jacques Carstens | et gravées par Joseph Koch | à Rome an MDCCXCIX.*

Lit: R. Zeitler: *Klassizismus und Utopia,* 1954. 129–43; Rosenblum 1967. 180–2.

56. THE DEATH OF CAPTAIN COOK (detail). By Johann Zoffany, *c.* 1789–97. Oil on canvas, 136·5 × 185 cm. *Greenwich, National Maritime Museum.* (Photograph: Museum.)

Lit: B. Smith: *European Vision and the South Pacific,* 1960. 84.

57. SAPPHO. By Johann Heinrich Dannecker, 1797–1802. Marble, 27 cm. high. *Stuttgart, Staatsgalerie.* (Photograph: Museum.)

Lit: A. Spemann: *Johann Heinrich Dannecker,* 1958. 12.

58. VOLTAIRE. By Jean-Baptiste Pigalle, 1770–76. Marble, 147 cm. high

Paris, Musée du Louvre. (Photograph: Giraudon.)
The best contemporary account of the commissioning and execution is
in Grimm's *Correspondance Littéraire*, 15 May, 15 June, 15 July 1770 and
April 1773 which also preserves the pasquinade:

> Voici l'auteur de l'Ingénu!
> Monsieur Pigal l'a fait tout nu;
> Monsieur Fréron le drapera,
> Alleluia.

According to Grimm, after the committee had dined and decided to com-
mission the statue, Pigalle brought in a model for it (probably that now in
the Musée des Beaux Arts, Orleans) which the Abbé de Raynal had asked
him to make some days before. Many years later the Abbé Morellet
(*Memoires*, 1821. i, 200) said of the statue that it was Diderot 'qui avait
inspiré à Pigalle de faire une statue antique comme le Sénèque se coupant
les veines'. Grimm makes no reference to Seneca nor does Voltaire him-
self in the amusing comments on the statue in his letters to Mme Necker.
Nevertheless, W. Sauerländer and H. W. Janson have recently suggested
that Pigalle represented Voltaire 'as Seneca'. Is it likely that a statue of a
great living writer would be intended to remind his admirers of a Roman
philosopher bleeding to death in his bath? If Morellet's recollection is
correct, his reference to Seneca can only mean that Diderot suggested
that Pigalle should take the then famous Borghese *Seneca* as a model for
the naturalistic rendering of an aged male nude. Winckelmann had al-
ready disputed the identification of this marble, but it was still widely
known as the dying Seneca. It is now in the Louvre, described as the
Borghese *Fisherman.*
Lit: Comte d'Haussonville in *G.B.A.* 1903. ii, 353–70; L. Réau: *Pigalle*,
1950. 60 ff.; W. Sauerländer: *Jean-Antoine Houdon: Voltaire*, 1963. 5–9;
H. W. Janson in the Acts of 21st Congress of Art History, Bonn, 1964,
Stil und Überlieferung in der Kunst des Abendlandes, 1967. i, 198–207.

59. SAINTE GENEVIÈVE (PANTHÉON). By Jacques-Germain Soufflot,
begun 1757. *Paris.* (Photograph: Giraudon.)
For the influence of Laugier on Soufflot, see W. Herrmann: *Laugier and
Eighteenth Century French Theory*, 1962. *passim*; R. Middleton in *J.W.C.I.*
1963. 90 ff.

60. SYON HOUSE, ENTRANCE HALL. Designed by Robert Adam, 1761.
Isleworth. (Photograph: *Country Life.*)

61. SETON CASTLE. Designed by Robert Adam, 1789–91. *Haddington, East
Lothian.* (Photograph: Drummond Young.)
Lit: J. Fleming in *Concerning Architecture*, ed. J. Summerson, 1968, pp.
75–84.

62. MODEL FOR A GATEWAY. By Carl August Ehrensvärd, *c.* 1785. Wood,
51·7 cm. high. *Karlskrona, Marinmuseum.* (Photograph: O. Reutersvard.)
Ehrensvärd was a militant masculinist ('woman's freedom destroys man's
way of thinking', he wrote, and, 'The Greeks, our teachers in taste and
happiness, did not live with their women as we do') and saw the Doric
as the male style *par excellence.* This gateway was intended for the naval
station at Karlskrona but never executed.
Lit: S. A. Nilsson in *Konsthistorick Tidskrift*, 1964. 1–20; Rosenblum 1967.
148.

63. GEOMETRICAL SOLIDS. By J. S. Muller after Joshua Kirby, 1754. Engraving, 20·2 × 16·5 cm.
Plate xvii from Joshua Kirby's *Dr Brook Taylor's method of perspective made easy, both in theory and practice*, Ipswich 1754. I am grateful to Mr John Gage for drawing my attention to this engraving.

64. ALTAR OF GOOD FORTUNE. Designed by Johann Wolfgang von Goethe, 1777. Stone, overall height 181 cm. (sphere 72, cube 89). *Weimar*. (Photograph: W. S. Heckscher.)
Lit: W. S. Heckscher: *Goethe and Weimar*, 1961. 5–9, and in *Jahrbuch der Hamburger Kunstsammlungen* VII, 1962. 35–54; Rosenblum 1967. 150.

65. THE ADMIRALTY. Designed by Adrian Dmitrievitch Zakharov, 1806–15. *Leningrad*. (Photograph: Gasilov.)
Lit: G. H. Hamilton: *The Art and Architecture of Russia*, 1954. 209–10.

66. THE ANATOMY THEATRE, ÉCOLE DE CHIRURGIE, PARIS. By Poulleau after Jacques Gondouin, 1780. Engraving from Poulleau's *Description des écoles de chirurgie*, 1780.
The anatomy theatre was designed by Gondouin in 1765 and built 1769–75.
Lit: J. Adhémar in *l'Architecture*, 15 May 1934; L. Hautecoeur: *Histoire de l'architecture classique en France*, 1952. 242–7.

67. DESIGN FOR A MAISON DES GARDES AGRICOLES. By Claude-Nicolas Ledoux, *c.* 1790. Engraving from *L'Architecture de C. N. Le Doux*, 1846. ii, pl. 254, 12·7 × 24·7 cm.
For a somewhat different interpretation of Ledoux with special reference to the influence of garden architecture on his work, see J. Langner 'Ledoux und die Fabriques' in *Zeitschrift für Kunstgeschichte*, 1963. 1–36.

68. DESIGN FOR A CITY GATEWAY. By Johann Jakob Friedrich Weinbrenner, 1794. Pen, ink and wash, 63·5 × 96·5 cm. *Karlsruhe, Staatliche Kunsthalle*. (Photograph: G.F.N.)
Drawn in Rome while travelling with Carstens in 1792–7, probably as a project for Karlsruhe.
Lit: Exh. Cat. Il Settecento a Roma, 1959. no. 660.

69. DESIGN FOR A NATIONAL THEATRE IN BERLIN. By Friedrich Gilly, 1798. Pen, ink and wash, formerly Technische Hochschule, Berlin, present whereabouts unknown.
Lit: A. Oncken: *Friedrich Gilly 1772–1800*, 1935.

70. CHELSEA HOSPITAL STABLES, EAST FAÇADE. By John Soane, 1814. *London*. (Photograph: National Buildings Record.)
Lit: D. Stroud and H.-R. Hitchcock (introduction): *The Architecture of Sir John Soane*, 1961.

71. SCENE FROM TERENCE'S ANDRIA (ACT II SCENE 3). By Nikolai Abraham Abildgaard, 1802. Oil on canvas, 157·5 × 128·5 cm. *Copenhagen, Statens Museum for Kunst*. (Photograph: Museum.)
Lit: F. Novotny: *Painting and Sculpture in Europe 1780–1880*, 1960. 50.

72. DESIGN FOR A LIBRARY. By Étienne-Louis Boullée, *c.* 1780–90. Pen, ink and wash, 105·6 × 65 cm. *Paris, Bibliothèque Nationale*. (Photograph: B.N.)
Lit: H. Rosenau: *Boullée's Treatise on Architecture*, 1953.

73. SEPTIMUS SEVERUS REPROACHING CARACALLA. By Jean-Baptiste Greuze, 1769. Oil on canvas, 124 × 160 cm. *Paris, Louvre*. (Photograph: Archives.)
The full title is: 'L'Empereur Sévère reproche à Caracalla, son fils, d'avoir voulu l'assassiner dans les défilés d'Ecosse et lui dit: Si tu désires ma mort,

ordonne à Papinien de me la donner avec cette épée.' Greuze presented it as his *morceau de réception* but much to his chagrin was accepted as an Academician only as a genre and not as a history painter, see J. Seznec in *G.B.A.* 1966. i, 339–56. The preliminary studies are analysed by E. Munhall in *L'Œil*, April 1965. 23–9.
Lit: Rosenblum 1967. 55.

74. THE WICKED SON PUNISHED. By Jean-Baptiste Greuze, 1778. Oil on canvas, 130 × 162 cm. *Paris, Louvre*. (Photograph: Bulloz.)
The drawing for this work, exhibited in the 1765 Salon, was the subject of a famous eulogy by Diderot who thought it 'beau, très beau, sublime; tout, tout', see *Diderot Salons*, eds. J. Seznec and J. Adhémar, 1960. ii, 157.
Lit: Rosenblum 1967. 37–9, 52–5.

75. EDWARD I AND ELEANOR OF CASTILLE. By John Deare, 1789–95. Marble, 83 × 97 cm. Private Collection. For a slightly earlier treatment of the subject, by Angelica Kauffmann, see A. Blunt: *The Art of William Blake*, 1959, pl. 5b.
Lit: J. T. Smith: *Nollekens and His Times*, 1829. ii, 326.

76. ROMAN CHARITY. By Gottlieb Schick, *c.* 1800. Oil on canvas, 100 × 125 cm. *Schweinfurt, Coll. Georg Schäfer*. (Photograph: Schäfer.)
Lit: Exh. Cat. *Klassizismus und Romantik in Deutschland*, 1966. no. 153.

77. BRUTUS SWEARING TO AVENGE LUCRETIA'S DEATH. By Gavin Hamilton, *c.* 1763. Oil on canvas, 208·3 × 270·5 cm. *London, Drury Lane Theatre*. (Photograph: Courtauld Institute.)
One of three versions of this subject painted by Hamilton in Rome. Engravings after the composition were published by D. Cunego.
Lit: E. K. Waterhouse in *Proceedings of the British Academy*, 1954. 57–74; R. Rosenblum in *Burl. Mag.* 1961. 8–16 and 146; B. Skinner in *Burl. Mag.* 1961. 146.

78. GENIUS OF DEATH ON THE MONUMENT TO POPE CLEMENT XIII. By Antonio Canova, 1787–92. Marble. *Rome, St Peter's*.
(Photograph: Alinari.)
Canova was commissioned to execute the monument in 1783, produced the *bozzetto* by 1785, began the full-scale *modello* 1787, modelled the 'genius' in March 1788, and completed the whole work in marble in 1792. (Canova archive, Museo Civico, Bassano del Grappa.) For the image of death in literature, see H. Hatfield: *Aesthetic Paganism in German Literature*, 1964. 24–32.

79. ENDYMION. By Anne-Louis Girodet-Trioson, 1793. Oil on canvas, 197 × 260 cm. *Paris, Louvre*. (Photograph: Giraudon.)
Lit: *Girodet 1767–1824*, exh. cat. *Musée de Montargis*, 1967. no. 13.

80. ANDROMACHE MOURNING HECTOR. By Jacques-Louis David, 1783. Oil on canvas, 275 × 203 cm. *Paris, École des Beaux Arts*. (Photograph: Giraudon.)
The full title is 'La Douleur et les regrets d'Andromache sur le corps d'Hector son mari'. It was David's *morceau de réception* for membership of the Academy.
Lit: R. Cantinelli: *David*, 1930. 34; L. Hautecoeur: *Louis David*, 1954. 66; Rosenblum 1967. 82 ff.

81. THE DEATH OF GENERAL WOLFE. By Benjamin West, 1770. Oil on canvas, 151 × 213 cm. *Ottawa, National Gallery of Canada*. (Photograph: Museum.)
Lit: C. Mitchell in *J.C.W.I.* 1944. viii, 20–33; E. Wind in *J.W.C.I.* 1947. x, 159–62.

82. KIMON, SON OF MILTIADES. By Jean-François-Pierre Peyron, 1782. Oil on canvas, 106 × 138 cm. *Paris, Louvre*. (Photograph: Archives.)

The full title is 'Cimon, fils de Miltiade, retirant de la prison le corps de son père'. The subject is derived from Valerius Maximus: Miltiades had died in prison and his son was able to obtain his body for burial only by surrendering himself.

Lit: Rosenblum 1967. 63.

83. MARAT ASSASSINÉ. By Jacques-Louis David, 1793. Oil on canvas, 165 × 126 cm. *Brussels, Musée Royaux des Beaux-Arts*. (Photograph: Giraudon.)

On the day before Marat's death a deputation, sent to visit him by the Jacobin club then under David's presidency, found him 'in his bath with a board before him on which he was writing his last thoughts for the people's salvation'. David wanted the corpse to be shown to the public in this attitude and although this proved impossible the body, the bath-tub and inkstand were exhibited in the church of the Cordeliers.

Lit: L.-J. David: *Notice sur le Marat de Louis David*, 1867; D. L. Dowd: *Pageant Master of the Republic*, 1948. 104–8; Rosenblum 1967. 82–4; K. Lankheit: *Der Tod Marats*, 1962.

84. MONUMENT TO THE ARCHDUCHESS MARIA CHRISTINA. By Antonio Canova, 1799–1805. Marble, 574 cm. high. *Vienna, Augustiner-Kirche*. (Photograph: Ritter.)

Canova began, in 1790, the *bozzetto* for a similar monument to be dedicated to Titian, but never executed. In 1799 he was commissioned to execute the present work. The marble was carved in Rome and sent to Vienna where Canova supervised its erection in 1805. (Canova archive, Museo Civico, Bassano del Grappa.)

85. MONUMENT TO GIOVANNI VOLPATO. By Antonio Canova, 1807–8. Marble, 190 cm. high. *Rome, SS Apostoli*. (Photograph: Anderson.)

Canova's first monument of this type is that to his first patron, Giovanni Falier, executed 1806–8 (*Venice, S Stefano*).

86. PORTRAIT OF CHRISTINE BOYER, WIFE OF LUCIEN BONAPARTE. By Antoine-Jean Gros, *c*. 1800. Oil on canvas, 213 × 134 cm. *Paris, Louvre*. (Photograph: Giraudon.)

For an essay on 'The Landscape Garden as a Symbol in Rousseau, Goethe and Flaubert' see E. M. Neumeyer in *Journal of the History of Ideas*, 1947, 187–217.

Lit: A. R. in *G.B.A.* 1895. ii, 335–6.

87. THE PARK AT STOURHEAD. Laid out by Henry Hoare, 1743–4 onwards. (Photograph: K. Woodbridge.)

Lit: K. Woodbridge in *Art Bull*. March 1965. 83–116.

88. LAITERIE DE LA REINE. By Hubert Robert and Thévenin, 1785–6. *Rambouillet, Château*. (Photograph: Giraudon.)

Hubert Robert seems to have been responsible for the design and the obscure Thévenin, whose Christian name is unknown, seems to have been no more than supervising architect. The interior was altered for Josephine in 1804 when the central table and consoles of marble replaced the furniture by Jacob (see 16 above) and the floor was renewed.

Lit: J. Langner in *Art de France*, 1963. 171–86.

89. GROTTO IN THE LAITERIE DE LA REINE. See No. 88 above.

The sculpture is a cast of the marble *nymphe Amalthée* by Pierre Julien now in the Louvre. It was carved in 1786–7 for the grotto and placed there in 1787; it was removed in 1797.

90. CUP AND SAUCER. Made at Sèvres, 1788. Porcelain, 7·5 cm. high. *Sèvres, Musée Nationale de Céramique.* (Photograph: Giraudon.)

91. VIRGIL'S TOMB. By Joseph Wright, 1779. Oil on canvas, 101·5 × 126·7 cm. *Parwich Hall, nr. Ashbourne, Derbyshire, Coll. Crompton-Inglefield.* (Photograph: Courtauld Institute.)
 Lit: B. Nicolson: Exh. Cat. *Joseph Wright of Derby,* 1958. 17.

92. THE VALE OF NARNI. By Richard Wilson, 1770–71. Oil on canvas, 66 × 49 cm. *London, Coll. Brinsley Ford.* (Photograph: Birmingham Museum.)
 The title is traditional and the scene imaginary.
 Lit: W. G. Constable: *Richard Wilson,* 1953. 28.

93. IDEAL LANDSCAPE WITH RAINBOW. By Joseph Anton Koch, 1805. Oil on canvas, 116·5 × 112·5 cm. *Karlsruhe, Staatlichen Kunsthalle.* (Photograph: Museum.)
 Lit: W. Stein: *Die Erneuerung der Heroischen Landschaft nach 1800,* 1917. 48; R. Zeitler: *Klassizismus und Utopia,* 1954. 170–82.

94. THE MONUMENTS OF EASTER ISLAND. By William Hodges, *c.* 1774. Oil on canvas, 77·3 × 121·6 cm. *Greenwich, National Maritime Museum on loan from the Admiralty.* (Photograph: Museum.)
 Lit: B. Smith: *European Vision of the South Pacific 1768–1850,* 1960. 51–2.

95. CUPID AND PSYCHE. By François-Pascal Gérard, 1798. Oil on canvas, 186 × 132 cm. *Paris, Louvre.* (Photograph: *Archives.*)

96. CLOCK. Anonymous, probably made in Paris, *c.* 1810. Gilt bronze and marble, 67 cm. high. *London, Buckingham Palace.* Reproduced by gracious permission of H.M. the Queen.
 There is a similar clock in the collection of Sir William Garthwaite and Mr Francis Watson has informed me of another in the Royal Collection, Stockholm.
 Lit: *Country Life,* 30 August 1962.

97. THE ARC DU CARROUSEL. By Charles Percier and Pierre-François-Léonard Fontaine, 1806–7. *Paris.* (Photograph: Giraudon.)
 Lit: M. L. Biver: *Pierre Fontaine,* 1964. 83–97.

98. DESIGN FOR A BED. By Charles Percier and Pierre-François-Léonard Fontaine, 1801. Engraving, 30 × 21 cm. From *Recueil de décorations intérieures,* 1801.
 Lit: S. Giedion: *Mechanization takes Command,* 1955. 329–44.

99. COIN CABINET. By Martin-Guillaume Biennais, *c.* 1800–14. Ebony and silver, 90 cm. high. *New York, Metropolitan Museum.* (Photograph: Museum.)
 The design, derived from the pylon of Ghoos, was probably by Vivant Denon.
 Lit: C. Eames in *Metropolitan Museum of Art Bulletin,* December 1958. 108–12.

100. CRADLE OF THE KING OF ROME. Designed by Pierre-Paul Prud'hon and made by Jean-Baptiste Claude Odiot and Pierre-Philippe Thomire, 1811. Silver gilt, mother-of-pearl, velvet, silk and tulle. *Vienna, Schatzkammer of the Kunsthistorisches Museum.* (Photograph: Museum.)
 The cradle was made for presentation to the infant king by the City of Paris.
 Lit: A. Weixlgärtner in *Kunst und Kunsthandwerk,* XIX, 1916. 353–71.

101. NAPOLEON IN HIS STUDY. By Jacques-Louis David, 1812. Oil on canvas, 202 × 124·5 cm. *Washington, National Gallery of Art, Kress Collection.* (Photograph: Museum.)

Napoleon's remark on the picture is quoted by both E.-J. Delécluze: *Louis David, son école et son temps*, 1855. 347, and Jules David: *Le Peintre Louis David*, 1880. 487.

102. BATHROOM IN PALAZZO PITTI, FLORENCE. Designed by Giuseppe Cacialli, 1811–12. *Florence.* (Photograph: Alinari.)
Cacialli is said to have worked from designs by Percier and Fontaine. The stuccos are by Marinelli.
Lit: P. Marmottan: *Les Arts en Toscane sous Napoléon*, 1901. 143–4; G. Hubert: *La Sculpture dans l'Italie Napoléonienne*, 1964. 384.

103. VASE. Made at Sèvres, *c.* 1805. Porcelain, 66·5 cm. high. *Malmaison, Château.* (Photograph: Giraudon.)
The painting by Robert shows Napoleon at Potsdam.

104. BARRACKS. Designed by Peter Speeth, 1809–10. *Würzburg.* (Photograph: Marburg.)
Built originally as a barracks and subsequently used as a prison.

105. TEATRO SAN CARLO. By Antonio Niccolini, 1810–16. *Naples.* (Photograph: Alinari.)
The façade was designed 1810–12, partly destroyed by fire in 1816 but rebuilt as before.
Lit: C. L. V. Meeks: *Italian Architecture 1750–1914*, 1966. 121–4.

106. EL SUEÑO DE LA RAZON PRODUCE MONSTRUOS. By Francisco de Goya y Lucientes, 1796–8. Etching, 18·2 × 12·2 cm.
There are two main literary sources for this etching, a passage in *Elegias morales* by Meléndez Valdés describing the torments of melancholia,

> . . . Sombre melancholy built there its horrid throne,
> Where omnipresent pains, sobs,
> Anguish, grief and bitter plaints
> Made their mansion,
> With all the monsters which, in its accursed delirium,
> Perturbed reason can beget.

The other and more surprising source appears to be Horace's *Ars Poetica* which Goya would have read in the translation of Tomás de Yriarte (1777) and which includes the lines: 'If through caprice a painter were to unite to a human shape the neck of a horse and limbs of various beasts, which he would adorn with different feathers. . . . Could you refrain from laughing O Pisos? Well, friends, believe that to this painting in all manners are similar the compositions whose insubstantial ideas resemble the dreams of delirious sick men.' See G. Levitine in *Art Bull.* March 1955. 56.

107. LE TREMBLEMENT DE TERRE. By Jean-Pierre Saint-Ours,1799–1806. Oil on canvas, 142 × 185 cm. *Lausanne, Musée Cantonal des Beaux Arts (on loan to Tribunal de district, Monthenon).* (Photograph: Museum.)
Saint-Ours recorded that the first version was completed in 1799: this is probably the picture now in the Musée d'Art et d'Histoire, Geneva. The larger and more elaborate Lausanne version was completed in 1806: a sketch for it dated 1802 was formerly in the Marc Debrit collection.
Lit: D. Baud-Bovy: *Peintres Genevois 1702–1817*, 1903, 153; ibid. *Peinture Genevoise*, 1924, pl. xviii, xxiii.

108. OSSIAN RECOIT DANS LE WALHALLA LES GENERAUX DE LA REPUBLIQUE. By Anne-Louis Girodet-Trioson, 1802. Oil on canvas, 192 × 182 cm. *Malmaison, Château.* (Photograph: Bulloz.)
Intended for the grand salon at Malmaison, the painting was a very

elaborate commentary on the treaty of 1801 (see G. Levitine in *G.B.A.* 1956. ii, 39–56). 'Ossian' was one of Napoleon's favourite authors.

109. OEDIPUS AND THE SPHINX. By Jean-Auguste-Dominique Ingres, 1808. Oil on canvas, 189 × 144 cm. *Paris, Louvre.* (Photograph: *Archives.*) Painted in Rome but considerably reworked before it was exhibited at the 1827 Salon.
Lit: G. Wildenstein: *Ingres*, 1956. 171; for the relations between Ingres and the *Barbus*, see N. Schlenoff: *Ingres ses sources littéraires*, 1956. 61–90; for the *Barbus*, see E.-J. Delécluze: *Louis David, son école et son temps*, 1885. *passim*, and G. Levitine in *Studies in Romanticism*, 1962. i, pt. 4.

Books for Further Reading

The best account of Neo-classical painting, sculpture and architecture in Europe and North America is R. Rosenblum, *Transformations in Late Eighteenth Century Art* (Princeton, N.J., 1967). R. Zeitler, *Klassizimus und Utopia* (Stockholm, 1954), considers many of the essential issues but deals with only a few artists (David, Carstens, Koch, Canova and Thorwaldsen). W. Friedlander: *David to Delacroix* (Cambridge, Mass., 1952) though brief is of seminal importance. G. Pauli, *Die Kunst des Klassizimus und der Romantik* (Berlin, 1925), is of value for its numerous illustrations. K. Lankheit, *Revolution und Restauration*, (Baden-Baden, 1965,) is informative but deals mainly with Romanticism. M. Praz, *Gusto Neo-classico* (Naples, 1959) is spirited but controversial.

On architecture E. Kaufmann, *Architecture in the Age of Reason* (Cambridge, Mass., 1955), was a pioneer work. The opening chapters of H.-R. Hitchcock, *Architecture: Nineteenth and Twentieth Centuries* (Harmondsworth, 1958), are authoritative and penetrating. On painting and sculpture there is F. Novotny, *Painting and Sculpture in Europe 1780–1880* (Harmondsworth, 1960). On painting alone M. Levey, *Rococo to Revolution* (London, 1966), is stimulating and perceptive.

French architecture is chronicled in detail by L. Hautecoeur, *Histoire de l'architecture classique en France*, vols. iv and v (Paris, 1952 and 1953). Though limited in range M. Gallet, *Demeures parisiennes, l'époque de Louis XVI* (Paris, 1964), is excellent. For French painting J. Locquin, *La peinture d'histoire en France de 1747 à 1785*, is still indispensible.

For England the essential source on architecture is J. Summerson, *Architecture in Britain 1530–1830* (Harmondsworth, revised edn 1963). British painting is best dealt with in E. K. Waterhouse, *Painting in Britain 1530–1830* (Harmondsworth, 1953). For painting and sculpture there is D. Irwin, *English Neoclassical Art* (London, 1966), and for sculpture alone M. D. Whinney, *Sculpture in Britain 1530–1830* (Harmondsworth, 1964). For architecture in the United States there is T. F. Hamlin, *Greek Revival Architecture in America* (New York, 1944).

The standard survey of German Neo-classical art is E. von Sydow, *Die Kultur des Deutschen Klassizimus* (Berlin, 1926). For German architecture there is S. Giedion, *Spätbarocker und romantischer Klassizismus*, Munich, 1922, in which the term Romantic-classicism was first used. Italian Neoclassical art and architecture is well chronicled and illustrated in E. Lavagnino, *Arte Moderna*, vol. i (Turin, revised edn 1961). An exhaustive account of Italian sculpture is provided by G. Hubert, *La sculpture dans l'Italie napoléonienne* and *Les sculpteurs italiens en France . . . 1790–1830* (both

Paris, 1964). For Spanish sculpture there is E. P. Canalis, *Escultura Neo-classica Española* (Madrid, 1958). For monographs and articles on individual artists and works of art, see my catalogue of plates.

On the cult of antiquity L. Hautecoeur, *Rome et la renaissance de l'antiquité à la fin du XVIII⁰ siècle. Essai sur les origines du style Empire* (Fontemoing, 1912), is still very useful; also L. Bertrand, *La fin du classicisme et le retour à l'antique* (Paris, 1895), though mainly concerned with French literature. H. T. Parker, *The Cult of Antiquity and the French Revolutionaries* (Chicago, 1937), if of value mainly for its account of the influence of antiquity on politics. H. Ladendorf, *Antikenstudium und Antikenkopie* (Berlin, 1958), and C. Vermeule, *European Art and the Classical Past* (Cambridge, Mass., 1964), both contain useful information. For the history of collecting antique statues the essential source is still A. Michaelis, *Ancient Marbles in Great Britain* (Cambridge, 1882). For archaeological activity in Rome C. Pietrangeli, *Scavi e Scoperte di Antichità sotto il pontificato di Pio VI* (Rome, 1958), is excellent.

For Marxist accounts of relations between politics and arts in the late eighteenth century there is a chapter in G. Plekhanov, *Art and Social Life* (1910 in Russian, English trans., London, 1953), some illuminating essays by F. Antal reprinted in *Classicism and Romanticism* (London, 1966) and the more tendentious M. H. Brown, *The Painting of the French Revolu-tion* (New York, 1938). These works should be read in conjunction with up-to-date histories of France, e.g. A. Cobban, *A History of Modern France*, vol. i (Harmondsworth, revised edn 1963), with good bibliography; G. Lefebvre, *The French Revolution from its Origins to 1793* (London, 1962) and *The French Revolution from 1793 to 1799* (London, 1964). E. J. Hobsbawm, *The Age of Revolution. Europe 1789–1848* (London, 1962) is penetrating and deals with a wider field. J. A. Leith, *The Idea of Art as Propaganda in France 1750–1799* (Toronto, 1965) is level-headed though better on ideas than on art.

There is no adequate account of artistic theory in late eighteenth-century Europe. J. Schlosser Magnino, *La Letteratura Artistica* (revised O. Kurz, Florence, 1960), lists the essential works. Though devoted to literature, R. Wellek, *A History of Modern Criticism . . . The Later Eighteenth Century* (London, 1955), is useful for the arts. N. Pevsner, *Academies of Art* (Cambridge, 1940), is the key work on academic theory. There are several works of French artistic theory: W. Folkierski, *Entre le classicisme et le romanticisme* (Paris and Cracow, 1925) and, for a good general introduction, R. G. Saisselin, *Taste in Eighteenth Century France* (Syracuse, N.Y., 1965). Two valuable studies have been devoted to the sublime but both deal almost exclusively with England – S. H. Monk, *The Sublime: A Study in Critical Theories in XVIII Century England* (New York, 1935) and W. J. Hipple, *The Beautiful, the Sublime and the Picturesque* (Carbondale, 1957).

There are excellent works on and editions of the main theorists. For Diderot there is J. Seznec, *Essais sur Diderot et l'antiquité* (Oxford, 1957), and the J. Seznec and J. Adhémar edition of *Diderot: Salons* (Oxford, 1957 – still in course of publication). P. Vernière has edited a handy one-volume selection of D. Diderot, *Œuvres Esthétiques* (Paris, 1965). For Winckel-

mann the standard life is C. Justi, *Winckelmann und seine Zeitgenossen* (1866; the most recent edn, Cologne, 1956); his letters are collected in *Winckelmanns Briefe*, ed. W. Rehm and H. Diepolder (Berlin, 1952–7). But there is no good modern edition of his works and the only English translation of the *Kunst des Altertums* is unreliable. Walter Pater's essay on him (in *The Renaissance*) is still worth reading. There is a somewhat inaccurate and generally perverse but amusing account of him in E. M. Butler, *The Tyranny of Greece over Germany* (Cambridge, 1935). H. Hatfield, *Winckelmann and his German Critics* (New York, 1943) and *Aesthetic Paganism in German Literature* (Cambridge, Mass., 1964) are both excellent. The standard English translation of Lessing, *Laocoön*, is that by W. A. Steel in Everyman's Library (London, 1930). The literature on Goethe is vast. B. Fairley, *A Study of Goethe* (London, 1947), provides a good introduction; W. H. Bruford, *Culture and Society in Classical Weimar* (Cambridge, 1962), gives an account of the artistic and other ideas of Schiller and Herder as well as Goethe. The best translation of Goethe's *Italian Journey* is by W. H. Auden and E. Mayer (London, 1962). S. Körner, *Kant* (Harmondsworth, 1955) is helpful and includes a brief account of Kant's aesthetic theory. For Reynolds there is F. W. Hilles, *The Literary Career of Sir Joshua Reynolds* (Cambridge, 1936), and R. R. Wark's immaculate edition of his *Discourses on Art* (San Marino, California, 1959).

For the philosophical background the literature is immense. P. Hazard, *European Thought in the Eighteenth Century* (London, 1954), is valuable and more serious than the chatty style might lead one to expect. P. Gay, *The Enlightenment: The Rise of Modern Paganism* (New York, 1966; London, 1967), with another volume still to come, is much fuller and more penetrating and includes a vast bibliography. A. O. Lovejoy, *Essays in the History of Ideas* (Baltimore, 1948) is indispensable for anyone approaching the history of eighteenth-century thought, aesthetic as well as philosophical. E. R. Wasserman (ed.), *Aspects of the Eighteenth Century* (Baltimore and London, 1965) contains several important essays.

ADDENDA (1976)

In the past nine years a great deal has been published on late-eighteenth-century European and American art and architecture. Lorenz Eitner: *Neoclassicism and Romanticism 1750–1850* (Englewood Cliffs, New Jersey, 1970), in the 'Sources and Documents in the History of Art' series, provides a unique introduction to the period in the form of a thoroughly annotated anthology of writings by the artists and their contemporaries. W. Kalnein and M. Levey: *Art and Architecture of Eighteenth Century France* (Harmondsworth, 1972), in the 'Pelican History of Art' series, and H. Keller: *Die Kunst des 18 Jahrhunderts* (Berlin, 1971), in the Propylaen-Kunstgeschichte are both very useful surveys. J. Starobinski: *1789, les emblèmes de la Raison* (Paris, 1973), is a stimulating account of art at the outbreak of the French Revolution.

Several exhibition catalogues include valuable introductory essays as well as up-to-date bibliographies covering periodical and other literature. The Council of Europe exhibition, *The Age of Neo-Classicism* (Royal Academy and Victoria and Albert Museum, London, 1972), was large and included

all the arts; *French Painting 1774–1830* (Grand Palais, Paris, as *De David à Delacroix*, Detroit Institute of Arts and Metropolitan Museum, New York, 1974–5), broke new ground. The catalogue is invaluable. Two exhibitions of drawings are notable, *Dessins français de 1750 à 1825: Le Néo-classicisme* (Cabinet des Dessins, Musée du Louvre, Paris, 1972), and *Le Néo-classicisme français: Dessins des Musées de Province* (Grand Palais, Paris, 1974–5). Two very interesting exhibitions, with valuable catalogues, were held at the Kunsthalle in Hamburg, *Ossian und die Kunst um 1800* (1974), and *Johan Tobias Sergel 1740–1814* (1975), also shown in the Thorvaldsens Museum, Copenhagen.

Several monographs on leading artists have been published. Outstanding is Gert Schiff: *Johann Heinrich Füssli* (Zurich and Munich, 1973). N. Powell: *Fuseli: The Nightmare* (London and New York, 1973), provides a study of this artist's most famous picture in the context of late-eighteenth-century thought. The literature on Jacques-Louis David has been augmented by R. L. Herbert: *David, Voltaire, 'Brutus' and the French Revolution* (London and New York, 1972), R. Verbraeken: *Jacques-Louis David jugé par ses contemporains et par la postérité* (Paris, 1973), and D. and G. Wildenstein: *Documents complémentaires au catalogue de l'oeuvre de Louis David* (Paris, 1973). On Greuze there is A. Brookner: *Greuze. The Rise and Fall of an Eighteenth Century Phenomenon* (London, 1972). The most notable recent account of an English painter of the period is Benedict Nicolson: *Joseph Wright of Derby, Painter of Light* (London and New York, 1968). Cross-currents between French and German painting are examined in Wolfgang Becker: *Paris und die deutsche Malerei 1750–1840* (Munich, 1971). Less has been written on sculpture but P. A. Mennesheimer: *Das klassizistische Grabmal, eine Typologie* (Bonn, 1969), is valuable. The major Neo-classical sculptor is the subject of stimulating lectures by G. C. Argan, *Antonio Canova* (Rome, 1969) and a fully illustrated catalogue of works by G. Pavanello, with introduction by Mario Praz: *L'Opera completa del Canova* (Milan, 1976). For architecture, John Harris: *Sir William Chambers* (London, 1970), and Jean-Marie Pérouse de Monclos: *Etienne-Louis Boullée* (Paris, 1969), are both standard monographs. Adolf Max Vogt: *Boullés Newton-Denkmal* (Basel and Stuttgart, 1969), and the same author's *Russische und französische Revolutions-Architektur 1917 1789* (Cologne, 1974), discuss with insight Neo-classical architectural ideals. For French decorative arts Svend Eriksen's *Early Neo-Classicism in France* (London, 1974), covers 1750–70.

The most notable additions to the literature on the philosophical background is Peter Gay: *The Enlightenment, an Interpretation: The Science of Freedom* (New York and London, 1970), the second of his two volumes on eighteenth-century thought. For artistic theory there is M. Sutter: *Die kunsttheoretische Begriffe des Malerphilosophen Anton Raphael Mengs* (Munich, 1968). Katharina Scheinfuss (ed.): *Von Brutus zu Marat, Kunst in National-konvent 1789–1795* (Dresden, 1973) is an annotated collection of French Revolutionary texts relating to the arts, translated into German.

Index

Numbers in *italics* refer to plate numbers

Abildgaard, Nikolai Abraham, 111, 135, 201, 203, *52*, *71*
Academies of Art, 22, 85, 88–9, 116, 139
Adam, James, 126
Adam, Robert, 14, 29, 54, 97, 123
 Seton Castle, 125, 202, *61*
 Syon House, 202, *60*
Aeschylus, 64, 66
Agrigentum, 123
Albani, Cardinal Alessandro, 31
Alberti, Leone Battista, 106
Alembert, Jean Le Rond d', 17, 23, 120
Alfieri, Conte Vittorio, 71, 72
Algarotti, Conte Francesco, 94, 136, 199
Alison, Archibald, 161–4
Allan, David, 113, 201, *53*
Amiens, Peace of, 184
Angelini, Giuseppe, 197
Angiviller, Charles-Claude Flahaut de la Billarderie, comte d', 71, 72, 75, 82, 198
Antique, à l', costume, 25, 193, 194
Antique art, attitudes to, 21, 106, 116, 172
Antiquity, attitudes to, 21, 22, 43–67, 112–13
Apelles, 45
Apollo Belvedere, 60, 194
Ariosto, Lodovico, 161
Artist, status of, 19, 88–9
Artois, Charles-Philippe, comte d', 66, 70, 72, 198
Athens, Arch of Hadrian, 107
 Choragic Monument of Lysicrates, 107
 Parthenon, 126
 Temple of the Winds, 107
Auguste, Robert-Joseph, 14

Azara, Don José-Nicolas, Cav. d', 89

Baalbeck, 123
Baltimore Cathedral, 57, 197, *24*
Bara, Joseph, 76
Barbus, *see*: Primitifs
Baretti, Giuseppe, 89, 199, *36*
Baroni, Eugenio, 122
Baroque art, attitudes to (*see also*: Rococo), 29
Batoni, Pompeo Girolamo, 31, 194, *5*
Batteux, Charles, 106
Baudelaire, Charles-Pierre, 76
Beaumarchais, Pierre-Augustin Caron de, 72
Beloeil, 159
Bellicard, Charles, 45
Bellori, Giovanni Pietro, 106
Benefial, Marco, 22
Berlin, National Theatre, design for, 203, *69*
Berlin, Sir Isaiah, 13, 184
Bernard, Pierre, 201
Bernardin de Saint-Pierre, Jacques-Henri, 105, 147
Bernini, Gianlorenzo, 39, 150
Bianchini, Francesco, 45
Biennais, Martin-Guillaume, 206, *99*
Birmingham, Lunar Society, 94–8
Blackwell, Thomas, 64
Blair, Hugh, 65
Blair, Robert, 146
Blake, William, 113–14, 186
Blondel, Jacques-François, 25
Boileau (Despréaux, Nicolas), 145
Boilly, Léopold, 80
Bonaparte, Elisa, 179
 Mme Lucien, 159, 205, *86*

Bonaparte, – *contd*
Napoleon, *see*: Napoleon
Bossi, Benigno, 194
Bossuet, Jacques-Bénigne, 23
Boswell, James, 141
Bottari, Mgr Giovanni, 29
Bouchardon, Edmé, 25, 116, 193, *2*
Boucher, François, 33
Boullée, Étienne-Louis, 85, 123, 139, 199, 203, *34, 72*
Boulton, Matthew, 94, 97, 110, 200, *42*
Brongniart, Alexandre-Théodore, 126
Buffon, Georges-Louis Leclerc, comte de, 94
Burke, Edmund, 122, 141
Burney, Frances, 105
Byron, George Gordon, 6th Baron, 61

Cacialli, Giuseppe, 207, *102*
Caffieri, Philippe, 193, *3*
Calas, Jean, 17, 88
Cambridge, Trinity College, 83
Canova, Antonio, 14, 32, 37
 and Bonaparte family, 171
 drawing in life class, 116
 opinions on copying, 107; on politics, 78
 works of: bozzetti, 101–2
 Cupid and Psyche, 102–4, 118, 147, 200, *44, 45*
 Hercules and Lichas, 77–8, 118, 199, *32*
 Monuments to Clement XIII, 150, 204, *78*; Clement XIV, 39–42, 156, 195, *10*; Giovanni Falier, 205; Maria Christina, 156, 205, *84*; Giovanni Volpato, 158, 205, *85*
 Napoleon, bust of, 179; statue of, 122
 Theseus and the Dead Minotaur, 37–9, 195, *9*
 Venus Crowning Adonis, 102
Carmontelle, Louis Carrogis called de, 194
Caroline, Queen, 83
Carrara, marble workshops at, 179
Carstens, Asmus Jakob, 114, 135, 201, 203, *55*

Cassel, Landgrave Friedrich of, 85
Cassel, Museum, 85
Catherine II of Russia, 89
Catinat, Maréchal de, 82
Caylus, Ann-Claude-Philippe de Tubières, comte de, 45
Ceramics, 14, 48, 100, 164, 198, 201, *18, 51, 90, 103*
Cesarotti, Melchiorre, 65
Chambers, Sir William, 126
Chaudet, Antoine-Denis, 179
Chénier, André, 71, 75
Chinard, Joseph, 101
Chodowiecki, Daniel Nikolaus, 88
Cicero, Marcus Tullius, 83, 106
Clarke, Samuel, 83
Claude Gellée, 159, 161, 167–8
Clement XIII, monument to, 150, 204, *78*
Clement XIV, monument to, 39–42, *10*
Clérisseau, Charles-Louis, 109, 201
Clodion, Claude Michel called, 116
Cochin, Charles-Nicolas, the younger, 23, 45
Cook, Captain James, 116, *56*
Copley, John Singleton, 88
Copying, attitudes to practice of, 61, 107
Corday, Charlotte, 155
Corneille, Pierre, 35
Correggio (Antonio Allegri), 59
Cowper, William, 19, 63, 197
Crébillon, Prosper Jolyot de, 19
Cunego, Domenico, 204
Cuvillier, Charles-Étienne-Gabriel, 198

Dacier, Mme, 64
Dalton, John, 123
Dandré-Bardon, François, 36
Dannecker, Johann Heinrich, 101, 118, 201, *57*
Dante Alighieri, 62, 64, 66, 161
Darwin, Erasmus, 94
David, Jacques-Louis, 14, 200
 antique paintings, drawings of, 47
 and Canova, 40
 and French Revolution, 71–7
 and Napoleon, 171, 175, 179
 opinion on nudity, 122

sensibility of, 141
studio of, 65, 186–9
Andromache Mourning Hector, 66, 146, 150, 204, *80*
Belisarius, 33, 71, 143, 194, *7*
Brutus, 72–6, 82, 155, 197, 198, *27*
The Dead Marat, 76, 80, 155–6, 205, *83*
Death of Bara, 76, 80
Death of Le Peletier de Saint-Fargeau, 76
Death of Socrates, 76
Intervention of Sabine Women, 76–7, 118, 125, 187, 198, *30*
Marie Antoinette (drawing), 76, 198, *29*
Oath of the Horatii, 32, 34–7, 39, 71–2, 82, 172, 194–5, *8*, *11*
Oath in the Tennis Court, 75–6
Paris and Helen, 66, 72, 198
Portraits of Lavoisier, 72, 198, *28*; Leroy, 89, 199, *37*; Napoleon (crossing the Alps), 175, (in his study), 179, 206, *101*
David, Marie-Geneviève Pécoul, Mme, 70
Deare, John, 117, 143, 204, *75*
Death, attitudes to, 146–59
Genius of, 147–50
Delacroix, Eugène, 187
Delécluze, Étienne-Jean, 37, 187
Delft, monument to Grotius at, 83
Denon, Dominique Vivant, baron, 175, 184, 206
Descartes, René, monument to, 83
Desprez, Louis-Jean, 83
Diderot, Denis, 18, 45, 82, 87, 144
 on Bouchardon, 25
 bust of, 92, 200, *38*
 on David, 34
 and *Encyclopédie*, 17
 on genius and sublimity, 146
 on Greuze, 146, 204
 on imitation of the Antique, 21
 on morality and art, 80
 on nudity, 118
 on patronage, 89
 and Pigalle's statue of Voltaire, 120, 202
 on posterity, 153
 on sketches, 101

 on subjects for painters, 142
 on Vien, 196
Dionysius of Halicarnassus, 35
Doric order, 36, 126
Dresden, Art Gallery, 114
 Zwinger, 22
Drouais, Jean-Germain, 195
Dubois-Crancé, Edmond-Louis-Alexis, 75
Du Fourny, Léon, 127
Dundas, Thomas, 1st Baron, portrait of, 194, *5*
Duqueylar, Paul, 187
Dyer, John, 51

Egyptian art, attitudes to, 59, 173–5, 184
Ehrensvärd, Karl August, 107, 127, 202, *62*
Empire style, 14, 15, 171–84
Encyclopédie, 17, 80, 146
Enlightenment, 13, 17, 81, 152–3
'Etruscan style', 29, 48, *17*
'Etruscan vases', 196
Euripides, 187
Exeter, 5th Earl of, 193
Exhibitions of art, 88

Fabre, François-Xavier, 194
Falier, Giovanni, 205
Flaxman, John, 14, 19, 101
 Goethe's opinion of, 113
 and early Italian paintings, 37
 illustrations to Homer, 63, 88, 197, 201, *25*, *54*
 linear style, 114
 on Piranesi, 53
 political views of, 71
 and Wedgwood, 97
Florence, Galleria degli Uffizi, 86
 Palazzo Pitti, 207, *102*
 S. Croce, 83
Fontaine, Pierre-François-Léonard, 173, 184, 206, 207, *97*, *98*
Fontenelle, Bernard Le Bovier de, 45
Foscolo, Ugo, 159
Fothergill, John, 200, *42*
Fragonard, Jean-Honoré, 116
Franzoni, Giuseppe, 201
Frézier, Amédée-François, 21
Friedrich, Caspar David, 146

Furniture, 47, 110–11, 171, 175, 179, 184, 196, 201, 206, *3*, *16*, *17*, *50*, *52*, *98*, *99*, *100*

Fuseli, Henry (Füssli, Heinrich)
 Achilles at Pyre of Patroclus, 66, 197, *26*
 Artist Moved by . . . Ancient Ruins, 53, 196, *20*
 on copying, 107
 on Nature, 105
 on patronage, 19
 translation of Winckelmann, 30

Gabriel, Ange-Jacques, 25, 26, 193, *1*
Galileo Galilei, monument to, 83
Genelli, Janus, 85
George III, 29
Gérard, François-Pascal, 171, 206, *95*
Gessner, Salomon, 141, 167
Ghoos, pylon at, 175, 206
Gibbon, Edward, 65–6, 87
Gilly, Friedrich, 135, 203, *69*
Giotto di Bondone, 37
Girardon, François, 25
Girodet-Trioson, Anne-Louis, 186–7
 Endymion, 150, 186, 204, *79*
 Hippocrates, 186
 Horatius killing his sister, 194
 Ossian, 186, 207, *108*
Gluck, Christoph Willibald, 21
Goût grec, *see*: Greek taste
Goethe, Johann Wolfgang von, 54, 64, 87, 195
 Altar of Good Fortune designed by, 130, 203, *64*
 on Flaxman, 113
 on Genius of Death, 149
 on the Ideal, 104–5
 on Nature, 106
 on Ossian, 64
 on Piranesi, 53
 on Winckelmann, 58
Gondouin, Jacques, 70, 130, 203, *66*
Goya y Lucientes, Francisco de, 80, 185, 207, *106*
Gray, Thomas, 152
Greek architecture, attitudes to, 50–51, 126–7

Greek taste (*goût grec*), 18, 26, 27, 194
Greek vases, 113, 196
Greuze, Jean-Baptiste, 70–71, 88
 Drunkard's Return, 143, 199, *33*
 Malédiction paternelle, 146
 Septimus Severus and Caracalla, 143, 203, *73*
 Wicked Son Punished, 204, *74*
Grimm, Baron Friedrich Melchior, 87, 89, 120, 142
 on Bouchardon, 193
 Correspondance littéraire, 89, 202
 on David, 146
 on the Greek taste, 27, 194
Gros, Antoine-Jean, baron, 159, 205, *86*
Grosley, Pierre-Jean, 194
Grotius, Hugo, monument to, 83
Guasco, Abbé del, 199
Guercino, Francesco Barbieri called, 198
Guérin, Daniel, 71
Guérin, Pierre-Narcisse, baron, 77, 198–9, *31*

Hagley Hall (Worcs.), 126
Hamann, Johann Georg, 64
Hamilton, Gavin, 31, 37, 39, 45, 88, 147, 204, *77*
Hegel, Georg Wilhelm Friedrich, 61
Helvétius, Claude-Adrien, 120
Herculaneum, 43–9
Herder, Johann Gottfried von, 61, 64, 150
 monument to, 85
Herschel, Sir William, 200
Hervey, John, Lord, 193
Hervey, James, 146
Hesiod, 64, 66
Hirt, Aloys, 86
Hoare, Henry, 161, 205
Hodges, William, 169, 206, *94*
Homer, 145, 146, 161, 187
 attitudes to, 62–70
 illustrations to, 142, 197, *25*, *26*, *54*
 translations of, 63
Hope, Thomas, 184
Horace (Quintus Horatius Flaccus), 207

Houasse, Michel-Ange, 22
Houdon, Jean-Antoine, 83, 92, 200, *38*

Ideal, the, 101–5
Imitation, 21, 54, 61, 107–9
Ingres, Jean-Auguste-Dominique, 187–90, 208, *109*

Jackson, John Baptist, 81
Jacob, Georges, 196, 205, *16*
Jacobin club, 75
Jefferson, Thomas, 107–9, 200, *47*
Johnson, Dr Samuel, 141, 152
Jones, Inigo, 22
Julien, Pierre, 118, 205

Kant, Immanuel, 85, 106, 114
Karlskrona, 127, 202, *62*
Kauffmann, Angelica, 204
Kirby, Joshua, 129, 203, *63*
Klinger, Max, 122
Klopstock, Friedrich Gottlieb, 64
Koch, Joseph Anton, 135, 168, 201, 206, *93*

La Font de Saint-Yenne, 23, 44, 85
La Fontaine, Jean de, statue of, 82
Lalive de Jully, Ange-Laurent de, 193
Lally-Tollendal, Thomas-Arthur, 198
Landscape gardening, 159–64
Landscape painting, 159–69
Laocoön, 61
La Motte, Antoine Houdar de, 63
Latrobe, Benjamin, 14
 Baltimore Cathedral, 57, 197, *24*
 Capitol, Washington, 109, 130, 201, *49*
Laugier, Marc-Antoine, 29, 123–4, 202
Lavater, Johann Caspar, 94
Lavoisier, Antoine, portrait of, 72, 198, *28*
Le Brun, Charles, 23, 82
Lebrun, Jacques, 80
Ledoux, Claude-Nicolas, 14, 42, 57, 109–10, 123, 126, 180
 architecture parlante, 139
 architecture of pure geometry, 130, *67*

Barrières, 32, 42, 70, *13*
Hôtel d'Hallwyl, 42, 195, *12*
Maison des gardes agricoles, 130, 203, *67*
Lefebvre, Georges, 70
Le Lorrain, Louis-Joseph, 193, *3*
Le Mans, Musée Tessé, 93
Leningrad, Academy of Arts, 85
 Admiralty, 130, 203, *65*
 Bourse (now Naval Museum), 109, 201, *48*
Lenoir, Alexandre, 86
Lenormant de Tournehem, 22
Le Nôtre, André, 64
Le Peletier de Saint-Fargeau, Louis-Michel, painting of, 76
Leroy, Alphonse, portrait of, 89, 199, *37*
Lessing, Gotthold Ephraim, 29, 118, 141, 148
Ligne, Charles-Joseph Lamoral, prince de, 159
Linear style, 20, 113–14, 173
Lisbon earthquake, 186
Livy (T. Livius), 23, 35, 82, 142
Locke, John, bust of, 83
Lodoli, Carlo, 136
London, Bank of England, 57, 197, 23
 Chelsea Hospital stables, 135, 203, *70*
 Westminster Abbey, 83
'Longinus', 145
Louis XIV, statue of, 25
Louis XIV style and revival of, 22, 23, 27, 34, 82
Louis XV, statue of, 25, *2*
Louis XVI, 69–70
Lovejoy, Arthur O., 105
Lowther, Sir James, 123
Lully, Jean-Baptiste, 25
Lysippos, 59

Mackenzie, Henry, 141
Macpherson, James, 64–5
Madrid, Prado, 94
Mälby, 107
Malmaison, Château, 186
Marat, Jean-Paul, 76, 155–6, 205, *83*
Marcus Aurelius, statue of, 25

Maria Christina, Duchess of Saxe-Teschen, monument to, 156, 205, *84*

Marie Antoinette, Queen, 76, 163, *29*

Mariette, Jean-Pierre, 54

Marigny, Abel-François Poisson, marquis de, 23

Marinelli, 207

Marmontel, Jean-François, 120

Mechel, Christian von, 86

Memmo, Andrea, 83, 136

Mengs, Anton Raphael, on copying and imitation, 107
on the Ideal, 105
on Pompeian paintings, 45
Gedanken über die Schönheit, 30
Jupiter and Ganymede, 46, 195, *14*
Parnassus, 31, 47, 117, 194, *6*

Michelangelo Buonarotti, 59

Middle classes, influence of, 18, 87–9

Milan, Arena, 179

Milizia, Francesco, 40, 42, 136, 156

Milton, John, 161

Moitte, Mme, 70

Montesquieu, Charles-Louis de Secondat, baron de, 136

Monuments, commemorative, 82–5

Morals, arts and, 18–19, 80–83, 114, 142–4

Morellet, André, 120, 202

Morris, Roger, 129

Muller, J. S., 203

Museums, 85–7

Music, 21, 25

Mythology, 43–4

Namier, Sir Lewis, 69

Napoleon Bonaparte, 44, 77, 175–6
portraits of, 122, 179, 206, *101*

Naples, Royal Porcelain Factory, 48, 196, *18*
Teatro S. Carlo, 179, 180–84, 207, *105*

Nature, meanings of the word, 21, 105–5

Neo-classicism, the word, 14

Newton, Sir Isaac, monuments to, 83, 85, 199, *34*

Nibelunglied, 64

Niccolini, Antonio, 207, *105*

Nimes, Maison Carré, 107, 201

Nude, the, 114–22

Nugent, Thomas, 194

Odiot, Jean-Baptiste-Claude, 206

Ossian, 64–6, 141, 142, 186–7, 207–8, *108*

Padua, Prato della Valle, 83

Paestum, 123, 126

Palladianism, 22

Palmyra, 123

Panofsky, Erwin, 106

Paris, Arc du Carrousel, 172, 179, 206, *97*
Arc de Triomphe, 179
Barrière de la Villette, 42, 195, *13*
Bourse, 179
Chambre des Deputés, 130
École de Chirurgie (now de Médecine), 130, 203, *66*
École Militaire, 23, 25
Hôtel d'Hallwyl, 42, 195, *12*
Louvre, 23, 26, 86, 179
Palais Luxembourg, 85
Panthéon, *see*: Sainte Geneviève
Place de la Concorde, 23, 25, 26, 193
Place Louis XV *see*: Place de la Concorde
Place Vendôme, 175
rue de Rivoli, 179
Sainte Geneviève (Panthéon), 23, 25, 123–4, 202, *59*

Pater, Walter, 60, 61

Patronage, 18, 22–3, 82

Percier, Charles, 173, 184, 206, 207, *97, 98*

Péron, A., 194

Perrault, Claude, 23

Perugino, (Pietro Vannucci), 36

Petitot, Ennemond-Alexandre, 194, *4*

Peyron, Jean-François-Pierre, 153, 205, *82*

Peyron, Mme, 70

Phidias, 59

Philadelphia, Academy of Art, 85

Pigalle, Jean-Baptiste, 120, 193, 201–2, *58*

Pindar, 64

Piranesi, Giovanni Battista, 50–57, 180
 Candelabrum constructed by, 56, 196–7, *21*
 Views of Rome, 51–3, 196, 197, *19, 22*
Pirolli, Tommaso, 197, 201
Pius VI, 86
Plekhanov, Georgy, 71, 197
Pliny (C. Plinius Secundus), 45, 106, 113, 120
Plutarch, 44, 75, 82, 142, 179
Polygnotus, 36, 45
Pompadour, Jeanne-Antoine Poisson, marquise de, 22
Pompeii, 43–9
'Pompeian style', 46
Pope, Alexander, 63
Pöppelmann, Mathaeus Daniel, 22
Portraiture, 89–94
Poussin, Gaspard (Dughet), 167
Poussin, Nicolas, 22, 34, 159, 167, 195
 statue of, 82
Praxitiles, 59
Priestley, Joseph, 94
Primitifs (Barbus), 65, 187, 208
Primitivism, 65–7, 126–7, 163–4, 187
Prud'hon, Pierre-Paul, 72, 175, 206, *100*

Quaï, Maurice, 187
Quatremère de Quincy, Antoine, 33, 120

Racine, Jean, 146
Rambouillet, Laiterie de la Reine, 118, 130, 163, 196, 205, *88, 89*
Raphael (Raffaello Sanzio), 46, 59
Raynal, Guillaume, 45, 120, 202
Razoumowsky, Count, portrait of, 194
Réaumor, R.-A.-F. de, 94
Rebecca, Biagio, 196
Revolution, French, 13, 69–80, 171, 184–6, 197, 199
Reynolds, Sir Joshua, 120
 on the Ideal, 105–6
 on imitation, 107
 on Nature and the Antique, 21

on linearity, 113
on universality, 29, 142
portrait of G. Baretti, 89, 199, *36*
Richardson, Jonathan, 120
Richardson, Samuel, 18, 87, 141
Richmond (Surrey), 83
Richmond (Virginia), State Capitol, 107, 200, *47*
Riesener, Jean-Henri, 14
Robert, Hubert, 196, 205
Robespierre, Maximilien-Marie-Isidore, 70, 77
Rococo style, 14, 187
 rejection of, 15, 17–21, 29
Rodin, Auguste, 122
Roentgen, David, 201, *50*
Rollin, Charles, 23
Roman Empire, attitudes towards, 44–6, 173–5
Romantic-classicism, 14
Romanticism, 14, 15, 186–90
Rome, importance of in Neo-classicism, 30
 Castel' S. Angelo, 53, 196, *19*
 Garden of Sallust, 51
 Palatine, 45
 Pantheon, 83, 130
 Pyramid of Caius Cestius, 53
 SS. Apostoli, 195, 205
 S. Maria del Priorato, 56, 197
 S. Pietro, 150, 204
 Temple of Jupiter Stator, 51
 Vatican, Museo Pio-Clementino, 86, 199, *35*
 Villa Albani, 31, 194
Rousseau, Jean-Jacques, 13, 17, 44, 87, 141
Rubens, Peter Paul, 187
Russell, John, 94, 200, *41*
Rysbrack, John Michael, 19

Sade, Donatien-Alphonse-François, comte de, 105
Saint-Ours, Jean-Pierre, 186, 207, *107*
Sallust (C. Sallustius Crispus), 56
Schall, Frédéric, 116
Scheemakers, Peter, 19
Schick, Gottlieb, 144, 204, *76*
Schiller, Johann Christoph Friedrich von, 64, 71, 75, 114, 149

Seneca, L. Annaeus, 155
 statue wrongly identified as, 120,
 202
Sensibility, cult of, 141–6
Sergel, Johann Tobias, 101, 200,
 46
Seroux d'Agincourt, Jean-Baptiste-
 Louis-Georges, 37
Seton Castle (East Lothian), 125,
 202, *61*
Sèvres Porcelain Factory, 14, 164,
 175, 179, 206, 207, *90, 103*
Seznec, J., 144
Shaftesbury, Anthony Ashley
 Cooper, 3rd Earl of, 69
Shakespeare, William, 62, 64, 142,
 146, 161
 monument to, 83
Shugborough Park (Staffs.), 107
Silius Italicus, 164
Silver, 14, 110, 179, *42*
Simonetti, Michelangelo, 86, 199,
 35
Sketches, 101–3
Soane, Sir John, 14, 57, 135, 197,
 203, *23, 70*
Socrates, 106, 150, 155
Soufflot, Jacques-Germain, 23, 25,
 123–4, 202, *59*
Spalato, 123
Speeth, Peter, 180, 207, *104*
Stockholm, monument to Des-
 cartes, 83
Storr, Paul, 14
Stosch, Baron Philip von, 193
Stourhead (Wilts.), 161, 205,
 87
Stowe House (Bucks.), 83
Stuart, James, 107
Sublime, the, 145–6
Sulzer, Johann Georg, 19, 81
Syon House (Middx.), 202, *60*

Tacitus, C. Cornelius, 23
Tardieu, 201
Tasso, Torquato, 161
Terence (Terentius Afer), 56
Theocritus, 161
· Thévenin, 205
Thomire, Pierre-Philippe, 206
Thomon, Thomas de, 70, 109, 201,
 48

Tourville, Maréchal de, statue of,
 82
Trevisani, Francesco, 22

Universality, 29, 105

Valdés, Meléndez, 207
Vandières, marquis de, *see*: Mari-
 gny, marquis de
Vanloo, Amédée, 200
Vanloo, Michel, 200
Vassé, Louis-Claude, 193
Vauban, Sébastian Le Prêtre de, 42
Versailles, Château, 23, 196
 Orangerie, 42
 Petit Trianon, 25, 26, 193, *1*
Vestier, Nicolas, 71
Vico, Giovanni Battista, 136, 197
Vien, Joseph-Marie, 33, 47, 195,
 198, *15*
Vien, Mme, 70
Vienna, Augustiner-Kirche, 156,
 205
 Belvedere, 86
 Porcelain factory, 196
Vincent, François-André, 198
Virgil (Virgilius Maro), 62, 65,
 146, 161, 164
Vitruvius Pollio, Marcus, 22, 45,
 146, 161, 164
Volney, Constantin-François-
 Chasseboeuf, comte de, 75
Volpato, Giovanni, monument to,
 205, *85*
Voltaire, François-Marie Arouet
 de, 17, 23, 75, 83, 187
 statue of, 120, 201–2, *58*
Voss, Johann Heinrich, 63

Walpole, Horace (4th Earl of Or-
 ford), 87
Washington, D.C., Capitol, 109,
 130, 201, *49*
Washington, George, 72, 85
Watt, James, 94
Webb, Daniel, 30, 80
Wedgwood, Josiah, 48, 94
Wedgwood Pottery, 14, 97, 110,
 201, *51*
Weimar, Goethe's garden, 130, *64*
Weinbrenner, Johann Jakob Fried-
 rich, 126, 134, 203, *68*

Weisweiler, Adam, 14
West, Benjamin, 88, 150–53, 204,
 81
Wicar, Jean-Baptiste, 72
Wilson, Richard, 168, 206, *92*
Winckelmann, Johann Joachim,
 19, 33, 40, 46, 50–51, 54, 57–
 62, 86, 145, 150, 195
 bust of, 83
 on Death and Sleep, 148
 Francophobia of, 29
 on imitation, 21
 on liberty, 69
 and Mengs, 31
 on nudity, 114, 116–17
 on patronage, 89
 on Pompeii and Herculaneum,
 45
 on sketches, 101

Wolf, Caspar, 94, 130, 200, *40*
Wolfe, General James, 151–3, *81*
Wollaston, William, bust of, 83
Wood, Robert, 64, 65
Wordsworth, William, 71, 139
Wren, Sir Christopher, 127
Wright, Joseph, 98, 164, 200, 206,
 43, 43a, 91
Würzburg, barracks, 180, 207, *104*
Wyatt, James, 14, 48, 196, *17*

Yeats, William Butler, 190
Young, Edward, 146
Yriarte, Tomás de, 207

Zakharov, Adrian Dimitrievitch,
 130, 203, *65*
Zeuxis, 45, 106
Zoffany, Johann, 116, 201, *56*

More about Penguins and Pelicans

The other titles in the Style and Civilization series

High Renaissance Michael Levey

Supreme accomplishment and total artistic confidence charac-
terize the work produced, not just in Italy but all over Europe,
during this marvellous period – in the palaces at Fontainebleau
and Granada, in Holbein's portraits as much as Raphael's, in
the princely monuments at Innsbruck and Antwerp. Con-
sidered as the interpreters of a divinely inspired energy and
lauded for their ability to transmit pleasure and refinement,
the High Renaissance artists, ranging wide in time and place,
produced a luxuriant profusion of paintings, buildings and
jewellery.

Michael Levey, author of the widely praised *Early Renaissance*
(which earned him the prestigious Hawthornden prize), views
the age as one triumphantly sure that art can rise above nature.
Here, writing absorbingly and aided by a great understanding
of the period and a selection of over 150 illustrations, Levey
demonstrates how Michelangelo's 'David', Titian's 'Assunta',
a piece of Spanish jewellery or a Palissy dish – to name only
a few – illustrate the defiant virtuosity of the High Renaissance.

Also published

Realism Linda Nochlin
Early Medieval George Henderson